Gentlemen;

Here's a $1.00 fee. Please send me any material
you have regarding the faces in the moon.

Years ago my mother showed me Venus, I believe,
being kissed by Cupid. For a ten-year old son we need
help with a picture which shows what I can see.

Anything you may send will find us grateful.

Sincerely,

Previous page: Picture request from Alden B. Baxter to the New York
Public Library's Picture Collection. 28 Aug. 1958.

Rear Views, a Star-Forming Nebula, and
the Office of Foreign Propaganda

The Works of Taryn Simon

Tate Publishing

Table of Contents

A Refusal to Float Free of Origin or Destination

In May 2011, shortly after the opening of Taryn Simon's exhibition *A Living Man Declared Dead and Other Chapters I–XVIII* at Tate Modern, the Serbian ex-general Ratko Mladic, who had been on the run for years following accusations of war crimes, was discovered living quietly in a village in northern Serbia and was captured. This event, which was widely covered in the international press, generated a distinct and significant echo within Simon's exhibition, a chapter of which traced the bloodline of a family that lost many male members in the Srebrenica massacre, for which Mladic was believed to have been responsible. When works from the same series were subsequently exhibited in China, the authorities censored several of the images and all of the text panels for the series. Simon represented this visually in the exhibition by blacking out all of the framed panels that contained the contested content, therefore underscoring, rather than mitigating, the act of censorship.

This ability of *A Living Man Declared Dead* to absorb and generate new meanings, both internally, from one story to another, and in relation to external pressures and events, is by no means accidental however, but lays at the heart of Simon's practice over the past decade. For hers is an approach to the politics of representation that derives its energy and power not only from the production of fixed meanings but from their circulation, restriction and resignification. Simon's work draws its audience into a deep and complicit relationship with the contemporary world of images in all its complexity and contradiction, from the status and function of an historic genre like the portrait, to the apparently arbitrary nature of the organisation and use of information in the age of the internet search engine.

From the outset, Simon's work has been characterised by an abiding engagement with primary research, and consequently with revealing what have come to be known, in the face of rising public scepticism about the way information is presented and used, as both 'known unknowns' and 'unknown unknowns'. She has brought forward individual stories of

injustice and complex inter-related webs of accumulated content – both for their own sake and for the implications that they raise – to reveal the contradictions implicit in the clash of personal and socio-political pressures to which individuals, groups and even nation states are increasingly subject. Possessed of an incredible passion for unearthing and re-presenting facts and narratives which are either overlooked by, or deliberately concealed from, public scrutiny, Simon's work suggests a vital role for the artist in contemporary discourses on politics and the economy of knowledge in the most significant and urgent senses of these terms. It is for this reason perhaps, and because of the absolute, unerring clarity with which the content underlying her practice is delivered, that Simon differs significantly from so many of her peers: speaking directly to a broad audience over the heads of the limited interests and self-consciousness characteristic of so much contemporary art that claims social and political relevance.

The first years of the twenty-first century, during which Simon has come to prominence as an internationally acclaimed artist (with major exhibitions in national museums and public spaces in the United States, Europe and Asia) have also seen serious critical reflection and anxiety over the status of the photographic image, both in the world at large and in the art world especially. Long after winning the battle to bring photographs into the museum, in the United States in particular, photographers, artists, curators, and critics alike still seem concerned with the nature and status of the photographic medium. But against this context of an almost neurotic self-regard about what photography *is* – after conceptual art's appropriations, re-photography, digital technology, camera phones, Google, Flickr, Instagram and so on – Simon's work sets out instead to establish and explore what the photographic image might *do*. Resolutely purposeful, but always balanced, and seldom disclosing any overt agenda, Simon has staked out a practice that attends both to the aesthetic nature of the photograph as part of the history of the medium, and to its rhetorical, political and social functions outside this limiting and often introspective history.

In one sense, Simon's work can be seen as both cutting across and repurposing a kind of investigative photographic practice that stretches back to the WPA during the Great Depression, and even beyond to the groundbreaking visual investigations of little-understood social injustices produced by Jacob Riis and Lewis Hine at the dawn of the twentieth century. But far from producing what is understood now as photojournalism or documentary photography, Simon takes the richest and most sophisticated aspects of these diverse approaches squarely into the field of post-conceptual photographic practice. For, while considering topics of political immediacy like wrongful conviction, state secrecy, and the porosity of international borders, Simon has also consistently been concerned with the rhetorical nature of the image within any such argument, producing text and image works that are as much about the radical potential of images as they are about their limits.

In an important arc of works beginning with *The Innocents* (2002) and stretching to *A Living Man Declared Dead and Other Chapters I–XVIII* (2011) and beyond, Simon has sought consistently and ever more determinedly to embrace and control what Walter Benjamin described as the rising star of the caption, producing work that insistently refuses to compromise in its aim of situating photographic images within the social, political, ethical and personal contexts that concern them, through the controlled use of her

own texts and graphic design. In every presentation of her work, whether specifically framed for exhibition or laid out on the page for publication, Simon exerts a powerful sense of control and intense attention to detail that is as much a signal of her concern for her subject matter as the means by which these stories are presented.

Beyond the compelling nature of the research driving Simon's work, beyond the rhetorical complexity of its presentation, and beyond even the final use-value of the works themselves, there is the undeniable quality of the photographs from which her practice draws its power. For Simon's work, arguably, relies for its impact as much on the precisely articulated, deeply seductive aesthetic through which its ideas are set out visually, as on the arguments themselves. And it is important to note also, in this respect, that Simon's work is situated in the context of the long-lasting aftermath of the so-called 'de-skilling' of photography associated with conceptual art in the 1960s and 1970s. But where artists of this previous generation sought to use photographic images of an impoverished technical character as the basis for works critical of both the social system and its associated politics of representation, Simon, by contrast, embraces the highest formal and technical standards of photographic practice. Her photographs of crime scenes, aberrations, and injustices are composed, calibrated and delivered with a remarkable sensitivity to the history of a medium whose politics are often directly called into question in Simon's work. With rigour, restraint and attention to both observed and technical detail, Simon has produced a stunning body of photographic work that ranges, in conventional genre terms at least, from portraits, to landscapes, to still lives, to images of actions and incidents, and even to pure abstractions, without ever deviating from their own identifiable visual signature.

Simon is a difficult artist, not because she deals with difficult subjects, but because her work resists the kinds of ambiguity so often inherent to the photographic image. She refuses to let her photographs float free of either their origins or destinations. For, as if in response to what Benjamin characterized as the absent-minded public examination common to much mass-circulation imagery, Simon expects her audience to work hard – offering many registers of material and a mass of accumulated detail, both visual and textual – as much to negate the ever-increasingly fast flow of images as to account for its existence and counteract its effects. In much of her work, Simon has reflected on the advancing effects of the post-internet age, on the ready availability of information, or, to be more accurate, its apparent availability. *A Living Man Declared Dead* is exemplary in this respect, pairing detailed, painstaking engagements with the obscure lineages of family histories with the kind of arbitrary 'footnote' facts that come out of online searches into major historical events and phenomena. This characteristic is also present in her analysis of the visual archives of the New York Public Library, *The Picture Collection* (2013), which offers a pre-internet version of a keyword search, once again pairing determined choices with their arbitrary results.

Whether revealing unknown but affecting stories of individuals whose lives have been shaped by the actions of their forebears, or taking issue with the apparatus of state secrecy, Simon's work offers a vision of the world that is at once shockingly simple at the level of facts and impossibly complex in their implications. For beyond the individual examples of stories, histories, and traces that form the basis of her photographic installations and publications, there is a radical acceptance of the entropic nature of bringing them

together. More than anything else, Simon's work is powerfully cumulative in its effect, working not by offering evidence of, or proving, one thing or another, but by suggesting that only by setting so many ideas and issues alongside one another is it possible to build a convincing and accurate picture of the complex and contradictory world that we live in.

Simon Baker
Curator of Photography and International Art, Tate

The Innocents

The Innocents (2002) documents the stories of individuals who served time in prison for violent crimes they did not commit. At issue is the question of photography's function as a credible eyewitness and arbiter of justice.

The primary cause of wrongful conviction is mistaken identification. A victim or eyewitness identifies a suspected perpetrator through law enforcement's use of photographs and lineups. This procedure relies on the assumption of precise visual memory. But, through exposure to composite sketches, mugshots, Polaroids, and lineups, eyewitness memory can change. In the history of these cases, photography offered the criminal justice system a tool that transformed innocent citizens into criminals. Photographs assisted officers in obtaining eyewitness identifications and aided prosecutors in securing convictions.

Simon photographed these men at sites that had particular significance to their illegitimate conviction: the scene of misidentification, the scene of arrest, the scene of the crime, or the scene of the alibi. All of these locations hold contradictory meanings for the subjects. The scene of arrest marks the starting point of a reality based in fiction. The scene of the crime is at once arbitrary and crucial: this place, to which they have never been, changed their lives forever. In these photographs Simon confronts photography's ability to blur truth and fiction—an ambiguity that can have severe, even lethal consequences.

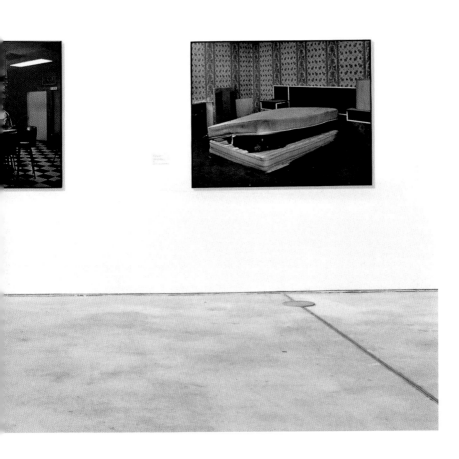

Installation view. *The Innocents*
KW Institute for Contemporary Art, Berlin, 2003

The Innocents, 2002

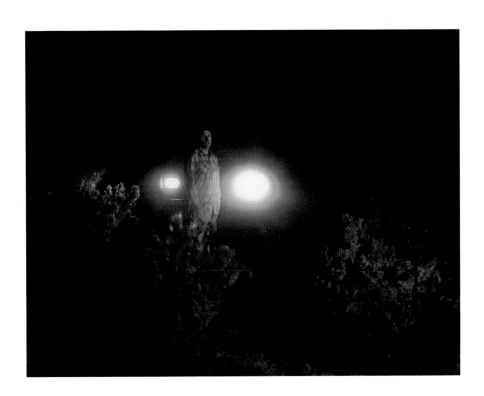

Charles Irvin Fain

Scene of the crime, the Snake River, Melba, Idaho
Served 18 years of a Death sentence for Murder, Rape and Kidnapping

Each: framed archival inkjet print and Letraset on wall
48 ¼ x 62 ¼ inches (122.6 x 158.1 cm)

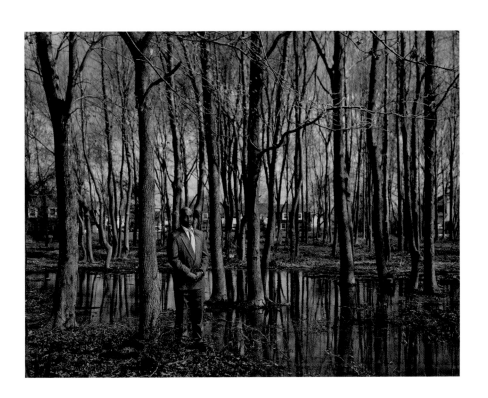

Troy Webb

Scene of the crime, The Pines, Virginia Beach, Virginia
Served 7 years of a 47-year sentence for Rape,
Kidnapping and Robbery

The Innocents, 2002

Frederick Daye

Alibi location, American Legion Post 310
San Diego, California, where 13 witnesses placed Daye at the time of the crime
Served 10 years of a Life sentence for Rape, Kidnapping and Vehicle Theft

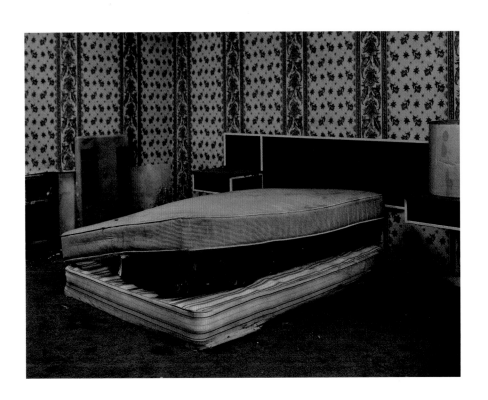

Larry Mayes

Scene of arrest, The Royal Inn, Gary, Indiana
Police found Mayes hiding beneath a mattress in this room
Served 18.5 years of an 80-year sentence for Rape, Robbery
and Unlawful Deviate Conduct

Tim Durham

Skeet shooting, Tulsa, Oklahoma
11 alibi witnesses placed Durham at a skeet-shooting
competition at the time of the crime
Served 3.5 years of a 3,220-year sentence for Rape and Robbery

The Innocents, 2002

Calvin Washington

C&E Motel, Room No. 24, Waco, Texas
Where an informant claimed to have heard Washington confess
Served 13 years of a Life sentence for Murder

The Innocents, 2002

Ron Williamson

Baseball field, Norman, Oklahoma
Williamson was drafted by the Oakland Athletics before being sentenced to Death
Served 11 years of a Death sentence for First Degree Murder

Larry Youngblood

Alibi location, Tucson, Arizona
With Alice Laitner, Youngblood's girlfriend and alibi witness at trial
Served 8 years of a 10.5-year sentence for Sexual Assault,
Kidnapping and Child Molestation

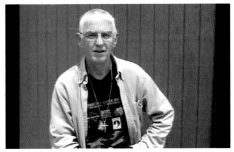

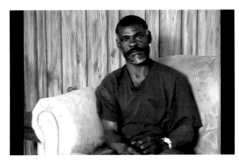

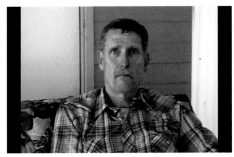

The Innocents, 2002

Single channel video (30:20 minutes) and Letraset on wall
Dimensions variable

Foreword from *The Innocents*

Taryn Simon

I was asked to come down and look at the photo array of different men. I picked Ron's photo because in my mind it most closely resembled the man who attacked me. But really what happened was that, because I had made a composite sketch, he actually most closely resembled my sketch as opposed to the actual attacker. By the time we went to do a physical lineup, they asked if I could physically identify the person. I picked out Ronald because, subconsciously, in my mind, he resembled the photo, which resembled the composite, which resembled the attacker. All the images became enmeshed to one image that became Ron, and Ron became my attacker.

–Jennifer Thompson, on the process to identify the man who raped her

From 2000–2002, I traveled across the United States photographing and interviewing men and women convicted of crimes they did not commit. In each case, photography offered the criminal justice system a tool that transformed innocent citizens into criminals, assisted officers in obtaining erroneous eyewitness identifications, and aided prosecutors in securing convictions. The criminal justice system had failed to recognize the limitations of relying on photographic images.

For the men and women in this book, the primary cause of wrongful conviction was mistaken identification. A victim or eyewitness identifies a suspected perpetrator through law enforcement's use of photographs and lineups. These identifications rely on the assumption of precise visual memory. But through exposure to composite sketches, mugshots, Polaroids, and lineups, eyewitness memory can change. Police officers and prosecutors influence memory—both unintentionally and intentionally—through the ways in which they conduct the identification process. They can shape, and even generate, what comes to be known as eyewitness testimony.

Jennifer Thompson's account of the process by which she misidentified her attacker illustrates the malleability of memory. A domino effect ensues in which victims do remember a face, but not necessarily the face they saw

during the commission of the crime. 'All the images became enmeshed to one image that became Ron, and Ron became my attacker.'

In the case of Marvin Anderson, convicted of rape, forcible sodomy, abduction, and robbery, the victim was shown a photographic array of six similar black-and-white mugshots and one color photo. The face that stood out to the victim was the color photo of Anderson. After the victim picked Anderson from the photo array, she identified him in a live lineup. Of the seven men in the photo array, Anderson was the only one who was also in the lineup. Marvin Anderson served 15 years of a 210-year sentence.

In the case of Troy Webb, convicted of rape, kidnapping, and robbery, the victim was shown a photo array. She tentatively identified Webb's photo, but said that he looked too old. The police then presented another photo of Webb taken four years before the crime occurred. He was positively identified. Troy Webb served 7 years of a 47-year sentence.

The high stakes of the criminal justice system underscore the importance of a photographic image's history and context. The photographs in this book rely upon supporting materials—captions, case profiles, and interviews—in an effort to construct a more adequate account of these cases. This project stresses the cost of ignoring the limitations of photography and minimizing the context in which photographic images are presented. Nowhere are the material effects of ignoring a photograph's context as profound as in the misidentification that leads to the imprisonment or execution of an innocent person.

I photographed each innocent person at a site that came to assume particular significance following his wrongful conviction: the scene of misidentification, the scene of arrest, the alibi location, or the scene of the crime. In the history of these legal cases, these locations have been assigned contradictory meanings. The scene of arrest marks the starting point of a reality that is based in fiction. The scene of the crime, for the wrongfully convicted, is at once arbitrary and crucial; a place that changed their lives forever, but to which they had never been. Photographing the wrongfully convicted

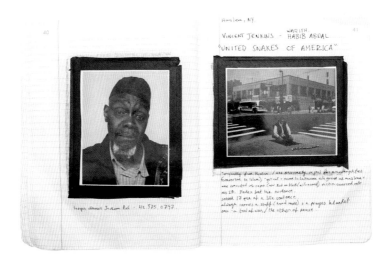

Project journals of large-format Polaroids and notes, 2000–2002

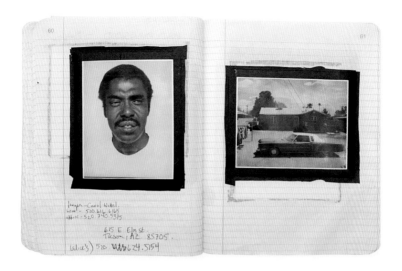

Project journals of large-format Polaroids and notes, 2000–2002

in these environments brings to the surface the attenuated relationship between truth and fiction, and efficiency and injustice.

The wrongfully convicted in this book were exonerated through the use of DNA evidence. Only in recent years have eyewitness identification and testimony been forced to meet the test of DNA corroboration. Eyewitness testimony is no longer the most powerful and persuasive form of evidence presented to juries. Because of its accuracy, DNA allows a level of assurance that other forms of evidence do not offer. In the exoneration process, DNA evidence pressures the justice system and the public to concede that a convicted person is indeed innocent. In our reliance upon these new technologies, we marginalize the majority of the wrongfully convicted, for whom there is no DNA evidence, or those for whom the cost of DNA testing is prohibitive. Even in cases in which it was collected, DNA evidence must be handled and stored and is therefore prey to human error and corruption. Evidence does not exist in a closed system. Like photography, it cannot exist apart from its context, or outside of the modes by which it circulates.

Photography's ability to blur truth and fiction is one of its most compelling qualities. But when misused as part of a prosecutor's arsenal, this ambiguity can have severe, even lethal consequences. Photographs in the criminal justice system, and elsewhere, can turn fiction into fact. As I got to know the men and women in this book, I saw that photography's ambiguity, beautiful in one context, can be devastating in another.

Originally published in Taryn Simon, *The Innocents*.
New York: Umbrage Editions, 2003

An American Index of the Hidden and Unfamiliar

In *An American Index of the Hidden and Unfamiliar* (2007),
Simon compiles an inventory of what lies hidden and
out-of-view within the borders of the United States.
She examines a culture through the documentation of
subjects from domains including: science, government,
medicine, entertainment, nature, security, and religion.

Confronting the divide between those with and without
the privilege of access, Simon's collection reflects and
reveals that which is integral to America's foundation,
mythology, and daily functioning.

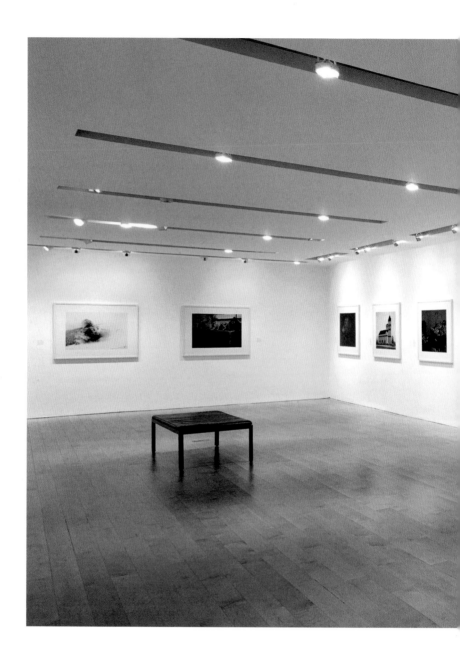

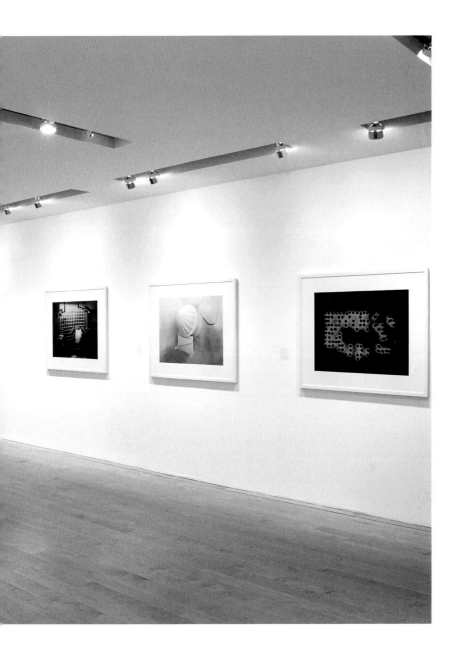

Installation view. *An American Index of the Hidden and Unfamiliar*
Whitney Museum of American Art, New York, 2007

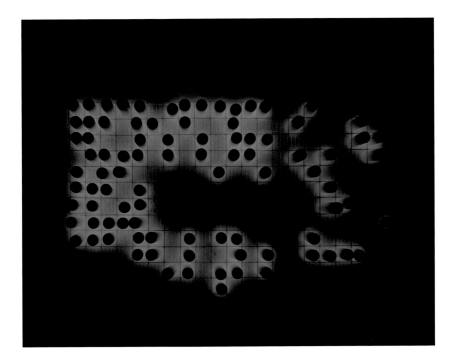

Nuclear Waste Encapsulation and Storage Facility, Cherenkov Radiation
Hanford Site, U.S. Department of Energy
Southeastern Washington State

Submerged in a pool of water at Hanford Site are 1,936 stainless steel nuclear
waste capsules containing cesium and strontium. Combined, they contain over
120 million curies of radioactivity. It is estimated to be the most curies under
one roof in the United States. The blue glow is created by the Cherenkov Effect
or Cherenkov radiation. The Cherenkov Effect describes the electromagnetic
radiation emitted when a charged particle, giving off energy, moves faster than
light through a transparent medium. The temperatures of the capsules are as
high as 330 degrees Fahrenheit. The pool of water serves as a shield against
radiation; a human standing one foot from an unshielded capsule would receive
a lethal dose of radiation in less than 10 seconds.

Hanford is a 586 square mile former plutonium production complex. It was
built for the Manhattan Project, the U.S.-led World War II defense effort that
developed the first nuclear weapons. Hanford plutonium was used in the atomic
bomb dropped on Nagasaki in 1945. For decades afterwards Hanford manufac-
tured nuclear materials for use in bombs. At Hanford there are more than 53 mil-
lion gallons of radioactive and chemically hazardous liquid waste, 2,300 tons of
spent nuclear fuel, nearly 18 metric tons of plutonium-bearing materials and about
80 square miles of contaminated groundwater. It is among the most contaminated
sites in the United States.

Each: framed archival inkjet print and Letraset on wall
37 ¼ x 44 ¾ inches (94.6 x 113.7 cm)

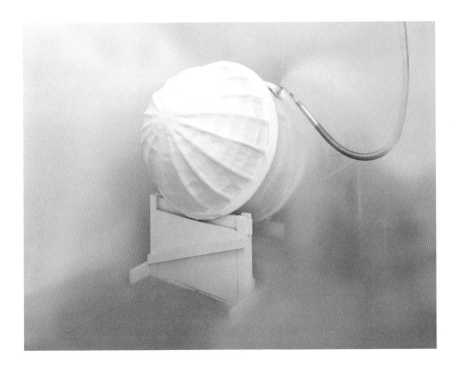

Cryopreservation Unit
Cryonics Institute
Clinton Township, Michigan

This cryopreservation unit holds the bodies of Rhea and Elaine Ettinger,
the mother and wife of cryonics pioneer, Robert Ettinger. Robert, the author of
The Prospect of Immortality and Man into Superman *is still alive.*

The Cryonics Institute is a non-profit, member-run corporation which offers cryostasis (freezing) services to individuals and pets upon death. Cryostasis is practiced with the hope that lives will ultimately be extended through future developments in science, technology, and medicine. When, and if, these developments occur, members hope to be awakened to an extended life in good health and free from disease or the aging process. Cryostasis must begin immediately upon legal death. A person or pet is infused with ice-preventive substances and quickly cooled to a temperature where physical decay virtually stops. They can be kept in this state indefinitely. For an additional cost, Cryonics Institute personnel will wait out the last hours of an individual's terminal illness and immediately begin cooling and cardiopulmonary support upon death in order to limit brain damage.

At present, the Cryonics Institute cryopreserves 74 legally dead human patients and 44 legally dead pets. It charges $28,000 for the process if it is planned well in advance of legal death and $35,000 on shorter notice. The cost has not increased since 1976 when the Cryonics Institute was established. The Institute is licensed as a cemetery in the state of Michigan.

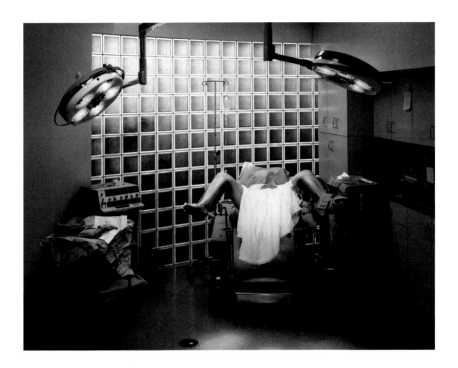

Hymenoplasty
Cosmetic Surgery, P.A.
Fort Lauderdale, Florida

The patient in this photograph is 21 years old. She is of Palestinian descent and living in the United States. In order to adhere to cultural and familial expectations regarding her virginity and marriage, she underwent hymenoplasty. Without it she feared she would be rejected by her future husband and bring shame upon her family. She flew in secret to Florida where the operation was performed by Dr. Bernard Stern, a plastic surgeon she located on the internet.

The purpose of hymenoplasty is to reconstruct a ruptured hymen, the membrane which partially covers the opening of the vagina. It is an outpatient procedure which takes approximately 30 minutes and can be done under local or intravenous anesthesia.

The hymen has not been proven to serve any biological function. Some girls are born with an imperforate hymen. Rupture most often occurs during first intercourse, but some girls tear their hymen during sports activities or as a result of injuries. The majority of the time there is a correlation between an intact hymen and a woman's virginity; many cultures view the tearing of the hymen as a critical symbol of that loss. While similar attempts to alter the hymen predate modern plastic surgery, hymenoplasty is now just one of several vaginal cosmetic surgeries that are growing in popularity worldwide. Dr. Stern charges $3,500 for hymenoplasty. He also performs labiaplasty and vaginal rejuvenation.

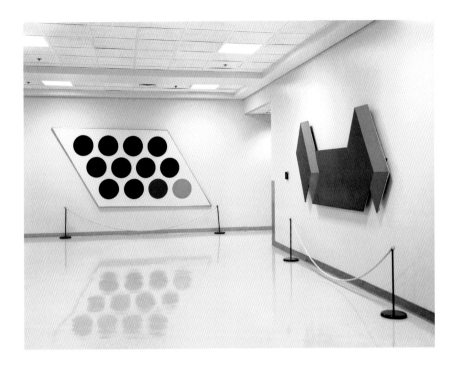

The Central Intelligence Agency, Art
CIA Original Headquarters Building
Langley, Virginia

The Fine Arts Commission of the CIA is responsible for acquiring art to display in the Agency's buildings. Among the Commission's curated art are two pieces (pictured) by Thomas Downing, on long-term loan from the Vincent Melzac collection. Downing was a member of the Washington Color School, a group of post World War II painters whose influence helped to establish the city as a center for arts and culture. Vincent Melzac was a private collector of abstract art and the Administrative Director of the Corcoran Gallery of Art, Washington D.C.'s premiere art museum. Among Melzac's many contributions to the CIA is a bronze bust of President George H.W. Bush, sculpted by Marc Mellon, and located in the Original Headquarters Building.

Since the founding of the CIA in 1947, the Agency has participated in both covert and public cultural diplomacy efforts throughout the world. It is speculated that some of the CIA's involvement in the arts was designed to counter Soviet Communism by helping to popularize what it considered pro-American thought and aesthetic sensibilities. One well documented example of their cultural involvement was the 1967 exposure of CIA funding, through the Congress for Cultural Freedom, of *Encounter Magazine*, a well respected outlet for US and European intellectuals. The Congress for Cultural Freedom, established in 1950, sponsored numerous journals, conferences of western intellectuals, art exhibits and books. Such involvement in cultural diplomacy and CIA sponsorship has raised historical questions about certain art forms or styles that may have elicited the interest of the Agency, including abstract expressionism.

Smith & Wesson .44 Magnum Revolver Frame
Smith & Wesson Headquarters
Springfield, Massachusetts

Following the hot forging and cutting stages of production, the frame of a revolver is transferred to the finishing department where it is de-burred, polished and blued. In the final assembly area, a barrel, cylinder and internal lock are hand fitted into the revolver.

Smith & Wesson is the leading manufacturer of handguns in the United States. The company works with law enforcement and government agencies including NYPD, Atlanta PD, Las Vegas Metro PD and the U.S. military, which recently purchased Smith & Wesson's Sigma series 9mm pistol for use in Afghanistan.

The Second Amendment of the U.S. Constitution declares: "A well regulated Militia, being necessary to the security of a free State, the right of the people to keep and bear Arms, shall not be infringed." The National Rifle Association Institute for Legislative Action currently estimates that there are well over 200 million privately owned firearms in the United States. Handguns account for upwards of 70 million of that number. The .44 Magnum was popularized by actor Clint Eastwood in the 1971 movie *Dirty Harry*.

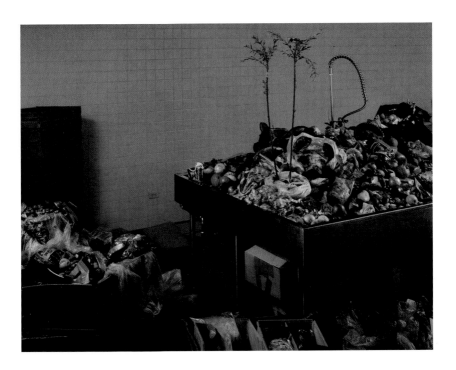

U.S. Customs and Border Protection, Contraband Room
John F. Kennedy International Airport
Queens, New York

*African cane rats infested with maggots, African yams (dioscorea), Andean
potatoes, Bangladeshi cucurbit plants, bush meat, cherimoya fruit, curry leaves
(murraya), dried orange peels, fresh eggs, giant African snail, impala skull cap,
jackfruit seeds, June plum, kola nuts, mango, okra, passion fruit, pig nose, pig
mouths, pork, raw poultry (chicken), South American pig head, South American tree
tomatoes, South Asian lime infected with citrus canker, sugar cane (poaceae),
uncooked meats, unidentified sub tropical plant in soil.*

All items in the photograph were seized from the baggage of passengers arriving
in the U.S. at JFK Terminal 4 from abroad over a 48-hour period. JFK handles
the highest number of international arrivals into the nation's airports and pro-
cesses more international passengers than any other airport in the United States.

Prohibited agricultural items can harbor foreign animal and plant pests and
diseases that could damage U.S. crops, livestock, pets, the environment and the
economy. Before entering the country, passengers are required to declare fruits,
vegetables, plants, seeds, meats, birds, or animal products that they may be car-
rying. The CBP agriculture specialists determine if items meet U.S. entry
requirements. The U.S. requires permits for animals and plants in order to
safeguard against highly infectious diseases, such as foot-and-mouth disease and
avian influenza. All seized items are identified, dissected, and then either
ground up or incinerated.

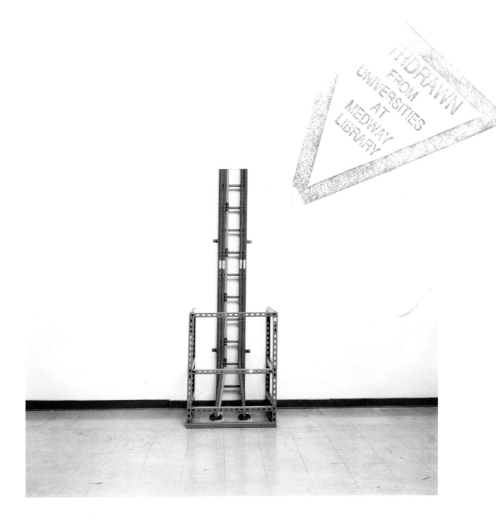

Transatlantic Sub-marine Cables Reaching Land
VSNL International
Avon, New Jersey

These VSNL sub-marine telecommunications cables extend 4,029.6 miles across the Atlantic Ocean. Capable of transmitting over 60 million simultaneous voice conversations, these underwater fiber-optic cables stretch from Saunton Sands in the United Kingdom to the coast of New Jersey. The cables run below ground and emerge directly into the VSNL International headquarters, where signals are amplified and split into distinctive wavelengths enabling transatlantic phone calls and internet transmissions.

Underwater fiber-optic cables are laid along the ocean's floor by specially designed ships. Cables are buried as they approach shore and armored to protect against undersea landslides, marine life (sharks, in particular) and fishing equipment. Fishermen are advised of cable locations as hooking one can interfere with international communication services as well as sink a boat.

VSNL operates one of 14 sub-marine cable systems connected to the continental United States. Exchanges originating in the U.S. are combined and enhanced before broadcast and transmission across the Atlantic. As of 2005, sub-marine cables link all the world's continents except Antarctica.

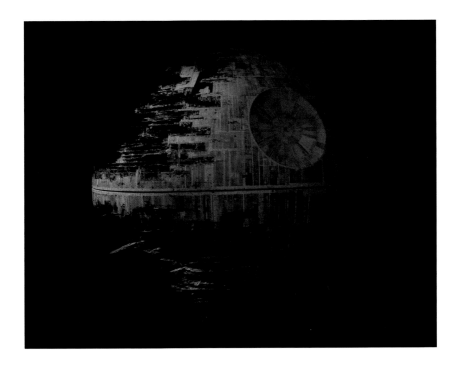

Lucasfilm Archives, Death Star II
Skywalker Ranch
Marin County, California

Lucasfilm Archives was built in 1991 to preserve the artifacts used in the making of writer, director and producer George Lucas's films. The collection, housed at Skywalker Ranch, includes props, costumes and set pieces from some of the highest grossing films in the history of cinema, including the *Star Wars* and *Indiana Jones* franchises. 95 percent of Skywalker Ranch is subject to a deed of gift to Marin Agricultural Land Trust and dedicated to open space.

In *Star Wars: Episode VI Return of the Jedi*, Death Star II is seen as a mirror image (flipped). Here it is pictured in its true orientation. Death Star II measures 51 x 27 x 51in. and has a painted acrylic façade with photo-etched brass detailing. Within the context of the films, Death Star II is a deep space battle station used by the Galactic Empire measuring 160 kilometers in diameter, outfitted with turbolasers, tractor beams and a superlaser which has the ability to annihilate planets and civilizations. The original Death Star was destroyed by Luke Skywalker in *Star Wars: Episode IV A New Hope*. Despite vastly improved shielding and targeting systems, the second Death Star was also destroyed, by Lando Calrissian and his co-pilot.

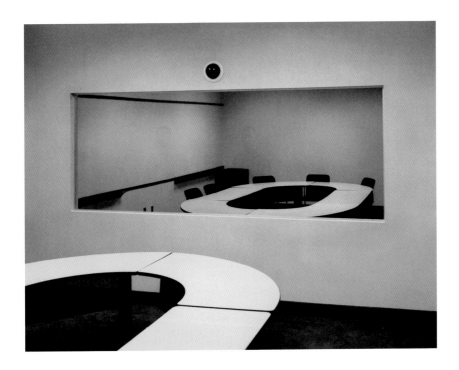

Jury Simulation, Deliberation Room with Two-Way Mirror
DOAR Litigation Consulting
Lynbrook, New York

*Director of Jury Consultation, David Klein, and Vice President of Jury Consulting,
James Dobson, monitor and analyze mock trial proceedings and jury deliberations
in order to assist their clients in developing effective trial strategies.*

Mock juries are an important part of litigation consulting, a little-known
professional field with annual profits of approximately $3 billion. DOAR's jury
simulations offer attorneys the opportunity to practice case presentations as well
as assess performances. The estimated cost of a single jury simulation is
$60,000. They are most often employed on high-profile, high-stake cases,
where cost is of little concern. Recently DOAR provided litigation consulting
services to parties involved in the World Trade Center insurance litigation and
the WorldCom Underwriters litigation. Participation of litigation consultants
in trial preparations has many critics concerned that legal outcomes will
increasingly depend on one's ability to pay.

Jurors for DOAR simulations are jury eligible individuals from the jurisdic-
tion where the actual case will be tried. They are recruited to accurately reflect
the socio-demographic backgrounds of that jurisdiction's population. They are
paid between $150 and $500 per day to participate in the simulation. All par-
ties sign a confidentiality agreement.

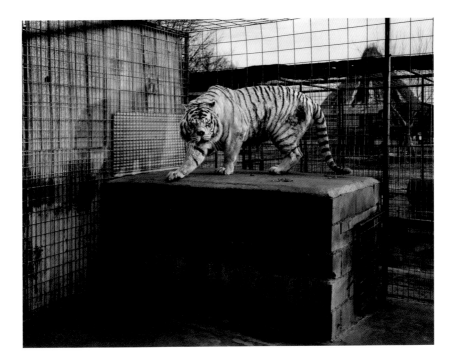

White Tiger (Kenny), Selective Inbreeding
Turpentine Creek Wildlife Refuge and Foundation
Eureka Springs, Arkansas

Kenny was born to a breeder in Bentonville, Arkansas on February 3, 1999. As a result of inbreeding, Kenny has mental retardation and significant physical limitations. Due to his deep-set nose, he has difficulty breathing and closing his jaw, his teeth are severely malformed and he limps from abnormal bone structure in his forearms.

White tigers are extremely rare in their natural habitats in Asia. In the U.S., all living white tigers are the result of selective inbreeding in captivity to artificially create the genetic conditions that lead to white fur, ice-blue eyes and a pink nose. Currently, inbreeding such as father to daughter, brother to sister, mother to son has become commonplace. It produces a white cub less than 25% of the time, with only approximately 3% of those considered "quality." The three other tigers in Kenny's litter are not considered to be quality white tigers as they are yellow coated, cross-eyed, and knock-kneed.

Conservation experts challenge the perception that white tigers are a rare and endangered species. Instead, they state that zoos, breeders, and entertainment acts have over-bred white tigers for financial gain, citing instances where private breeders and zoos have sold "quality" white tigers for over $60,000. The grave health consequences of inbreeding and over-breeding have led to abortions, stillbirths and a high mortality rate among infants. The Species Survival Plan has condemned the practice. In recent years there has been a significant drop in their market value.

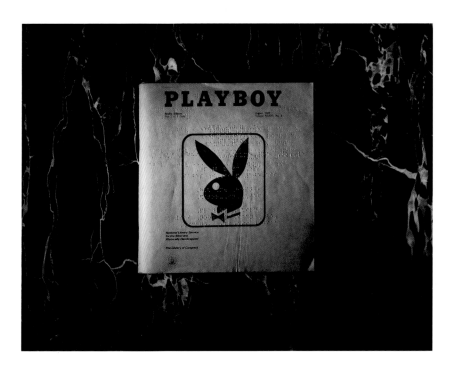

Playboy, Braille Edition
Playboy Enterprises, Inc.
New York, New York

The National Library Service for the Blind and Physically Handicapped (NLS), a division of the U.S. Library of Congress, provides a free national library program of Braille and recorded materials for blind and physically handicapped persons. Magazines included in the NLS's programs are selected on the basis of demonstrated reader interest. This includes the publishing and distribution of a Braille edition of *Playboy*.

Approximately 10 million American adults read *Playboy* every month, with 3 million obtaining it through paid circulation. It has included articles by writers such as Norman Mailer, Vladimir Nabokov, Philip Roth, Joyce Carol Oates, and Kurt Vonnegut and conducted interviews with Salvador Dalí, Jean-Paul Sartre, and Malcolm X.

In 1985, opposition to federal funding for *Playboy* in Braille led Congress to withhold the $103,000 it cost to produce the NLS editions. *Playboy* in Braille was the only magazine targeted for elimination. Representative Vic Fazio of California, the American Council of the Blind, the Blinded Veterans Association, the American Library Association, and subscribers to NLS's *Playboy* in Braille filed a lawsuit in Federal District Court, claiming that their First Amendment rights had been violated. The next year Federal District Judge Thomas F. Hogan ruled in their favor. The NLS publication and free distribution of *Playboy* in Braille continues, funded by Congress.

After giving your request serious consideration, even though it is against company policy to consider such a request, it is with regret that I inform you that we are not willing to grant the permission you seek ... As you are aware, our Disney characters, parks and other valuable properties have become beloved by young and old alike, and with this comes a tremendous responsibility to protect their use and the protection we currently enjoy. Should we lapse in our vigilance, we run the risk of losing this protection and the Disney characters as we know and love them. Especially during these violent times, I personally believe that the magical spell cast on guests who visit our theme parks is particularly important to protect and helps to provide them with an important fantasy they can escape to.

Excerpted from a faxed response from Disney
Publishing Worldwide, July 7, 2005

Silkscreened text on wall, 16 ¼ x 9 ⅝ (41.3 x 24.4 cm)

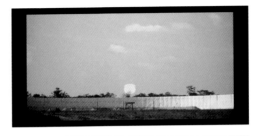

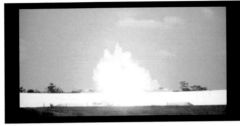

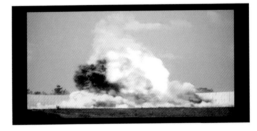

Exploding Warhead
Test Area C-80C
Eglin Air Force Base, Florida

This is a test of an MK-84 IM (Insensitive Munition) Warhead conducted at the Eglin Air Force Base Air Armament Center. The warhead was tested by the 46th Test Wing's 780th Test Squadron in order to collect pressure and fragment velocity data on a new experimental explosive warhead fill. The Air Armament Center is responsible for the development, testing and deployment of all U.S. air-delivered weapons. It tripled its production of Joint Direct Attack Munition (JDAM) for Operation Iraqi Freedom. This film was shot using a remote sequencer that detonated the warhead from a control bunker. It was captured on U.S. government issue film with a red marking.

Exploding Warhead, 2007

72 mm-Kodak film (1:08 minute, loop) and Letraset on wall
Dimensions variable

Foreword from *An American Index of the Hidden and Unfamiliar*

Salman Rushdie

"Our interest's on the dangerous edge of things," the poet Robert Browning wrote in *Bishop Blougram's Apology* (1855). It's a line that has inspired writers from Graham Greene, who said in his 1971 memoir *A Sort of Life* that it could serve as an epigraph to all his novels, to Orhan Pamuk, who sets it at the beginning of his novel *Snow*. It could equally well serve as an introduction to the photography of a woman whose aesthetic is one of stretching the limits of what we are allowed to see and know, of going to the ambiguous boundaries where dangers – physical, intellectual, even moral – may await. She doesn't think twice about entering the mountain cave of a hibernating black bear and her cubs, or a room filled with nuclear waste capsules glowing blue with radiation that, were you not shielded against it, would kill you in seconds. Taryn Simon has seen the Death Star and lived to tell the tale.

I am always immensely grateful to people who do impossible things on my behalf and bring back the picture. It means I don't have to do it, but at least I know what it looks like. So one's first feeling on looking at many of these extraordinary images is gratitude, (followed quickly by a momentary pang of envy: the sedentary writer's salute to the woman of action). I once knew a sports photographer who bribed a course attendant at Aintree racecourse in Liverpool, England, to allow him to sit wedged in at the foot of the giant fence, Becher's Brook, that is the most dangerous obstacle in the four-and-a-half-mile Grand National Steeplechase, so that he could bring back "impossible" photographs of the mighty racehorses jumping over his head. If one of them had fallen on him, of course, he would almost certainly have been killed, but he knew, as Simon knows, that one of the arts of great photography is to get yourself into the place – the radioactive room, an animal disease centre, the racecourse fence – in which the photograph is about to occur, and seize it when it does.

"Most of what matters in our lives takes place in our absence," the narrator of my novel *Midnight's Children* reflects. If Saleem Sinai had seen Simon's photographs he would have realized that he was more right than he knew.

Look at these innocent orange and yellow cables coming up through the floor in an almost empty room in New Jersey, protected only by the simplest metal cage: they have travelled four thousand miles (actually, 4,029.6 miles: Simon likes to be precise) across the ocean floor from Saunton Sands in the United Kingdom to bring America news from elsewhere – 60,211,200 simultaneous voice conversations, Simon says. But the point about these cables is that you might have guessed that such things probably existed but you almost certainly had no notion of where they were, or how many, or how thick, or what colour, until you saw this picture. You could not have imagined your voice into this banal yet magical room, but it has been here, transformed into little digital parcels of energy. Every day we pass through secret worlds like the worlds inside these cables, never suspecting what is happening to us. Which, then, is the phantom world and which the "real": ours, or theirs? Are we no more than the ghosts in these machines?

Ours is an age of secrets. Above, beneath and beside what Fernand Braudel called the "structures of everyday life" are other structures that are anything but everyday, lives about which we may have heard something but of which we have almost certainly seen nothing, as well as other lives about which we have never heard, and yet others in whose existence it is hard to believe even when we are shown the pictorial evidence. Would you have believed in the existence, for example, of *Playboy* magazine in Braille? Well, here it is, bunny-ears and all, published by a branch of the Library of Congress, no less. And here, too, is a photograph looking for all the world like a slightly stagey Hitchcockian crime scene, like, for example, the wooded slope in *The Trouble With Harry* where we first learn what the trouble with Harry is (he's dead, is what the trouble is). It's a picture of a young boy's corpse rotting in a wood, taken at a research facility in Tennessee set up specifically to study how bodies decompose in different settings. Here, Simon tells us, there are up to 75 cadavers at any given time, decomposing across a six-acre site. Maybe Patricia Cornwell or the folks at CSI knew about this kind of cutting-edge forensic research, but I didn't, and even as one looks at Simon's preternaturally beautiful picture, with its bare glistening branches and fallen leaves and rich autumnal palette, one finds oneself wondering at human beings' limitless ingenuity, our need to know, in which cause even our own dead bodies might someday be pressed into service, to decay in a woodland glade.

How do you get into some of the world's most secret places, and get out again with the picture? The great journalist Ryszard Kapuscinski says that he survives the world's most dangerous war zones by making himself seem small and unimportant, not worthy of keeping out, not worthy of the warlord's bullet. But Simon doesn't deal in stolen images; these are formal, highly realized, often carefully posed pictures, which require their subjects' full co-operation. That she has managed to gain such open access to, for example, the Church of Scientology and MOUT, an inaccessible simulated city in Kentucky used, for training purposes, as an urban battlefield, and the Imperial Office of the World Knights of the Ku Klux Klan with its Wizards and Nighthawks and Kleagles, looking like characters from a Coen Brothers movie, and even the operating theatre in which a Palestinian woman is undergoing hymenoplasty, a procedure generally used to restore virginity, is evidence that her powers of persuasion are at least the equal of her camera skills. In a historical period in which so many people are making such great efforts to conceal the truth from the mass of the people, an artist like Taryn Simon is an invaluable

counter-force. Democracy needs visibility, accountability, light. It is in the unseen darkness that unsavoury things huddle and grow. Somehow, Simon has persuaded a good few denizens of hidden worlds not to scurry for shelter when the light is switched on, as cockroaches do, and vampires, but to pose proudly for her invading lens, brandishing their tattoos and Confederate flags.

Simon's is not the customary aesthetic of reportage – the shaky hand-held camera, the grainy monochrome film stock of the "real." Her subjects – gray parrots in their quarantine cages, marijuana plants grown for research purposes in William Faulkner's home town of Oxford, Mississippi, the red-hot form of Dirty Harry's .44 Magnum shot in the heat of the forge, a pair of Orthodox Jews United Against Zionism – are suffused with light, captured with a bright, hyper-realist, high-definition clarity that gives a kind of star status to these hidden worlds, whose occupants might be thought to be the opposites of stars. In her vision of them, they are dark stars brought into the light. What is not known, rarely seen, possesses a form of occult glamour, and it is that black beauty which she so brightly, and brilliantly, reveals. Here is the beach house at Cape Canaveral where astronauts go with their spouses for a last private moment before they blast off into space. Here is a man skewered through the chest hanging in the air during the Lone Star Sun Dance. Here is the floodlit basketball court of the Cheyenne Mountain Directorate in Colorado, a surveillance post designed to survive a thermo-nuclear bomb. One can only imagine what strange post-apocalyptic one-on-one games, what last-ever turn-around jump shots might be attempted here if things go badly wrong for the rest of us. This is the way the world ends: not with a bang but a sky-hook. (No, on reflection, there would probably be a bang as well.)

Simon uses text as few photographers do, not merely as title or caption but as an integral part of the work. There are images which do not reveal their meaning until the text is read, such as her photograph of the flowing Nipomo Sand Dunes in Guadalupe, California, beneath which, she tells us, lies buried one of the most extraordinary film sets ever built, the City of the Pharaoh created for Cecil B. DeMille's 1923 silent version of *The Ten Commandments,* and deliberately buried here to prevent other productions from "appropriating his ideas and using his set." There are (rare) instances when the text is more bizarrely interesting than the image. Cataloguing the confiscated contents of the US Customs and Border Protection Contraband Room at John F. Kennedy Airport, Simon offers up a kind of surrealist fugue, an ode to forbidden fruit (and meat) that outdoes even her cornucopia of an image: *"African cane rats infested with maggots,"* she sings, *"African yams (Dioscorea), Andean potatoes, Bangladeshi cucurbit plants, bush meat, cherimoya fruit, curry leaves (murraya), dried orange peels, fresh eggs, giant African snail, impala skull cap, jackfruit seeds, June plum, kola nuts, mango, okra, passion fruit, pig nose, pig mouths, pork, raw poultry (chicken), South American pig head, South American tree tomatoes, South Asian lime infected with citrus canker, sugar cane (Poaceae), uncooked meats, unidentified sub tropical plant in soil."*

For the most part, however, her images easily hold their own, even when accompanied by the most astonishing information. The smoky, white-on-white portrait of the degree-zero cryogenic preservation pod in which the bodies of the mother and wife of cryonic pioneer Robert Ettinger lie frozen is beyond spooky, speaking so eloquently of our fear of death and our dreams of immortality that few words are necessary. The top-shot of a mass of infectious medical waste achieves the abstract beauty of a Jackson Pollock drip-painting, or, perhaps, a

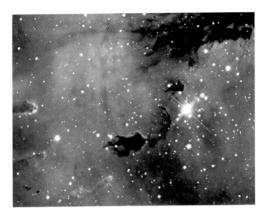

NGC 281, The Pacman Nebula, Kitt Peak National
Observatory, Tohono O'odham Reservation, Arizona,
An American Index of the Hidden and Unfamiliar, 2007

Schnabel smashed-crockery piece. There are images of deep humanity, such as
the portrait of Don James, a terminal cancer patient, taken just after he received
a prescription for a lethal dose of pentobarbital, for which he had successfully
fought under Oregon's Death With Dignity act. There are mind-numbing gro-
tesques, such as the picture of Pastor Jimmy Morrow the Serpent Handler of
Newport, Tennessee holding a lethally poisonous Southern Copperhead snake
just above a Biblical text instructing us to "Call His Name Jesus" – and there
are mind-expanding epic images, such as a roseate portrait of a star-forming
region, the Pacman Nebula, nine and a half thousand light years away. (That's
slightly less than 57,000,000,000,000,000 miles, by my calculation: a long
way to go for a good picture.) And in at least one instance there's a remarkable
piece of "found" art. Who could have predicted that those ninety stainless steel
capsules containing radioactive cesium and strontium submerged in a pool
of water and giving off that blue radiation would so closely resemble, when
photographed from above, the map of the United States of America? When
a photographer comes up with an image as potently expressive as that, even a
dedicated word-person such as myself is bound to concede that such a picture
is worth at least a thousand words.

Originally published in Taryn Simon, *An American Index of the Hidden and
Unfamiliar*. Exh. cat., Whitney Museum of American Art. Göttingen: Steidl, 2007

Introduction from *An American Index of the Hidden and Unfamiliar*

Elisabeth Sussman & Tina Kukielski

This book is an inventory of what lies deep within the borders of the United States at the foundation of a national culture. It anticipates the reconstruction of a confused moment in the midst of a country's burgeoning self-consciousness. In compiling *An American Index of the Hidden and Unfamiliar* photographer Taryn Simon assumes the role of a shrewd informant while invoking the spirit of a collector of curiosities, culling from the diverse domains of science, government, medicine, entertainment, nature, security, and religion. One commonality persists in her chosen subjects: each remain relatively unknown or out-of-view to a wider public audience. These are the hidden and unfamiliar. Yet Simon is quick to admit that her selection process is random and the 62 annotated photographs comprising the series are by no means a system of classification. This is not an archive, but a time capsule. And as such, *An American Index* documents one artist's journey, over a period of four years, to uncover and examine subjects integral to America's foundation, mythology, and daily functioning. Offering visions of the unseen, and explanations for the unexplained, Simon captures the strange magic locked beneath the surface of these unsettled times.

In the years leading up to *An American Index,* Simon's work focused on international regions in turmoil. Her personal projects in Lebanon and Israel and professional assignments in Gaza, Syria and Aceh have informed and influenced her photographic program, which has come to occupy a territory bridging the world of art and politics. Simon confronts this divide between politicization and aestheticization by casting a seductive spotlight on individuals and locations that traditionally might not receive such a carefully sculpted stage.

As a child Simon experienced another seminal period when she first saw far corners of the world in Kodachrome slides her father had shot and amassed during his work and travels as a young man. Simon's father documented Moscow, Leningrad and Kiev at the height of the Cold War. As an employee of the Department of State, stationed in Bangkok during the

Vietnam War, he documented sites in Northeast Thailand, Vietnam, Cambodia, and Laos. He later photographed extensively in Afghanistan, Iran, and Israel. These were sites unseen to most American eyes during a time when the United States was engaged in a program of cultural, political, and economic exportation, spearheaded by such government organizations as the United States Information Agency (1953–1999).

A desire to uncover unknowns, understand their purpose, and display their majesty motivates much of Simon's work. *An American Index* was inspired by a visit to Fidel Castro's Palace of the Revolution, the seat of the Central Committee of the Communist Party and of the Council of State and Government, where Castro greets special guests. A photograph Simon took of the grand entrance hall, lavishly decorated with tropical plants and illuminated with gleaming strips of light, laid the groundwork for her ensuing project. It was a discerned movement away from an earlier body of work, *The Innocents*, which focused exclusively on portraiture of Americans wrongfully convicted of crimes they did not commit and subsequently exonerated due to DNA evidence. As a marker of a communist stronghold, her photograph of Castro's Palace captures the incongruous opulence of an immutable foreign leader. It is a window into a power structure that both intrigues and threatens a large global constituency, much like the photographs Simon's father procured during the Cold War and, in turn, those that comprise *An American Index*.

In the midst of a national identity crisis post 9/11, Simon quickly recognized that a more immediate and revelatory window to the unknown opened onto a critical moment in America's own history. Like many great American photographers before her, she turned her eye inward. There is more than a century's worth of photography's social realist history proceeding *An American Index*, from Jacob Riis's late nineteenth century muckraking exposé of the impoverishment of Manhattan's lower east side in his acclaimed reform-inducing book *How the Other Half Lives*; to Lewis Hine's commitment to uncover child labor exploitation; to the government-supported Farm Security Administration's exhaustive documentation of poor, rural America. Though situated in the wake of these powerful reformist movements, Simon's project is not preeminently critical. Rather, there is a certain liberatory spirit to her work, which draws from other movements

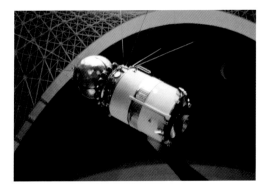

Richard Simon, Vostok 1 capsule, in which Yuri Gagarin orbited
Earth as the first man in space, Moscow, 1965

occurring throughout the history of American art, even those distanced from overarching political apparatuses. *An American Index* calls to mind the optimism rooted in the potential discovery of uncharted territories which has been so endemic to American art throughout its development, an ethos thrust to the fore with romanticized notions of the American landscape in nineteenth-century painting and complicated a century later by the indeterminacies, banalities, and strangeness of American culture exposed by flâneur photographers such as Diane Arbus, Walker Evans, and Robert Frank.

Simon's commitment to an aestheticized realism positions her closer to photographers like Frank or Evans, than it does to any romanticist tradition. Yet there is also something of the scientific realism of a nineteenth-century painter like Thomas Eakins coursing through the photographs of *An American Index*. Eakins's belief in the empirical, and later his reliance on photography as an aid to his precise renditions, made his view of the world one committed to a seductive, calculated beauty while nonetheless deeply entrenched in direct, hard facts. Simon's portraits of *The Innocents* align with Eakins's psychologically intimate figure studies, whereas the photographs of *An American Index* borrow more from the intense clinicism found in a painting like Eakins's *The Gross Clinic* (1875). A crisply focused portrait of a doctor presiding over a bloody bone operation on a young boy, it utilizes a tight pyramidal structure illuminated by a sharp shaft of sunlight overhead. The direct sense of measurement, light, and form evident in each of Simon's compositions, especially the pseudoscientific subjects like that of the Hymenoplasty, the Serpent Handler or the Cryopreservation Unit, recall a nineteenth-century view of the world with all its expanded possibilities.

Since the 1970s, skepticism about the political efficacy of imagery has questioned the ability of the documentary to be interventionist in the face of aestheticization. Contested by artist-critics Martha Rosler and Allan Sekula, objectivity was implicated on the grounds that it was morally and ethically questionable. As a way out of this irresolvable dilemma, photographers of this era integrated image and text into a conceptualist, yet decisively socio-political context. The impact of this technique on art-making has been evident in Simon's practice since she inaugurated *The Innocents*, a project which directly responded to the photograph's potential to render

Taryn Simon, *Interior of The Palace of the Revolution, Havana, Cuba,* 2002;
Thomas Eakins, *The Gross Clinic,* 1875

an innocent man guilty; a number of *The Innocents* were wrongly accused due to erroneous photographic documentation supported by eye witnesses. Acknowledging the pitfalls of being seduced by imagery, or the risk in removing it from its relevant context, Simon is disciplined in her juxtaposition of image and text. She makes use of the annotated-photograph's capacity to engage and inform the public. Transforming that which is off-limits or under-the-radar into a visible and intelligible form, she confronts the divide between the privileged access of the few and the limited access of the public.

Sometimes Simon spends over a year researching each of these photographs and its accompanying text. Access takes time, effort, and commitment. Simon's application for admission often requires prolonged correspondence and screening before she is granted permission and, typically, that admission is subject to strict protocol. Her trip to Plum Island's Animal Disease Center required her to shower upon entering and exiting the facility and an earlier trip to the Avian Quarantine Facility delayed her entry onto Plum Island for two weeks due to fear of cross-contamination. When inside, Simon's tool is a large-format 4x5 camera, unless otherwise prohibited. Her lighting requirements make her equipment heavy and the shot she will take of her predetermined location is rarely decided upon before entering the site. David Levi Strauss writes about photography: "To be compelling, there must be tension in the work; if everything has been decided beforehand, there will be no tension and no compulsion to the work."[1] The compulsion comes from an artist with a crisp artistic vision committed to the facts. The tension emerges from the high risk of failure. Sometimes, after months of negotiation, Simon admits to returning without a photograph that meets her artistic standards, yielding to the medium's preeminent principle of image above all else.

In Simon's photography, the American soil is wrapped up in a political, cultural, and economic quagmire, yet it never fails to offer unexpected splendors. As her photograph of a fireworks display informs us, this is where the largest American firework manufacturing firm tests their materials and works to develop beauty, precision, and safety in pyrotechnic art. Yet even in a photograph so evocative of American patriotic celebration, there is something foreboding in its tone. The text continues, listing the explosive simulators Grucci develops and supplies for military training exercises. Here, Simon's project subverts, not fearful of turning down a road with gestures of the ominous, as if something from a David Lynch daydream. This unwavering sense of doom is the undercurrent of *An American Index*, made overt in a photograph like *Nuclear Waste Encapsulation and Storage Facility, Cherenkov Radiation.* The beautiful and eerie blue glow of the cesium chloride capsules submerged in neutralizing water is a quiet reminder of what lies volatile beneath the surface, just visible through the murk.

Notes
1. David Levi Strauss, "The Documentary Debate: Aesthetic or Anaesthetic? Or, What's So Funny About Peace, Love, Understanding, and Social Documentary Photography?" in *Between the Eyes: Essays on Photography and Politics* (New York: Aperture, 2003) p. 10.

Originally published in Taryn Simon, *An American Index of the Hidden and Unfamiliar.* Exh. cat., Whitney Museum of American Art. Göttingen: Steidl, 2007

Sepia Officinalis

Sepia Officinalis (2008), also known as cuttlefish, can adapt to an array of backgrounds through neural control of its skin. Cuttlefish, a member of the Cephalopod group of mollusks, have the highest brain-to-body size ratio of their fellow invertebrates.

The survival strategy of the cuttlefish is invisibility; altering its appearance to be undetected by predators. Cuttlefish can change their appearance at a rate and range unequaled in the animal kingdom. This rapid modification is practiced in mating rituals and as protection against predators. To confuse predators, the cuttlefish can emit a decoy in the form of a black cloud of ink or ejected bubbles of ink engulfed in mucus that can be the same size as the cuttlefish itself.

Research reveals that cuttlefish, although colorblind, camouflage themselves primarily in response to visual information. The advanced structure of the cuttlefish eye is different from that of vertebrates, reptiles and mammals. Although they are unable to see color, they are able to distinguish polarized light which gives them a heightened view of contrast. Their ability to mimic specific colors is little understood by modern science.

Studies on cuttlefish skin have been of interest to the military and led to the development of gels and alternative camouflage for future military equipment.

Cuttlefish need to be maintained in individual tanks to avoid cannibalism.

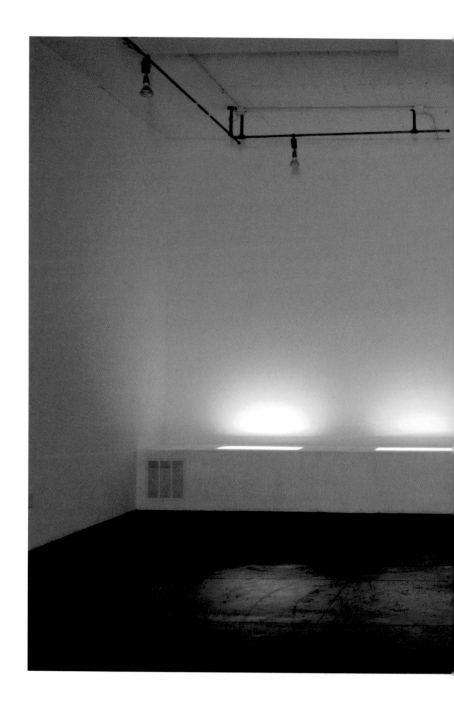

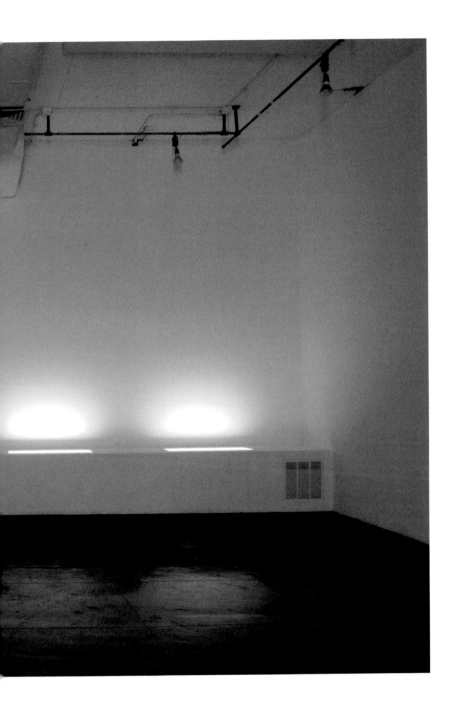

Installation view. *Sepia Officinalis*
Artpace, San Antonio, 2008

------ Forwarded Message

From: Riley Robinson <rrobinson@artpace.org>
Date: Tue, 2 Dec 2008 10:32:30 -0600
To: Taryn Simon <tarynsimon@gmail.com>
Subject: cuttlefish

Taryn,

The cuttle in tank two died on Sunday night. Sarah Lundt, lab manager from the NRCC was staying with us when the cuttle died and she performed an autopsy, which was inconclusive. She thinks the specimen was stressed and died due to age. She tested the waters and made recommendations, which we are implementing today.

First, we are removing the spacers under the photos to eliminate the area under the photos, which collects debris, making it extremely difficult to keep the tanks in balance. She also recommended either making the filtering system equal to the size of the tanks or changing up to 50% of the water in the tanks per week. Because of the expense of adding a new filtering system and that the exhibition will end in about a month, we are going to change the water on a daily basis.

With all the emergency calls to Aquatics Unlimited, staff time overtime, costs for live food and equipment involved with maintaining the tanks, Artpace has spent about 2200.00 over the budget with more costs expected. Artpace will need to be reimbursed or recover these extra expenses.

Please know that I have at least one person working 4 to 8 hours per day, 7 days per week to maintain the integrity of the exhibition. The tanks look great and it is a very popular exhibition.

Riley Robinson
Studio Director
Artpace San Antonio
445 North Main Avenue
San Antonio, Texas 78205
t (210) 212.4900 x307
f (210) 212.4990

International Artist-In-Residence Program
08.3 artists currently in residence:
Richie Budd (San Antonio, TX)
Lu Chunsheng (Shanghai, China)
Taryn Simon (New York, NY)

Selected by guest curator: Hans Ulrich Obrist
Opening November 6

------ End of Forwarded Message

Installation details. *Sepia Officinalis*
Artpace, San Antonio, 2008

Contraband

Contraband (2010) comprises 1,075 photographs
taken at both the U.S. Customs and Border Protection
Federal Inspection Site and the U.S. Postal Service
International Mail Facility at John F. Kennedy
International Airport, New York. For one working week,
Taryn Simon remained on site at JFK and continuously
photographed items detained or seized from passengers
and express mail entering the United States from abroad.

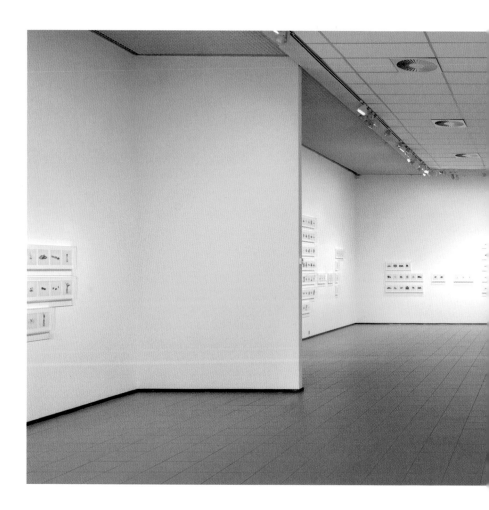

Installation view. *Contraband*
Helsinki City Art Museum, Helsinki, 2012

Contraband, 2010

Animal Corpses (Prohibited), Animal Parts (Prohibited),
Animal Skeletons (Prohibited), Animal Specimens (Prohibited),
Snails (Prohibited), Butterflies (Prohibited)

15 archival inkjet prints in 6 Plexiglas boxes and Letraset on wall
9 ¼ x 22 ¾ [#1,3,4]; 30 [#2]; 8 ¼ [#5,6] inches (23.5 x 57.8; 76.2; 21 cm)

Branding, Chanel (Counterfeit), Branding, Tiffany & Co.
(Counterfeit), Branding, Misc. (Counterfeit)

22 archival inkjet prints in 5 Plexiglas boxes and Letraset on wall
9 ¼ x 22 ¾ [#1,2]; 44 ½ [#3,4]; 30 [#5] inches (23.5 x 57.8; 113; 76.2 cm)

Cashier's Checks (Counterfeit), Checks (Counterfeit),
Money Orders (Counterfeit), Traveler's Cheques (Counterfeit)

27 archival inkjet prints in 5 Plexiglas boxes and Letraset on wall
9 ¼ x 22 ¾ [#1]; 30 [#2]; 51 ¾ [#3,5]; 44 ½ [#4] inches (23.5 x 57.8; 76.2; 131.4; 113 cm)

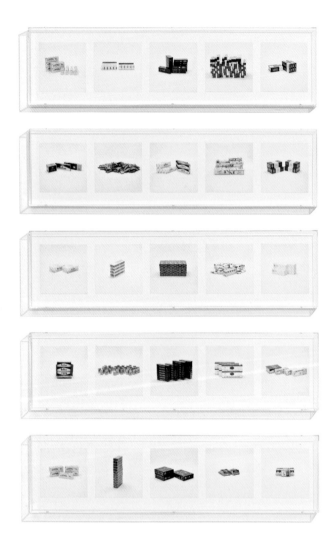

Cigarettes & Tobacco (Abandoned/Illegal/Prohibited)

25 archival inkjet prints in 5 Plexiglas boxes and Letraset on wall
9 ¼ x 37 ¼ [#1-5] inches (23.5 x 94.6 cm)

Cow Dung Toothpaste (Prohibited)

1 archival inkjet print in Plexiglas box and Letraset on wall
9 ¼ x 8 ¼ inches (23.5 x 21 cm)

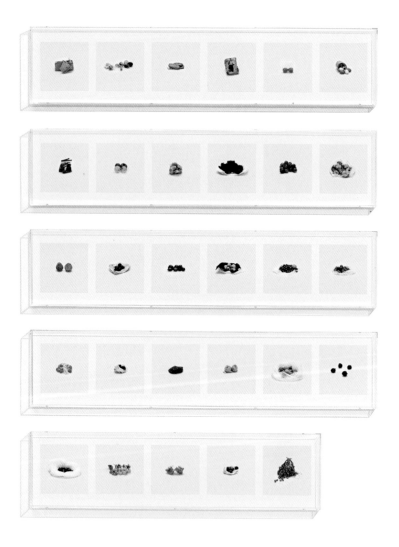

Fruit, Misc. (Prohibited)

29 archival inkjet prints in 5 Plexiglas boxes and Letraset on wall
9 ¼ x 44 ½ [#1–4]; 37 ¼ [#5] inches (23.5 x 113; 94.6 cm)

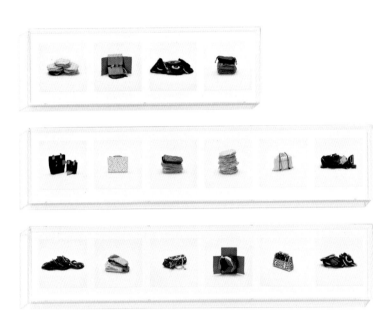

Handbags, Louis Vuitton (Counterfeit)

16 archival inkjet prints in 3 Plexiglas boxes and Letraset on wall
9 ¼ x 44 ½ [#1,2]; 30 [#3] inches (23.5 x 113; 76.2 cm)

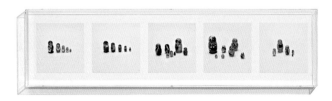

Nesting Dolls (Counterfeit)

5 archival inkjet prints in Plexiglas box and Letraset on wall
9 ¼ x 37 ¼ inches (23.5 x 94.6 cm)

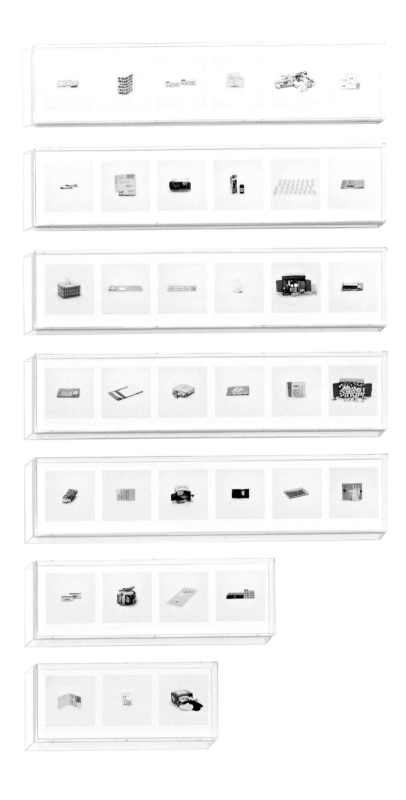

Pharmaceuticals, Misc. (Counterfeit/Illegal/Prohibited)

37 archival inkjet prints in 7 Plexiglas boxes and Letraset on wall
9 ¼ x 44 ½ [#1-5]; 30 [#6]; 22 ¾ [#7] inches (23.5 x 113; 76.2, 57.8 cm)

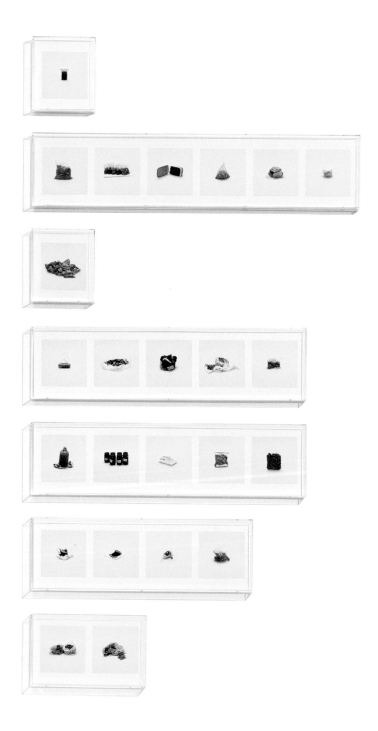

Unidentified Biohazard, Unidentified Food (Prohibited), Unidentified Liquid,
Unidentified Meat (Prohibited), Unidentified Meat (Prohibited),
Unidentified Mushrooms (Prohibited)

27 archival inkjet prints in 9 Plexiglas boxes and Letraset on wall
9 ¼ x 8 ¼ [#1,2,4]; 44 ½ [#3]; 37 ¼ [#5,6]; 30 [#7]; 15 ½ [#8,9] inches
(23.5 x 21; 113; 94.6; 76.2; 39.4 cm) [*#1 and #9 not pictured*]

Wood Carvings (Prohibited)

3 archival inkjet prints in Plexiglas box and Letraset on wall
9 ¼ x 22 ¾ inches (23.5 x 57.8 cm)

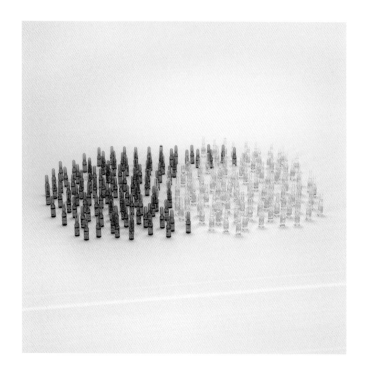

Steroids, Testosterone & Sustanon, Pakistan (illegal)

Detail, Anabolic Steroids (Illegal)

Each: archival inkjet print, 6 ¼ x 6 ¼ inches (15.9 x 15.9 cm)

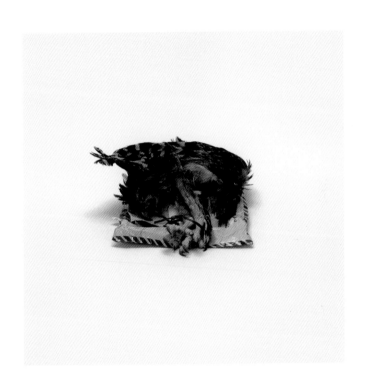

Bird corpse, labeled as home décor, Indonesia to Miami, Florida (prohibited)

Detail, Animal Corpses (Prohibited), Animal Parts (Prohibited),
Animal Skeletons (Prohibited), Animal Specimens (Prohibited),
Snails (Prohibited), Butterflies (Prohibited)

Cigarettes, *Shuangxi*, China (prohibited)

Detail, Cigarettes & Tobacco (Abandoned/Illegal/Prohibited)

GBL, Poland (used as date rape drug) (illegal)

Detail, GBL, Component Of Date Rape Drug (Illegal)

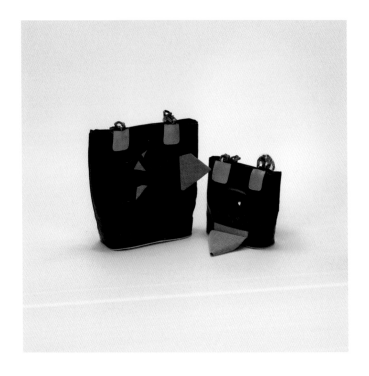

Handbags, Louis Vuitton (disguised) (counterfeit)

Detail, Handbags, Louis Vuitton (Counterfeit)

Oxalis tuberosa, Peru (7CFR) (prohibited)

Detail, Oca (Prohibited)

Blue and yellow pharmaceutical pills awaiting testing, Pakistan (prohibited)

Detail, Pharmaceuticals, Misc. (Counterfeit/Illegal/Prohibited)

Plastic pitcher of salami, Eastern Europe (9CFR.94) (prohibited)

Detail, Sausages (Prohibited)

Ever Airport

Hans Ulrich Obrist
London Heathrow, May 2010

Paul Virilio dedicated his 1991 book *The Aesthetics of Disappearance* to one
Zara Kasnov, a woman compelled by circumstance to live between worlds,
in a kind of 'interzone' where she could not be found, into which she con-
stantly disappeared. At the end of her life, her existence played itself out at
the limits of international law, space and time, in an ultimately fatal bid
to escape all three. Kasnov travelled ceaselessly around the globe with her
grandson, in order to escape the authorities who sought to retrieve the boy
from her. Her journeying eventually settled into a shuttling back and forth
between Holland and the US, until she finally dropped dead from exhaus-
tion in an airport.

Kasnov's story reminds me of my beginnings as a curator, travelling on
night trains every weekend to a different place in Europe; a marathon of visits
to artists' studios, living on the cusp of today's time-space compression in the
non-places of the train compartment and the station. For Marc Augé, the non-
place is a new object for anthropology, a world 'surrendered to solitary indi-
viduality, to the fleeting, the temporary and ephemeral'; 'a space which cannot
be defined as relational, or historical, or concerned with identity'. Non-places
'create solitary contractuality', relations between people as between things
that are determined by specific functions in a larger systemic whole.

The ideas of the marathon and of the non-place converge in Taryn Simon's
recent labour-intensive work, *Contraband*, a prolonged investigation of both
the inner life of the airport and its passengers – as a between-space, a place
of transit – and of the global traffic in miscellaneous, forgotten, illegal and
counterfeit objects. This project is an extended study of international tran-
sit, of the international currency of prohibited items, and especially of the
tide of counterfeit goods that have flooded Western markets in the wake of
the relocation of production to the newly developing countries of the East.
Simon stayed at John F. Kennedy International airport for a week and pho-
tographed over one thousand items seized from passengers and express mail
entering the US from abroad. *Contraband* is a record of a flow of confiscated

objects ranging from the fake to the contaminated, that marks the airport as what Augé calls a 'spatialized expression of authority', and Simon spent five days and nights, from November 16 to November 20, 2009, documenting items in both the US Customs and Border Protection Federal Inspection Site and the US Postal Service International Mail Facility, sites that are a contraband space, a space between America and other nations.

The series of photographs offers an exhaustive narrative of the airport, and of airborne traffic, in something approaching the appropriately impersonal and administrative form of the list, to be presented alongside actual lists of the objects themselves. Simon's work thereby takes its place in a long history of artists' deployment of the list-form, from the lists of Gilbert & George, to Hans-Peter Feldmann's and Christian Boltanski's lists from the 1970s: list-portraits of individuals as revealed through their belongings. Boltanski's *Lost Property – Tramway*, of 1994, gathered around 5,000 forgotten objects from as many people, and, as he told me: '...each person has his own history, each person is different ... each face is different; each adventure is different'. This history of the list has continued into the present, with Umberto Eco's extensive exhibition and event series, *The Infinity of Lists* at the Louvre in November 2009, a project that gathered together numerous list-forms, from ancient reliquaries (collections of objects as lists made tangible) to lists produced by artists from Bosch to Boltanski, writers from Aristotle and Diogenes Laërtius to Rabelais, and on to Borges and Georges Perec. Eco lists categories of lists: 'lists of infinities'; 'practical' lists and 'poetic' lists like Calvino's lists of books; and 'exchanges between practical and poetic lists' like Perec's inventories and itineraries:

> A few fleeting slogans ... A little soil ... A few stones ... A little asphalt ...
> A few trees ... A fairly large portion of the sky ...

Of course, Eco pays tribute to the 'mother of all lists', the Internet, and it is not without significance here that Taryn Simon lists Google among her key inspirations. The hyperlink creates trajectories within this endless list-space, micro-lists within the mother of all lists. Douglas Coupland has recently written of this new virtual space, where linking and listing meet:

> Everywhere we look, people are making online links – to conspiracy, porn, and gossip sites; to medical data sites and genetics sites; to baseball sites and sites for Fiestaware collectors; to sites where they can access free movies and free TV, arrange hookups with old flames or taunt old enemies – and time has begun to erase the twentieth-century way of structuring one's day and locating one's sense of community ... Time speeds up and then it begins to shrink. Years pass by in minutes.

Linking creates lists and creates trajectories. For Simon, who – she has assured me – spends 'most days researching on the Internet': 'Google usually fails my original intentions but then leads me to something I would never have imagined.'

Who would have imagined the litany of stray items, the 'redundancy of garbage' in Simon's strange collection?

Pork (Mexico), syringes (Indonesia), Botox (Indonesia), chicken and duck, chicken, duck, beans and nuts, beans, nuts, beef, bird's nest, booze, gastro meds, GBL date rape drug, heroin, hydrochlorothiazide, imitation Lipitor, Ketamine tranquillizer, Klonopin, Lidocaine, Lorazepam, locust

tree seed, ginger root, deer tongues, cow urine, Cohiba cigars, toy AK47 and protective goggles, toy AK47, Egyptian cigarettes (24 cartons).

The sheer repetition of objects (endless accumulations of counterfeit luxury handbags, every time the same; bottomless supplies of sexual stimulant drugs; meat products; pirated DVDs; animal parts used as medicine or for religious rituals) presents a metonymic view of the social whole, as constructed by our endless drive to accumulate; an overproduction of stuff.

Contraband therefore raises profound questions of preservation and ecology amid continuing technological upheaval. If the digital revolution has in many ways dematerialized aspects of everyday life, the paradigm of built-in obsolescence has not been superseded, nor does it seem likely to anytime soon, in the absence of some singular transformative event. Simon's work clearly shows the myriad ways in which we continue to rely on the ceaseless material production of ever more disposable commodities, a maelstrom of overproduction steadily depleting our natural resources. *Contraband* gives the lie to phrases such as the 'dematerialized economy', which only ensure that we conveniently forget that we are beholden to both nature and material production as never before.

Simon's lists are also playful and absurd, like those of OuLiPo, the *Ouvroir de littérature potentielle*: the famous literary group founded by Raymond Queneau and François Le Lionnais in 1960, which to this day functions like a permanent research laboratory for innovation. In their works, OuLiPo writers from Perec to Jacques Roubaud have invented and imposed new rules of the game, and while at first these rules might appear as limitations, they can in fact open up all kinds of previously unimaginable possibilities, or potentialities for literary production, enabling the creation of what Harry Mathews, one of the protagonists of the group, has called 'absolutely unimaginable incidents of fiction'. Mathews has written eloquently of the continual interplay of order and disorder within poetry, of poetry's constant dialectic between conformity to, and deviation from, systems of rules:

> All formulas for meters and stanzas distort language, and the strictest, most arbitrary formulas – for example, the formula of the limerick – produce writing that verges on nonsense and sometimes topples over the edge. Instead of avoiding such formulas, however, writers embrace them.

Similarly, the photographs and texts of Simon's *Contraband* reveal disorder and chance within the strictures of a system determined by absolute order and control; both the logistical control of the airport – its rhythms, structures, issues of access, authorization and exclusion – and the legal control of the restriction on certain categories of foreign objects entering US territory. Simon's images and lists embrace both order and disorder, and open up a third space within the cracks of these forms of control: a space of the surreptitious, the forgotten, the bizarre and the banal, exposed to the cold light of the camera, and all set against an unchanging grey backdrop, the colour of administration and neutrality. The very uniformity of the photographs' formats, what Simon calls their 'painful repetition', echoes the repetition of the objects. It is a production-line aesthetic that conceals the intense concentration of labour expended by both Simon and her assistants in the production of the artwork, and the immense concentration of labour contained in the objects themselves. As Simon has told me: 'Photography inevitably always looks easy, like it's a simple exchange with whatever the subject is ... the conquest of it all is not necessarily a part of what you digest visually.'

As one of the distinctions that can be introduced in order to cope with these diverse items, Simon has suggested to me the distinction between those objects that had been personally smuggled, and those that had been mailed. Mailing, she has told me, 'offers up a space of anonymity', a space of 'anonymous desire', where anonymity ensures the disclosure of private desires. The distinction also suggests the different levels of risk that are in play in the traffic of illegal objects. The collection of photographs is, above all, an answer to some big questions of our time. What are people after today? What threatens authority and security in today's world? *Contraband* cannot be said to present an entirely optimistic picture of our world, but rather suggests what Simon has called a 'flattening of personality' through objects, or again, a 'flattening of desire' into a parade of artificial desires: for luxury, for the cheap fix, the quick high, for religious experience as well as entertainment. Perhaps it speaks of the collapse of all of these forms of experience into one another. Does *Contraband* present the forging of a new global space, 'une nouvelle région du monde' as Édouard Glissant might say, or is it somehow more entropic?

Contraband is a 'time-capsule' of early twenty-first century global experience as revealed through one of the principal conduits of the distribution of commodities, whose oddities and surprises will surely only increase and continue to transpire as their historical moment recedes from us. It is a portrait of the world, but, as Simon has also told me, 'as time passes, it'll become even more of a portrait, because right now all of these items are so familiar, they're what's currently surrounding us'. And so, 'as the objects cease to be familiar', what kind of a portrait can we expect *Contraband* to become?

Not least, it tells us of a world where the traffic in counterfeit goods is ever on the increase, where designer-label desire reaches fever pitch, and where – according to one report pointed out to me by Simon – 'fake Porsches and Ferraris zoom along the streets of Bangkok', while a 'bank has discovered an ersatz gold ingot made of tungsten in its reserves'. The proliferation of the fake has been one result of the enormous shift of commodity production to the South and East in recent decades, where there is in general far poorer protection of intellectual property, and hence, the same report continues, there is a greater 'opportunity to make knock-offs' without fear of reproach.

Already, in our own time, we can see that *Contraband* strips away the aesthetic and lays bare these dispossessed items, which cover an enormous range of types, from the mundane (undeclared jewelry, visas) to the illicit (numerous counterfeit items, from DVDs to the Louis Vuitton bags and Gucci buckles, Nike trainers and even a fake set of Disney matryoshka dolls) and the esoteric (a deer penis, a dead bird intended for use in witchcraft rituals). All of these objects appear like abbreviated ciphers of their geographical origin (in some cases clear, in others unknown) and of their anonymous owners, who themselves have been subject to abbreviated forms of identification amid the efficient 'speed-space' (Virilio) of the airport – the x-ray, passport control and body search – and its abbreviated consumer rituals: champagne and caviar bars, coffee and sandwich stops and one-shop-holds-all duty free.

To return to that most important element of *Contraband*, the labour of the artist, we can say that the tremendous self-discipline and effort that Simon imposed on herself in order to produce the project is an OuLiPian self-imposition of constraints, to sleep for five days at JFK and to photograph the innumerable items with a metronomic regularity that repeats that

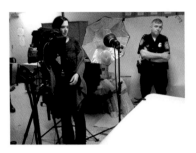 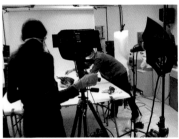

Taryn Simon photographing at the U.S. Customs and Border Protection Federal Inspection Site and the U.S. Postal Service International Mail Facility at John F. Kennedy International Airport, New York, 2009

of the objects' continuous arrival and handling by airport officials: a painstaking, forensic photographic procedure; and the cancellation, following the initial decision to impose these constraints, of any and all subsequent artistic decision-making and spontaneity. For Simon, after all, 'photography is closely linked to imitation', and the work seems to enact an 'industrialization of seeing'. In the event, Simon suffered from sleep deprivation and was able to take only one shower during the entire period. She was yoked to the twenty-four hour rhythm of the movement of goods across borders and time zones, to which the project bore witness; yoked to 'the tyranny of real time'.

It is, finally, of utmost interest for the artist that this tremendous effort of labour and discipline in her work – which, as she told me, represents 'nearly 100 per cent' of her activity – is hidden and remains off-camera, just as the origins and secret histories of the objects themselves is forever concealed, knowable only by type, understandable only as contraband, as Simon's laconic title suggests. There are clear links here to earlier photographic series by Simon, like *The Innocents* of 2002, in which Americans wrongly convicted of crimes are catalogued at sites that had particular significance to their illegitimate conviction. Simon investigates photography's function as a credible eyewitness and arbiter of justice. Or like *An American Index of the Hidden and Unfamiliar* of 2007, which, like *Contraband*, is an almost anthropological view of America, as told through its material life, its secret history of things. She confronts the divide between public and expert access through an investigation of that which is little known but at the very foundation of America's mythology and daily functioning. *Contraband* is, of course, more intensive than expansive. It is the result of an extreme performance over a concentrated span of time; very much a marathon. But like the production and distribution of illicit goods around the world, and the continual effort to restrict their supply, as well as the sheer overproduction of material goods in all corners of the world, its 'challenge is invisible'.

Originally published in Taryn Simon, *Contraband.* Göttingen: Steidl/New York: Gagosian Gallery, 2010

Zahra/Farah

Zahra/Farah (2008)

Iraqi actress Zahra Zubaidi playing the role of Farah in Brian De Palma's film "Redacted". Simon created this photograph to serve as the final frame in De Palma's film.

The film is based on the gang rape and murder of a 14-year-old Iraqi girl, Abeer Qasim Hamza, by U.S. soldiers outside Mahmudiya on March 12, 2006. Abeer's mother, father, and 6-year-old sister were murdered while she was being raped. After the soldiers took turns raping Abeer, she was shot in the head and her body was set on fire.

Four American soldiers of the 502nd Infantry Regiment were convicted of crimes including rape, intent to commit rape, and murder.

Zahra/Farah (2009)

Iraqi actress Zahra Zubaidi playing the role of Farah in Brian De Palma's film "Redacted". Simon created this photograph to serve as the final frame in De Palma's film.

Zahra Zubaidi is currently seeking political asylum in the United States. Since appearing in the film, she has received death threats from family members and criticism from friends and neighbors who consider her participation in the film to be pornography.

The film is based on the gang rape and murder of a 14-year-old Iraqi girl, Abeer Qasim Hamza, by U.S. soldiers outside Mahmudiya on March 12, 2006. Abeer's mother, father, and 6-year-old sister were murdered while she was being raped. After the soldiers took turns raping Abeer, she was shot in the head and her body was set on fire.

Four American soldiers of the 502nd Infantry Regiment were convicted of crimes including rape, intent to commit rape, and murder.

Zahra/Farah (2011)

Iraqi actress Zahra Zubaidi playing the role of Farah in
Brian De Palma's film "Redacted". Simon created this
photograph to serve as the final frame in De Palma's film.

Since appearing in the film, Zahra has received death
threats from family members and criticism from friends
and neighbors who consider her participation in the film
to be pornography.

The film is based on the gang rape and murder of a
14-year-old Iraqi girl, Abeer Qasim Hamza, by U.S.
soldiers outside Mahmudiya on March 12, 2006. Abeer's
mother, father, and 6-year-old sister were murdered
while she was being raped. After the soldiers took turns
raping Abeer, she was shot in the head and her body was
set on fire.

Four American soldiers of the 502nd Infantry Regiment
were convicted of crimes including rape, intent to
commit rape, and murder.

In 2011, while this work was on view at the Venice
Biennale, Zahra Zubaidi was granted political asylum
in the United States. Her legal defense cited the
international exhibition of this photograph as a
contributing factor to her endangerment.

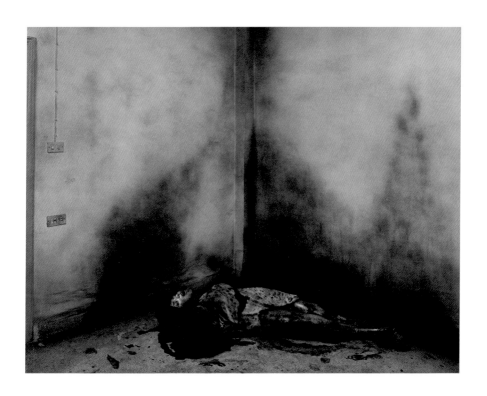

Zahra/Farah (2008/2009/2011)

Framed archival inket print and Letraset on wall, 61 ½ x 79 inches (156.2 x 200.7 cm)

Blow-Up

Brian De Palma & Taryn Simon in conversation

TARYN SIMON: I recently found a short news film you shot in 1965, at the opening night of MOMA's Op art exhibition "The Responsive Eye." You're zooming in and out of all these hypnotic Op pictures with moiré patterns. It made me think about vision as a physical reflex, even a form of mind control—and about the long arc of your style, which is so distinctive and pored over. Do you think your aesthetic is conscious at this point, or is it unconscious? Is it something that just comes out and you can't control?

BRIAN DE PALMA: Look, the hard thing—I'm sure you've experienced this, too—is that once you have a project, you think about how you're going to photograph the scene until you actually do it. I have always felt that the camera view is just as important as what's in front of the camera. Consequently, I'm obsessed with how I'm shooting the scene. When you're making a movie, you think about it all the time—you're dreaming about it, you wake up with ideas in the middle of the night—until you actually go there and shoot it. You have these ideas that are banging around in your head, but once you objectify them and lock them into a photograph or cinema sequence, then they get away from you. They're objectified; they no longer haunt you.

TS: The haunting can be torturous. I don't think I've ever enjoyed the making of my work. It's a labor. Do you find pleasure in getting to that point of objectification?

BDP: You know, there is no rest. That's the problem ... I'm a very solitary figure on set—I just walk in. I don't want to say hello and kiss everybody. I'm completely uninterested in that because—I'm sure you have the same feeling—when you go to shoot a movie, you've assembled hundreds of people waiting for you to tell them what to do. For the first time, you've got the actors. You have the location. You have the cinematographer. You have the weather, the light, the emotional stance of the various people around you, and it's catching lightning in a bottle. You're there to maximize the moment on film. And you'd better be very alert and watching everything

constantly, because once you shoot it, it's gone forever. If you make a mistake or haven't thought everything through correctly, you will look at that mistake for the rest of your life.

TS: Yes—there's enormous pressure on the day of shooting. And photography's history is bound to the mistake, to the accident. But I've never been one to embrace surprise. I think the invisible lead-up to the point of actually taking a photograph is, in many ways, my medium. Years of research, accessing, organizing, and writing are behind the construction of a single piece. But no matter how prepared and calculated the details of the shoot days are, its imagined form always seems to crumble and mutate.

BDP: I guess a lot of people shoot alternatives. I never do that. I spend months planning it all out, and then we actually edit as we shoot. I know exactly where the camera should be and how all the film fits together.

TS: Yeah, me too.

BDP: But if something happens on the set that's different, I immediately accommodate it. You don't want to go in with such a rigid idea that this is the way it should be. You have to see what is there. These are living creatures in front of you.

TS: But accommodation can be dangerous. It's important to remind yourself of what you want and not get lost in the noise of it all. Sadly, one has to do a lot of interacting, which I find distracting. I avoid lunch and conversation as much as possible. There is no time or space for anything other than the work. But there's a perceived cruelty in that focus.

BDP: I'm exactly the same way. I never talk to my driver while going to work. I never eat lunch with anybody.

TS: For me, though, interaction can be a necessary precursor to gaining access. Making *A Living Man Declared Dead and Other Chapters I–XVIII* [2011], I was traveling nonstop, often to remote locations. I was constantly trying to avoid illness from local water and food that might slow me down. So my assistant and I lived on powdered meals, PowerBars, and bottled water. But in many cultures, refusing offers of food or tea can lead to the demise of a shoot. Cigarettes are helpful. Even after I quit smoking, I would smoke in order to find a way of transcending language barriers, of connecting.

BDP: In fact, you always seem to structure work around difficulties. You structured an entire project about the places you were not allowed to go.

TS: Well, in that work (*An American Index of the Hidden and Unfamiliar*, [2007]), I wanted to confront the divide between public and expert access. After September 11, America felt like a new landscape: religiously, ethically, politically. So I wanted to revisit the practice of exploration as registered in early records of visits to the "New World." In those historical accounts, you see interpretive, seductive, even abstract renderings of plants, animals, people, and terrain accompanied by seemingly factual data and texts. I decided to use text and image in a similar way, to look inward. I wanted to confront the hidden, both physically and psychologically, and see how far I could get, with permission, as an individual citizen within realms that were usually reserved for privileged or expert audiences: the CIA's art collection, or a nuclear-waste encapsulation facility, or a hibernating bear's cave.

BDP: That was one reason, I think, that I wanted to work with you on the photograph of Zahra [Zubaidi] for *Redacted* [2007]—that you were interested in taking a picture of what you can't access, and that film was about images and events we can't access, either. After our collaboration,

what did you end up doing with the photograph? I know you presented it at the Venice Biennale, but then afterward?

TS: Well, since the image was originally produced for the final frame of your film, it had a text associated with it—your screenplay. But then the image took on associations with other texts, as the world responded to it. Its final form, on the walls of museums, includes three different annotations that are silk-screened to the wall beside the image. These annotations represent the changing contexts that the image and the actress who is its subject endured over the past five years. The texts clock the ways in which the photograph mutated through time.

BDP: And Zahra's story is fascinating because she comes to audition in a movie. She plays the character of a girl who is raped and killed and set on fire, which sort of dramatizes the whole involvement of America in Iraq, and the penalty she has to pay for it is she is a pariah in the Muslim world. They want her dead because of the fact that she portrayed this character.

TS: The photograph began as a fictionalized rendering of a real event. The resulting image of Zahra, an Iraqi actress, playing the role of this young girl led to the second annotation associated with the image. That text highlights the response to Zahra's portrayal—the death threats from family members; the criticism from friends and neighbors, who considered her participation in the film to be pornography. The photograph was completely recontextualized by these accusations. It became evidence of a new reality—a reality in which Zahra had to pursue political asylum in the United States. In the third and final annotation, written in 2011, I cite her legal defense, which used the international exhibition of this photograph at the Venice Biennale as a factor contributing to her endangerment. The photograph and its exhibition were used to reveal a continued threat and, at the same time, to support Zahra's case for political asylum, which was granted in 2011. She couldn't go home because of the images. You could see an image's very real influence on an individual life from start to finish: from a casting call with you in Jordan to ending up in the United States and receiving political asylum.

BDP: Her story just tells me that we have no knowledge about her culture. You know? This makes absolutely no sense to us. By the same token, this idea that you're just going to go in and put a few schools up and everybody is going to become democratic overnight is a specifically American idea.

TS: But at the same time, why is Western cinema so present throughout the world, then? If there are all of these intransigent cultural differences, why does an American aesthetic still seem to dominate global popular culture?

BDP: Because it's the devil's candy.

TS: Well, I wanted to ask you about that. Thinking about Zahra and everything that happened to her, what is the difference for you between art being violent and violence in art? Is there a difference?

BDP: There are many violent images in my movies. But cinema is kinetic. It's motion. So obviously violent and very dramatic motions are part of the paint box of cinema. They are not really attainable or key in the same way in painting, not really in literature, not really in music. But in cinema, you can take these shots and make things go very fast and do very dramatic things. They can be very realistic at the same time and very terrifying. Violence can be used correctly. It obviously can be used incorrectly, but to me it's just part of the vocabulary. I am a great believer in trying to maximize the visual impact of what I'm trying to show. That's why there is the image of Carrie getting blood dumped on her. I mean, I have been

watching that image being reproduced over and over for close to forty years now. That image is constantly repeated.

TS: When I think of the relentless return of a violent image, I think of the atomic bomb on film. Do you know what [J. Robert] Oppenheimer's response to that footage was? He likened it to Vishnu trying to impress the king with his many arms: "Now I am become Death, the destroyer of worlds." I wonder if you think there are cases when an artwork has gone too far and takes on a "multiarmed" form, when a vision can destroy? Is there a boundary? Do boundaries matter in a world of spectacularized violence and anesthetized audiences?

BDP: No, I don't think there is a boundary. I mean, we can graphically represent things, and we can emotionally—and even intellectually—create quite an effect. But that's nothing compared with the actual bombing of innocent people.

TS: Zahra was in real danger of being killed. And you chose to not capitulate to censorship or threats. I remember during that time, you felt very strongly that images could stop the war and that their absence in mainstream media was perpetuating complacency.

BDP: There were absolutely no pictures coming out. They redacted all the real pictures of people who got killed in Iraq in *Redacted*—pictures that had been published and on the Internet, and that everybody had already seen or knew about. And I think that that containment of images had a real effect. The Bush administration went to the lengths of "embedding" reporters with the troops, and they would supposedly tell you the real story—which, of course, is nonsense. It's another way of completely controlling the image, which is what the military does all the time.

TS: As much as they used it to great propagandistic effect, the Third Reich feared photography because it makes you pensive. There's a long history of controlling the distribution of images in conflict. But those were times when the image was precious. Do you actually think it would have made a difference had we received the images?

BDP: Absolutely. I think it would have made a difference. What's ironic, of course, is that everybody has cameras now.

TS: But now that they are ubiquitous, do photography and video still maintain a position of power and authority?

BDP: Everybody can take video, and yet somehow none of it got back onto our American television screens. Or if there was anything too disturbing, they pixelated it, as if to say, "Oh my God, you can't see that."

TS: Are there things that you don't want to see?

BDP: I'm not a good person to ask about this, because my father was a surgeon and I grew up in a hospital. So I saw it all. I saw operations. I saw blood. I saw people dying. I was even shot once. So nothing much shocks me.

TS: You were shot?

BDP: Yeah. I had broken up with a girl. I got drunk, stole a motor scooter, started to drive home. Some cop pulled me over. I knocked him down, jumped on my motor scooter, and tried to drive away, and they knocked me over. I ran, and they shot me.

Are there things you don't want to see?

TS: I want to see everything. I guess the positive version of not seeing or not knowing would be the preservation of fantasy.

BDP: I would agree with you. It's 1984. Fantasy sells.

TS: Is there a film you wouldn't dare to do?

BDP: I don't know. A film I wouldn't dare to do ... It's ironic that you mention something like that. You know, there are things I didn't want to do, mainly because of lack of foresight. For instance, Paul Schrader gave me the script to *Taxi Driver*. I read it during Christmas week when I was in California. I thought, "God, this is incredible, but who would want to see this? I don't see how you can make a movie out of this." Then I gave it to Marty [Scorsese]. What a mistake. I mean, I couldn't see how you could make a movie about this that anybody would go see, and Marty, of course, made a brilliant movie out of it.

Do you have limits, formal limits, that you're afraid to go beyond?

TS: I have one project in particular that allows me to work without rigid conceptual constraints. For the past six years, I've built a series of images that follow the dimensions of [Kazimir] Malevich's black square, on which I can project anything. For instance, I photographed [Henry] Kissinger in shadow, and an artificial heart; two of the most recent images have to do with protest, both imagined and real. One centers on a makeshift anti-hijacking system that is a reaction to the proliferation of carjackings in South Africa, in the most beautiful and spectacular form. Another highlights a blue bucket in Moscow that imitates the ersatz police sirens used by the wealthy and the powerful to circumvent traffic.

What does protest look like to you today? I know you protested against Vietnam.

BDP: Obviously, I am appalled by the fact that our independent cinema is not more political, but it seems to me it's because of the ability of the media over the past several decades to steer the public away from the really dangerous material. They just want us to show an image of ourselves, get us involved in gossip.

TS: I teach sometimes, and I've noticed a marked resistance to and anxiety about making something too concrete. An anarchic, abstract approach, with no discernable objective, is championed. It feels like a phenomenon of the past decade—in film, too. Or maybe I'm getting old.

BDP: But isn't *The Innocents* [2002] precisely about photographs doing something—not just as documents but as things that have an effect?

TS: Well, in that work, I look at the ambiguity of a photograph—and its danger. The men I photographed were victims of misidentification. They were convicted of crimes they did not commit, through the use of visual material—composite sketches, live lineups, and, mainly, photographs. Victims and eyewitnesses identified these men from photographs presented to them by law enforcement. Their identifications relied on precise visual memory. But through repeat exposure and manipulations—both purposeful and unconscious—the photographs replaced the memory of the actual perpetrator, if there ever was one.

BDP: And then you introduced a plot twist, I'd say, by bringing the misidentified "perpetrator" to the crime scene that he had never seen.

TS: The crime scene represented this place to which they'd never been but that had changed their lives forever. The men in those photographs had imagined that location, in court proceedings, prison, dreams, but it had no real visual anchor.

BDP: And did you see your work as a form of justice?

TS: No. It was more schizophrenic than that. I was deeply invested in the issues of truth and culpability that the project raised, but also in its aesthetic concerns and in the issues it highlighted about a photographic

image, its history and its context. And the material effects of ignoring a photograph's context are directly seen in the misidentification that leads to the imprisonment or execution of an innocent person. I was always working in a fragmented form—a single image in which I'm constantly trying to keep both my conceptual and my visual interests alive. And sometimes one is failing and one is succeeding.

BDP: That kind of schizophrenia can happen in making a film, too.

TS: Right—and I guess the split screen, which is a technique I associate very much with your work, is the perfect example of that. That's both a narrative and a stylistic choice. To me, the device, the multiple views, implies the inevitability of a kind of alienation.

BDP: Well, I first used the split screen in *Dionysus* in '69 [1970], which I recently transferred digitally, so I have been looking at it again. The idea there was that there was the Performance Group's new play, the original Greek play, and then there was the relationship between the actors and the audience. I shot the narrative of the play while my codirector Bob Fiore went off and showed the relationship of the audience to the players. And we were shooting simultaneously.

So you have this split screen from beginning to end. Dionysus starts dancing. Everybody in the audience, some rise, some get in, and they all start dancing. And then the troupe start dancing even more vigorously, and they start taking off their clothes, and then so does the audience. Pentheus, the king of Thebes, looks around, and everybody is naked and groping one another and dancing. He's going, "Oh my God." Suddenly, the audience realizes they're naked. They're humiliated, and they run back to their seats. It's an astounding moment.

TS: So is that less about alienation and more about cause and effect?

BDP: Well, in *Sisters* [1973], I used the split screen to show a guy getting murdered and writing HELP in blood on a window, and the woman in the apartment across the street seeing him writing HELP simultaneously. And then you see the murderers covering their tracks and the woman trying to get the police, both actions unfolding at the same time.

I like murder mysteries. I like suspense. Don't you? When you were shooting all of that contraband—it's like finding evidence for something, some crime, some puzzle we don't know the answer to.

TS: I think of *Contraband* [2010] as a performance piece. I lived at JFK airport for a full working week and documented all the items seized by US Customs and Border Protection from passengers and express mail entering into the US. I worked without sleep for a five-day period. I'd take naps between the last flight and the first morning flight on an air mattress I shared with my assistants in the contraband room. There were counterfeit Louis Vuitton bags, counterfeit Chanel sunglasses; there was counterfeit Viagra, counterfeit Ambien—everyone chasing the same fantasy and escape. I anticipated collecting photographs of guns, heroin, animals ... and I did. But the customs officials' overwhelming focus was on safeguarding brand identity. They were battling a relentless influx of copies.

BDP: And as a photographer, you are making yet another copy.

TS: Yes. A copy of a copy. The goods couldn't enter the US, but the photograph could. I then took the photograph and inserted it into another economy—the economy of art.

BDP: There is no question that desire is tied to threat. I mean, television is the most insidious invention ever because it's basically a selling machine.

We have these things we call commercials, but don't think the stuff between the commercials is not selling you something also.

The effects of consumerism on film are obviously insidious too. To me, the sad thing is that expensive films are now dominated by the visual-effects houses. And who are the artists of the visual-effects houses? You know, nerds who have spent their whole lives looking at comic books and video games. So that's where they get all their visual ideas. That's why there is an endless repetition of visual ideas in so-called spectacular fantasy or in science fiction. Look at *Star Wars*. It's basically George [Lucas] looking at those old *Flash Gordon* serials and finding a new way to do that with what was then new technology.

TS: Your films often depict manipulative systems and invisible powers that influence your characters, who go mad in the face of it. It makes me think of one of my favorite films of yours—*Phantom of the Paradise* [1974].

BDP: *Phantom* is about the corruption of art. I got the idea in an elevator, listening to the Muzak version of a Beatles song. Money corrupts art. The money managers get richer; the artwork is reduced to pap. Yes, I've always thought about larger systems of power—how they monetize and ultimately destroy originality—and their historical arc, the rise and fall of empires. How do you picture those kinds of systems?

TS: Well, in my latest work *A Living Man* ... , I've tried to do that, in a way. To articulate certain systems, patterns, and codes through design and narrative. I traveled around the world researching and recording eighteen bloodlines and their related stories. There are several empty portraits representing living members of a bloodline who could not be photographed for reasons including dengue fever, imprisonment, army service, and religious and cultural restrictions on gender. Some just refused because they didn't want to be part of the narrative. The blanks establish a code of absence and presence. The stories themselves function as archetypal episodes from the past that are occurring now and will happen again. I was thinking about evolution and if we are in fact unfolding, or if we're more like a skipping record—ghosts of the past and the future.

BDP: Like the story in Brazil?

TS: Yes. I documented two bloodlines that are in an active feud in Northeast Brazil. Their story reads like something out of Shakespeare, something inexorable. Over the past two decades, their feud has claimed the lives of more than twenty members of both bloodlines and forty others involved in their dispute. It includes decapitation. One woman received a death threat by phone while I was photographing her. People are being born into a battle that is not of their making, but becomes their own.

BDP: But who's the Big Brother here? What's the power structure?

TS: The forces of economics, geography, religion, governance, are butting up against the internal forces of psychological and physical inheritance. I wanted to explore fate in relation to these categories. Power is less fixed. It's not necessarily top-down. And I was interested in using the accepted order of blood at a time when it is very slowly breaking apart—artificial wombs, or genome manipulation.

BDP: So your next place of study has got to be Mars.

TS: Yeah, but you've already done it.

BDP: I made *Mission to Mars* [2000]. I have a good feel for the whole terrain. But photographing the unphotographable, that's for you.

Originally published in *ArtForum* vol. 50, n°10, summer 2012

Detail, "'Patterns' [Hong Kong], 10/27/2014, 5:29 PM (Eastern Standard Time)," *Image Atlas* (2012)

Black Square

Black Square (2006–) is an ongoing project in which Simon collects objects, documents, and individuals within a black field that has precisely the same measurements as Kazimir Malevich's 1915 suprematist work of the same name.

Installation view. *Black Square*
Taryn Simon Studio, New York, 2014

Black Square, 2006–

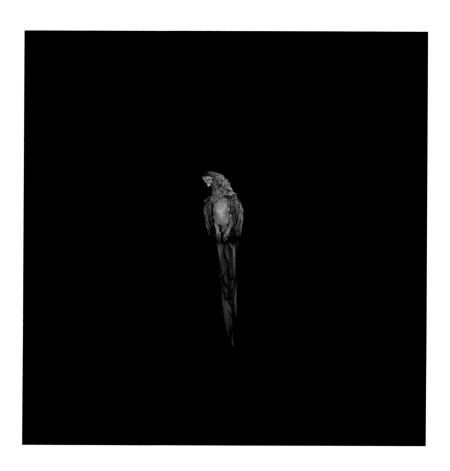

Black Square XI.

In captivity many birds develop Feather Destructive Behavior as a
result of conditions including lack of psychological and emotional
stimulation, stress, lack of companionship, and limited freedom.
"Amiga" is a blue and gold macaw suffering from this condition.

Each: framed archival inkjet print and Letraset on wall
31 ½ x 31 ½ inches (80 x 80 cm)

Black Square, 2006–

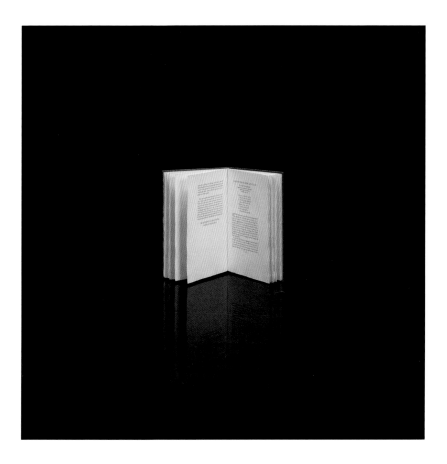

Black Square X.

Inside the Time Capsule of Cupaloy, buried beneath the grounds of the 1939 New York World's Fair, is a book published by Westinghouse Electric & Manufacturing Company that contains diagrams and phonetic illustrations teaching the people of the future about a language called "English." The introduction to *The Book of Record of the Time Capsule of Cupaloy* reads: "After five thousand years, all the spoken languages of the present time will have become extinct or so altered as to require a key for their understanding. The English language spoken in the United States today, if not replaced by some other natural or invented tongue, will have suffered complete reforming many times over through the laws of linguistic evolving – laws which though proceeding in regular paths will, because of their complexity, work the apparent result of radical havoc. Books of the present day, through chemical change, will have disappeared." The time capsule was deemed capable of resisting the effects of time for 5,000 years.

Black Square, 2006–

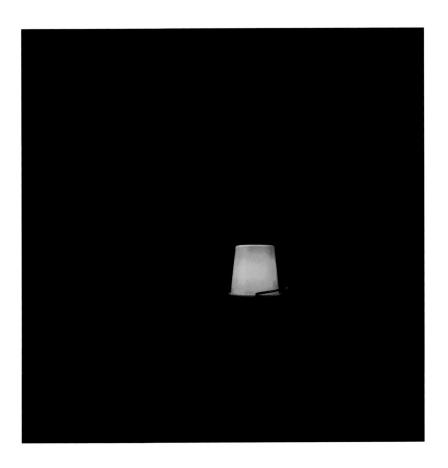

Black Square VI.

Blue buckets were mounted atop civilian vehicles in Moscow to protect the misuse of emergency blue rotating lights by VIP businessmen, celebrities, and officials to bypass Moscow traffic.

Black Square, 2006–

Black Square XIV.

The average color of the universe was determined by a team of scientists at Johns Hopkins University, who computed the average response of the human eye to all the optical wavelengths of light in the local volume of the universe. The result—assuming an observer sees all light in the Universe simultaneously and in a static state— was a beigeish white, with a hexadecimal RGB value of #FFF8E7.

Black Square, 2006—

Black Square XIII.

"The Liberator" is a 3D-printed handgun, printed on the MakerBot
Replicator 1, in New York, NY on July 12, 2013, using black ABS
plastic. Print time: 9 hours, 48 minutes. The online blueprints for
the gun were downloaded over 100,000 times before the U.S. State
Department demanded their removal from the creator's website.

Black Square, 2006–

Black Square XII.

The Protocols of the Learned Elders of Zion is a publication that purports to document the minutes of a meeting between Jewish leaders outlining their plan to control the world. Printed in Russia in 1903, it continues to be widely distributed in multiple languages and media, despite having been exposed as a false document by the London *Times* in 1921. From left, in Russian, *Sionskie Protokoly: plan zavoevaniia vselennoi, osushchestvliaemyi zhido-masonami* (2nd edition, ca. 1918), in German, *Die Geheimnisse der Weisen von Zion* (23rd edition, ca. 1935), in English, *Protocols of the Learned Elders of Zion/* Translated from the Russian text by Victor E. Marsden (ca. 1937).

Black Square, 2006—

Black Square IV.

"The Blaster" is an anti-carjacking system created by Charl Fourie
for installation beneath vehicles in South Africa. The flamethrower
is activated by pushing a button from the interior of a car under
attack. It was photographed installed on one of the most frequently
carjacked vehicles in South Africa, the Toyota Corolla.

Black Square, 2006 –

Black Square XVI.

George Orwell's *Animal Farm* was rejected by Knopf Publishing
Company on September 18, 1945. The manuscript was described as
a "[s]tupid and pointless fable in which the animals take over a farm
and run it, and their society takes about the course of the Soviet
Union as seen by Westbrook Pegler. It all goes to show that a
parallel carried out to the last detail is boring and obvious. Even
Pegler gets off a few smart lines now and then but this is damn dull.
Very very NFK."

The Dilemma of Instrumentalization
(or: From which Position is one talking?)

Markus Miessen in conversation with Taryn Simon and Liam Gillick

MARCUS MIESSEN: Power has many meanings associated with it. Power is often confused with force. It can be understood as motive power, which moves something forward, statistical power, which describes the probability that a test will reject a false null hypothesis, power as the ability to make choices and influence outcomes, power held by a person or group in a country's political system, the ability of nation states to influence or control other states; it can be understood as purchasing power in the sense of the amount of goods and services a given amount of money can buy, or the ability to set the price of a sold good – in the case of monopoly power. The conference Evasions of Power explored the relations between architecture, literature and geo-politics, attempting to get a closer understanding about the consequences and implications of spatial practices today. Both of your particular modes of research and practice are arguably dealing with issues of power, enclaves, and extra-territorial sites throughout the world. Generally speaking, is it possible to evade power?

TARYN SIMON: Evasion is reactive and implies some form of power. It is impossible to evade the examples you have listed and participate in a modern complex society. Buddhist monks approach it.

LIAM GILLICK: Contemporary structures with an interest in growth and development work hard to disguise their power with elaborate veils. These veils themselves become the phantoms and shadows of power-structures, revealed to us in a series of codes and behaviours. Not being a pacifist, I am not necessarily against the notion of manipulating power towards positive ends. I think that it is sometimes necessary to harness power in order to change things. It is impossible to evade power. One can be a victim of it or take a series of critical positions in relation to it. An evasion of the implications and structural applications of power merely allows repressive forms to take control. This does not mean, however, that one has to mimic known power structures in order to critique them.

MM: Are there forms of institutionality that allow for a practice that does not only superimpose power but also shares it?

TS: I don't think so. Perhaps in the algorithm of a Google search.

LG: There are no forms of institutionality that allow for this. If there were, they would not be institutional in form or manner. There are various flows within the culture that attempt to formulate new ways to negotiate power structures. These can be improvised or take a horizontal form for a while, but in a Lacanian sense there is often a self-institutionalising that takes place after a while, especially within alternative forms of practice that attempt to institutionalize open exchange.

MM: It seems to me that one of the crucial issues that are at stake in a conversation like this is the question of the position from which one is talking. There seems to be, in my mind at least, a recent romanticisation about bottom up processes. What happens if the one 'in power' provides models for change?

TS: I think it amounts to nothing more than a system change. But when the one in power provides a model for extreme change, it creates a chaotic state for those on the same level as the powerful and those that the power is communicated to and assimilated by. The creation of the Kadima party in Israel is a contemporary example of this.

LG: I agree. There are many revolutionary models that give us a perfect image of the idea of a small group or individual offering a new model of society. The notion of becoming organised or nominating someone or some group to speak for others is a perfectly reasonable procedure towards imagining a better situation. In fact it is arguable that merely waiting for a spontaneous shift among a large group will never lead to anything. The problem is, that this set of truisms works the same way whether one is thinking about the left or the right in political terms. It is true that the left is more committed to open democratic procedures but this fact does not render the left more impotent nor does it mean that bottom up processes are merely a romantic fantasy. The point is to create real exchanges of ideas and create a situation where it is possible to formulate structures that offer alternatives and participatory potential for the multiple publics that operate within developed societies.

MM: Is democracy always desirable?

TS: In many instances a strong central power structure can lead a country from a very low economic level upward, but with that process should come an evolution from centralized power toward democracy. But democracy is only a means, not an end. It can also lead to authoritarian results.

LG: Yes, yet with the proviso that it will tend to create the problems described by Chantal Mouffe. The tension between liberalism and democracy has been eloquently expressed and agonised over within her writing. The European project is torn between liberalism and democracy. Democracy as an abstraction is dysfunctional without broader debates about how it is applied, gauged and critiqued.

MM: Can language become a mode of evading power?

TS: Language transmits power.

LG: Absolutely. A sophisticated intellectual discourse should have a problematization of the dominant language at the heart of its analysis.

Language carries traces of power at all times. Critical language contains traces of critique at all times. We have seen that even the most repressive forces in the culture have become elegant semioticians. This means that the implication of the question is not merely applicable to whoever we might be imagining to be the "correct thinking" people, but is used by repressive forces to create endless synonyms for control and non-control.

MM: Is there power in dilettantism, in the role of the one waiting to be instructed?

TS: There is only if the "one waiting to be instructed" is not waiting simply for direction, but for an instruction that meets with his taste. In any other scenario the "dilettante" only becomes an instrument for the powerful.

LG: If one accepts that such strategies are only productive in the extremely short term and extremely long term. In the short term, as we have learnt from queer theory, feminism and other forms of social reassess-ment, rejecting the terms of engagement that underscore the dominant culture can produce levels of refusal to acknowledge the power structures that effect us all. Contrary and dismissive languages create discourses that cannot be assessed or controlled. However, these strategies work in a direct and engaged way with the present for the most part. Yet such strategies also have a long term effect in relation to style, social behaviour and bound-ary pushing, which tend to become mainstream over time. It is the space between the immediate sense of refusal and the long-term effects of social shift that I am generally interested in and is the area dominated by govern-ment, bureaucracy and straight white men.

MM: If one is looking at the slightly contested forms and understand-ing of participation today, one immediately gets frustrated about the romantic conception and nostalgic implications of the term. What are the modes of participation that are still operational rather than a mode of outsourcing responsibility?

TS: The romanticism you ascribe to these ideas of participation exists for a reason. They were systems that succeeded or failed at a specific his-toric moment. They may seem large as hallmarks but these groups were essentially systems operating in group-consciousness in a micro-sphere. Any operational contemporary system of participation is, for the most part, bolted to the foundations of outmoded or failed systems. The footprint of these romanticized participatory movements, at the end of the day, was more profound pop culturally than culturally or politically.

LG: One danger here is connected to the problem of instrumentaliza-tion. Most dominant power structures today claim to be committed to par-ticipation and transparency, certainly within an Anglo-Saxon context. As a result, any sense of participation – or attempt to create it – have to be super-self-conscious about being co-opted by more insidious structures. Yet, it is still reasonable to argue strongly in favour of participation, assuming that it is combined with a series of critical reflections.

MM: The role of the uninvited outsider seems to be very interesting. One could argue that actually it is no longer the one who participates in a given structure or system that has been set up by others, but the practi-tioner that breaks into alien – and possibly not-yet-known or established – fields of knowledge. Not in a romantic way – not in the sense of a

participatory democracy that postulates an idea of inclusion and invitation of the entire social body – but in terms of production. Taryn, your work in that respect is super-interesting. Can you please elaborate on your practice of "entering"?

TS: There are no insiders. And the outsider can never reach a core. He or she can only find another perch from which to observe. In my work, "entering" was testing physical and intellectual boundaries; confronting the divide between public and expert access and knowledge.

MM: I am wondering whether naivety, in its most positive terms – as "not-knowing", as one driven by relentless curiosity – produces a productive, opportunistic means of rupture in often very static systems?

TS: There is no version of a positive "not knowing". Lack of knowing itself is a gap easily and readily filled with obfuscation to maintain and expand an unknowing state by the powerful.

LG: This is not something I can comment on. It is a kind of Wittgensteinian dilemma. If one knew how to not-know one would know what could be known and therefore know what cannot be known. Actually, worse it is a kind of Donald Rumsfeld-ism. The known knowns and the known unknowns ...

MM: Is there a quality or an advantage to "not knowing"?

TS: Only to have a fantasy to escape to.

LG: It is a permanent state and a dysfunctional paradox. Not knowing is fetishised by those who claim to "believe" in some higher power. Faith is an extreme form of not knowing. Therefore arguing in favour of not knowing falls into the trap of a quasi-religious thinking.

MM: Within the constraints of your practice, do you understand yourself as outsiders or as someone who directly operates from within a given system?

TS: I operate from within a given system. But the system is not stagnant and not all-confining. It is a system that provides tools to alter its dimensions.

LG: Operating from within a system, but not one that is given, but rather one that requires analysis and critical self-consciousness.

MM: When you produce, is there a particular audience that you have in mind or are you attempting to produce new audiences in the sense of alternative formation of receivers that – without your work – would not exist?

TS: I consider the material forms that the work will live in; as a book, as an exhibition, in print. These forms desire an audience. I consider the multiple contexts it will enter into and work very hard to establish a fixed context within the work that can survive all these mutations intact. I am admittedly invested in seducing a broad audience and strategically use tools that have been proven to do so. My technical approach gives a stage typically reserved for heavily funded and distributed visual forms to subjects that would not receive such a stage.

LG: There are many publics. I don't think about audience, as that implies a performative aspect. I acknowledge the multiple publics for cultural practice and I think this problem or question is also a crucial one for the curators and others that I work with. Consequently, this discussion never happens alone.

MM: How do you communicate your work other than through conventional channels such as galleries, shows and publications?

TS: Through conversation.

LG: In dialogue. In lecture form. In argument. Via teaching. In bars. In silence. By thinking.

MM: What role does emotion play in your practice?

TS: It is a catalyst that is at best absent in the end result.

LG: It is sublimated.

MM: Would you call yourself romantic?

TS: Never. But I am.

LG: Never.

MM: The autonomy of the art world, by definition, means that things always happen in a very privileged and introverted, often apolitical, environment. This autonomy, on the other hand, is its potential: a "test-ground" without direct consequences.

TS: Everything has a consequence.

LG: I do not agree with any of the statement in your question.

MM: I am wondering whether you think that rather than being a test-ground of sorts, it is an environment that produces direct results?

LG: It really depends what a direct result might be and how we might measure it. I am sure that art has potential. I am not sure that we should only talk about it in terms of the "laboratory" or "test ground" but actually attempt to imagine that it is doing something precise and contingent simultaneously.

MM: Do you understand your practice as one that has or might produce global repercussions?

TS: I wish.

LG: Yes, but only in the sense that any act has a potential repercussion.

MM: As to the notion of opposition, there is always the question as to what degree one should go "with it" or "against it". Do you ever feel like there is a certain expectation directed towards yourself as to what to produce?

TS: I am always producing work from within very defined margins. The subjects I document force me to navigate through agendas. As a result, I remain hyper aware of my inability to be clean and consequently avoid absolutes. Images have multiple truths. In their accompanying texts, I present un-authored facts and formulas, never answers. At best, they attempt to lead to disorientation, but never to distortion.

LG: People often ask me directly for a specific action, thing or text. I am not necessarily against this. The idea of a unique context-free semi-autonomous producer does not appeal to me.

MM: Has critique ever turned against you in terms of direct censorship?

TS: In production, I have been denied access to sites for seemingly political reasons. In writing, I have been told to not record certain facts and have been denied information. In distribution, I have been told certain images cannot be presented for political reasons.

LG: Yes.

MM: Of what kind?

LG: The suppression of information that is necessary to understand an art work. This has happened at least twice in specific situation where the overtly political basis of a work is omitted from the published material distributed by an institution and substituted with generalised statements about the form of the work.

MM: Is there still potential for opposition or is it a nostalgic mode of operation that has been superseded by more productive means of involvement? Often, opposition to something produces the exact opposite of what the core of opposition intended.

TS: Opposition often turns what it opposes into the opposition. Catch-22.

LG: I agree with the general aspect of this question/statement. However I think that there are moments where precise direct action are necessary.

MM: Can conflict become somewhat operational?

TS: Yes.

LG: My Irish ancestry proves it.

MM: Do you consider Gramsci's slow march through the institutions as a still valid thesis?

LG: No.

TS: The Infinite Monkey Protocol Suite (IMPS) describes a protocol suite which supports an infinite number of monkeys that sit at an infinite number of typewriters in order to determine when they have either produced the entire works of William Shakespeare or a good television show. The suite includes communications and control protocols for monkeys and the organizations that interact with them. If you have an infinite number of monkeys typing on an infinite number of typewriters, eventually they will type the correct answer to this question.

Originally published in Katherine Carl, Aaron Levy, and Srdjan Jovanovic Weiss, *Evasions of Power: On the Architecture of Adjustment*. Philadelphia: Slought Foundation, 2011

Season 3, Episode 12, "Clear"

Simon confronts the fear of losing one's self and all
semblance of humanity in her performance as a zombie
on the television series, *The Walking Dead*. Simon's
Season 3, Episode 12, "Clear" (2015) acknowledges the
modern zombie as a projection of social unease and a
representation of consumerism: the zombie needs to
consume flesh to multiply.

Season 3, Episode 12, "Clear", 2015

Single Channel Video (loop) and Letraset on wall
Dimensions variable

A Living Man Declared Dead and Other Chapters
I – XVIII

A Living Man Declared Dead and Other Chapters I – XVIII
was produced over a four-year period (2008–2011),
during which Simon traveled around the world
researching and recording bloodlines and their related
stories. In each of the eighteen 'chapters' that make
up the work, the external forces of territory, power,
circumstance, or religion collide with the internal forces
of psychological and physical inheritance. The subjects
documented by Simon include feuding families in
Brazil, victims of genocide in Bosnia, the body double
of Saddam Hussein's son Uday, and the living dead in
India. Her collection is at once cohesive and arbitrary,
mapping the relationships among chance, blood, and
other components of fate.

Each work in *A Living Man Declared Dead* comprises
three segments. On the left of each chapter are one or
more large portrait panels systematically ordering a
number of individuals directly related by blood. The
sequence of portraits is structured to include the living
ascendants and descendants of a single individual. The
portraits are followed by a central text panel in which
the artist constructs narratives and collects details. On
the right are Simon's 'footnote images' representing
fragmented pieces of the established narratives and
providing photographic evidence.

The empty portraits represent living members of a
bloodline who could not be photographed. The reasons
for these absences are included in the text panels and
include imprisonment, military service, dengue fever and
women not granted permission to be photographed for
religious and social reasons.

Simon's presentation explores the struggle to determine
codes and patterns embedded in the narratives she
documents, making them recognizable as variations
(versions, renderings, adaptations) of archetypal episodes
from the present, past, and future. In contrast to the
methodical ordering of a bloodline, the central elements
of the stories – violence, resilience, corruption, and
survival – disorient the highly structured appearance of
the work. *A Living Man Declared Dead and Other Chapters
I – XVIII* highlights the space between text and image,
absence and presence, and order and disorder.

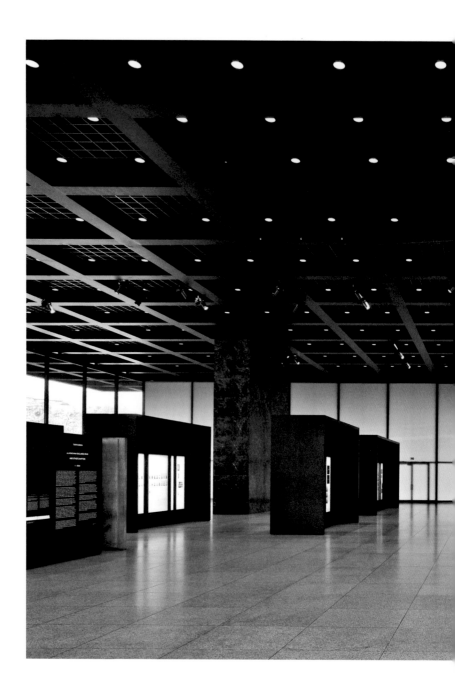

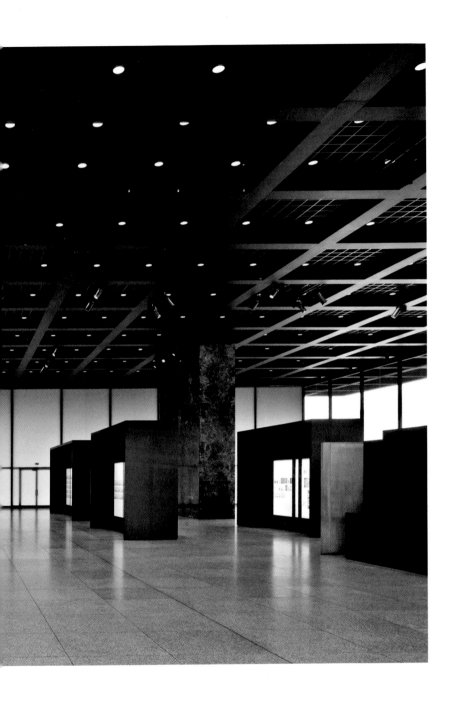

Installation view. *A Living Man Declared Dead and Other Chapters I – XVIII*
Neue Nationalgalerie, Berlin, 2011

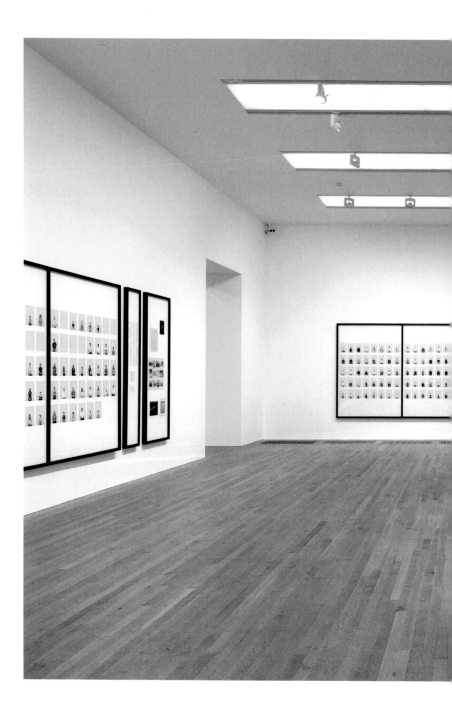

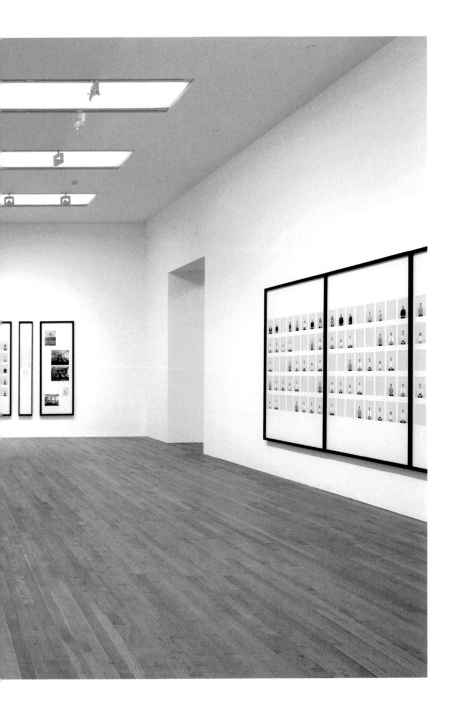

Installation view. *A Living Man Declared Dead and Other Chapters I – XVIII*
Tate Modern, London, 2011

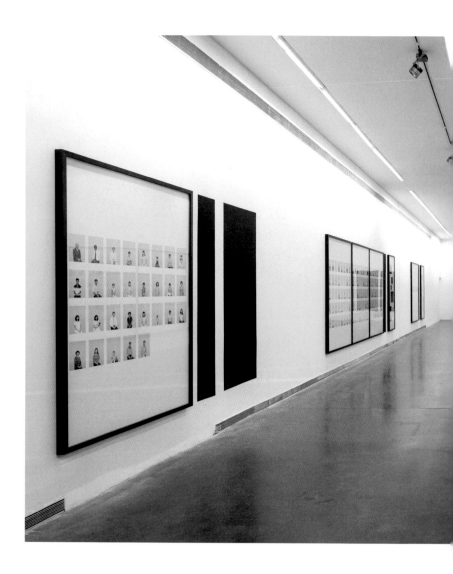

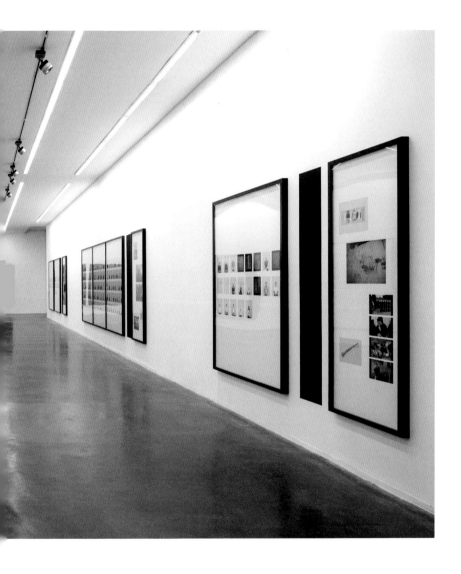

Installation view. *A Living Man Declared Dead and Other Chapters I – XVIII*
Ullens Center for Contemporary Arts, Beijing, 2013

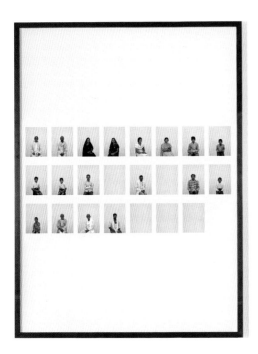

Chapter I

Framed archival inkjet prints and text
84 x 118 ⅓ inches (213.4 x 301.7 cm)

I

While visiting the local land registry office, Shivdutt Yadav discovered that official records listed him as dead. His land was no longer registered in his name. Yadav's two brothers, Chandrabhan and Phoolchand, and their first cousin, Ram Surat, were also listed as dead. Land registry records documented the transfer of Yadav's property to his father's other living heirs, allowing them to inherit his share of the family's ancestral farmland. These relatives reportedly threatened to destroy the family home on the property unless it was vacated immediately.

In Uttar Pradesh, India, land provides the primary source of income for most residents. Exponential population growth, property shortages, and repeated subdivision have heightened competition for land. Records officials are frequently bribed to have living people declared dead in order to redirect the hereditary transfer of land to new owners. These bribes commonly range from 45 to 2,250 INR (1 to 50 USD).

Yadav, his brothers, and his first cousin have been trying to reverse land registry records and regain legal status as living owners and heirs. Several official letters, including some signed by village residents, were sent to local police and records officials supporting their claims. According to the Yadav family, the local court has been scheduling dates for a case review since 2001, but a judge has never appeared. Judicial delay is common in Uttar Pradesh due to corruption, backlogs, and a shortage of judges. In several instances, people have died before their cases were reviewed.

Yadav and his family vacated their home but still farm the contested land. The house is currently unoccupied.

b. Letter to the chief judicial magistrate of Azamgarh demanding official recognition that Shivdutt, Chandrabhan, Phoolchand, and Ram Surat Yadav are living and maintain legal title to their land. The letter also requests that legal action be taken against all officers and family members who filed false information. *Family file, Azamgarh.*

d. Corpse of a person with leprosy floating in the Ganges River. The dead are cremated on the banks of the river or tied to heavy stones and sunk in the water. Dhanaiy Yadav, Shivdutt Yadav's father, was cremated along the banks and his ashes were scattered in the river. *Ganges River, Varanasi.*

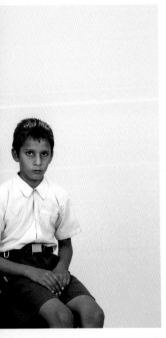 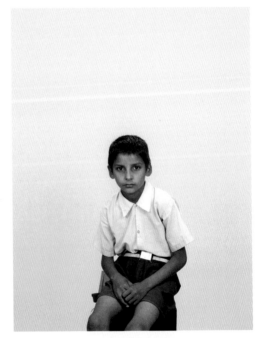

9. 10.

9. Yadav, Babloo (यादव, बबलू), ~11/12 (birth date unknown). Student. Azamgarh, Uttar Pradesh, India.

10. Yadav, Mukesh (यादव, मुकेश), ~10/11 (birth date unknown). Student. Azamgarh, Uttar Pradesh, India.

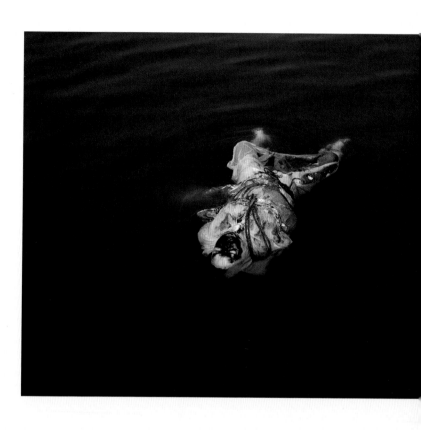

b.

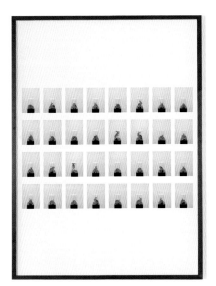

Chapter VI

Framed archival inkjet prints and text
84 x 326 ⅖ inches (213.4 x 829.6 cm)

VI

Twenty-four European rabbits were introduced to Australia in 1859 for hunting purposes on an estate in Victoria. Within one hundred years the rabbit population exploded to half a billion. As a consequence of early sexual maturity, short gestation, and large litters, a single female rabbit can produce between thirty and forty young per year.

Since the 1950s Australia has introduced lethal diseases into the wild rabbit population to control growth. This includes the rabbit haemorrhagic disease virus (RHDV), which was introduced in 1995. Rabbits in certain regions have shown moderate resistance to the original strain of RHDV, but not to field strains that subsequently emerged.

In a controlled test, the Robert Wicks Pest Animal Research Centre (RWPARC), a division of Biosecurity Queensland, bred three bloodlines of test rabbits from wild rabbits trapped at Turretfield near Adelaide, a region that has shown resistance to RHDV. Scientists at the RWPARC infected the test rabbits with samples of RHDV field strains collected in 2006, 2007, and 2009. These newer field strains killed most of the rabbits in the course of the trial, revealing that these strains maintained greater virulence than the strain of RHDV introduced in 1995. Rabbits not infected were euthanized.

European rabbits have no natural predators in Australia. They compete with native wildlife, degrade land, and damage native plants and vegetation. Earlier population control methods involved shooting, trapping, destruction of warrens, fumigation, and the construction of 3,256 kilometers of fencing. Severe environmental and agricultural damage attributed to rabbits incurs annual costs in Australia of between 600 million and 1 billion AUD.

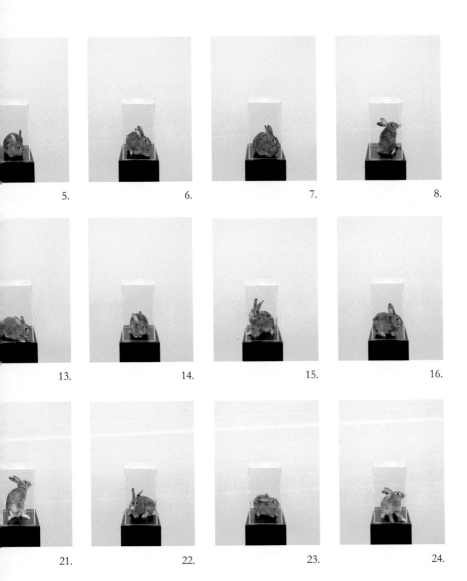

a. Haigh's chocolate Easter Bilby replaced Haigh's Easter Bunny
 in 1993. Haigh's stopped making chocolate bunnies and joined
 forces with the Foundation for Rabbit-Free Australia in an effort
 to counter the annual celebration of rabbits. *Product of Haigh's
 Chocolates, Adelaide.*

b. Rabbits killed with .22 Magnum rifles by NatureCall, an organization hired to eliminate rabbits from private properties. Dead rabbits are laid out to record data, including sex, age, pregnancy, and active virus status. *Cattle-grazing property west of Kingaroy, Queensland.*

a.

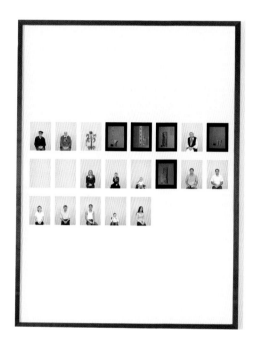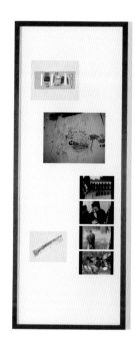

Chapter VII

Framed archival inkjet prints and text
84 x 118 ⅓ inches (213.4 x 301.7 cm)

VII

In five days in July 1995, Bosnian Serb soldiers systematically executed approximately 8,000 Bosnian Muslim men and boys in Srebrenica. Under the command of General Ratko Mladić, units from the Army of Republika Srpska attacked a United Nations-designated safe area. Dutch troops charged with protecting the UN camp were outnumbered and not equipped to fight back. Muslim men and boys from the camp and surrounding areas were rounded up, beaten, and killed. They were buried in mass graves, some still alive. Disarticulated body parts were found in secondary grave sites, indicating that human remains had been scattered in an effort to conceal the event.

Tooth and bone samples of Ahmedin Mehić, Hazim Mehić, Enis Mehić, Mustafa Muminović, and Ibro Nukić were discovered in mass graves in Podrinje, eastern Bosnia. The International Commission on Missing Persons (ICMP) identified them by matching their DNA with blood samples from family members. The mortal remains of Bajazit Mehić (3) were assembled at the ICMP's Podrinje Identification Project in Tuzla and buried at the Srebrenica-Potočari Memorial and Cemetery on the fifteenth anniversary of the Srebrenica massacre. The ICMP has identified over 6,000 of the estimated 8,000 persons killed at Srebrenica. All remains are archived in a photographic database at the Identification Coordination Division of ICMP.

The Srebrenica massacre is the largest mass murder in Europe since the Second World War. Ongoing trials at the International Criminal Tribunal for the former Yugoslavia have led to convictions of genocide. Mladić, charged with genocide, complicity in genocide, crimes against humanity, and violations of the laws or customs of war, remains a fugitive. The Bosnian war left over 100,000 dead. Approximately 20,000 people, mostly Bosnian Muslims, were killed in and around UN-designated safe areas.

b. Graffiti in the Potočari battery factory used as a barracks by
Dutch UN soldiers and Bosnian Serb soldiers after the fall
of the Srebrenica enclave. *Potočari battery factory, Srebrenica.*

b.

1. Nukić, Nezir, 1928 (exact birth date unknown). Forester
 and road builder. Živinice, Bosnia and Herzegovina.

2. Mehić, Zumra, 09 Dec. 1950. Homemaker. Kladanj,
 Bosnia and Herzegovina.

3. Mehić, Bajazit, 16 Sept. 1972 – 11 July 1995. Mortal
 remains, International Commission on Missing Persons,
 Podrinje Identification Project. Tuzla, Bosnia and
 Herzegovina.

4. Mehić, Ahmedin, 16 Feb. 1974 – 12 July 1995.
 Tooth sample used for DNA matching, International
 Commission on Missing Persons. Srebrenica-Potočari
 Memorial and Cemetery, Srebrenica, Bosnia and
 Herzegovina.

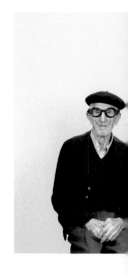

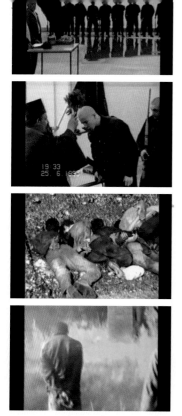

d.

d. Video footage introduced at former Serbian president Slobodan Milošević's trial, revealing a Serbian paramilitary unit's involvement in the Srebrenica massacre. It depicts an Orthodox priest blessing members of the "Scorpions" unit, who are subsequently shown lining up six young Bosnian Muslim men along a dirt road. The young men are later shot in the back in a grassy area beside the road. *Undisclosed source, Sarajevo.*

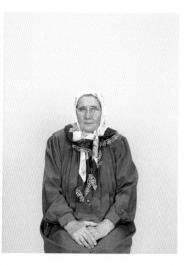

2.

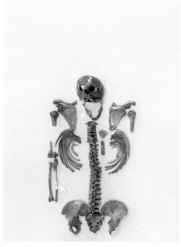

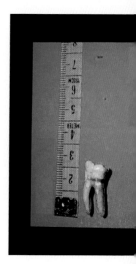

3.

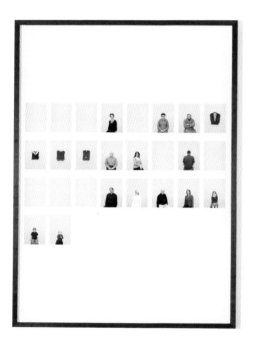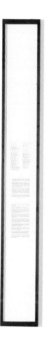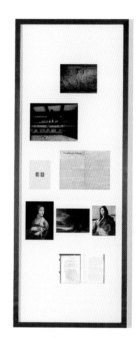

Chapter XI

Framed archival inkjet prints and text
84 x 118 ⅘ inches (213.4 x 301.7 cm)

XI

Hans Frank was Adolf Hitler's personal legal advisor and governor-general of occupied Poland. He was found guilty of war crimes and crimes against humanity during the International Military Tribunal at Nuremberg and was executed on October 16, 1946.

During Hitler's rise to power, Frank represented the interests of the National Socialist German Workers' Party in over 2,000 cases. He was appointed minister of justice for Bavaria, chairman of the National Socialist Jurists Association, and president of the Academy of German Law, which he founded. Frank crafted and enacted laws and legal doctrines serving the Third Reich's ideological and territorial ambitions, including mobilization for war. At the end of 1934 Hitler appointed him Reich minister without portfolio.

Under Frank's rule as governor-general of occupied Poland and Heinrich Himmler's command of the SS, the Generalgouvernement conscripted Polish nationals into forced labor in Germany; closed Poland's schools and colleges; arrested Polish academics and intellectuals; increased food contributions to Germany while the Polish population was starved; implemented forcible resettlement projects, including the development of Jewish quarters; required Jews and other minorities to wear identifying symbols; and initiated a program to exterminate Jews.

Frank was captured by American troops in southern Bavaria on May 4, 1945. Upon his arrest, Frank attempted suicide. During his imprisonment and trial, he renewed his Catholic faith. In his testimony at Nuremberg, Frank claimed he submitted fourteen resignation requests to Hitler, but all were rejected.

c.

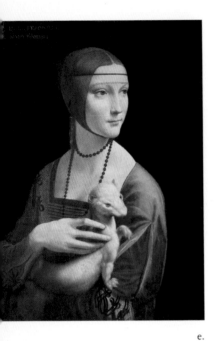

f.

e.

e. Leonardo da Vinci's *Lady with an Ermine*, taken by German troops from the Czartoryski collection during the Second World War. It hung in the Wawel apartment of Hans Frank and was later brought to his family home, Schoberhof. After Frank's arrest, the painting was returned to the Czartoryski Museum, where it now hangs across from the empty frame for Raphael's missing *Portrait of a Youth*. *Czartoryski Museum, Krakow.*

f. Rembrandt's *Landscape with the Good Samaritan*, taken by German troops from the Czartoryski collection during the Second World War. One of only eight oil landscapes painted by the artist, it was returned to the Czartoryski Museum upon Frank's arrest. *Czartoryski Museum, Krakow.*

c. Official Adolf Hitler postage stamp and Hans Frank imitation stamp. The
 Hitler stamp was printed in 1941 for the second anniversary of the founding
 of the Generalgouvernement and was in circulation until the end of the
 Second World War. A replica of the Hitler stamp, with Frank's image, was
 produced by British intelligence and released in Poland to provoke friction
 between Frank and Hitler. *Henry Gitner Philatelists, Inc., New York.*

7.

7. Frank, Norman, 06 Mar. 1928. Bavarian television
 facilities director (retired). Schliersee, Germany.

8. MJK, 24 May 1958. (Information withheld). [Sent
 clothing as representation]

14. Sommerfeld, Maximilian, 31 Mar. 2002. Student.
 Gross-Umstadt, Germany. [Parent declined
 participation/child not old enough to decide for
 himself]

15. (Information withheld).

16. (Information withheld). [Parent declined participation]

17. (Information withheld). [Parent declined participation]

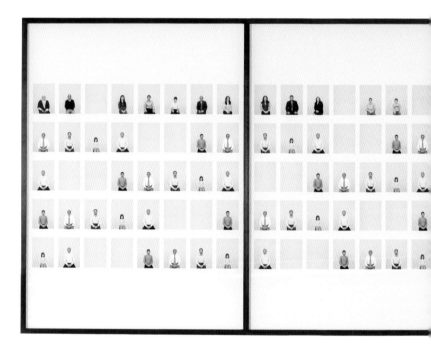

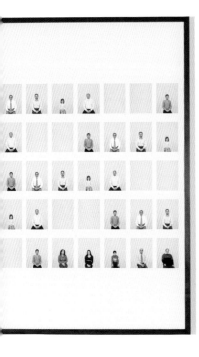

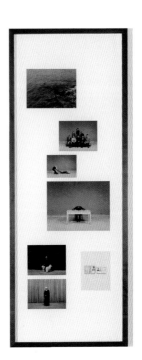

Chapter XIV

Framed archival inkjet prints and text
84 x 241 ⅞ inches (213.4 x 641.42 cm)

Ribal Btaddini is believed to be the reincarnation of his paternal grandfather, Milhem Btaddini. He is therefore both father and son to his own father, Fouad Btaddini, and the grandfather of his brothers, Feras Btaddini and Iad Btaddini. As a child, Ribal was able to recall aspects of his previous life, including the location of his home and how to get there; clothing and where it had been purchased; bombings that had taken place the night of his death; and how his wife tried to drag his injured body to safety. Ribal belongs to the Druze, a religious community found primarily in Lebanon, Israel, Jordan, and Syria. Reincarnation is central to their beliefs. Druze traditions derive from the Ismaili sect of Islam and are influenced by Gnostic principles and Greek philosophy. They do not accept converts, as their belief in intra-community reincarnation precludes the possibility of outside believers. The largely secular majority of Druze (juhhal) are denied access to holy literature and religious meetings by initiated members (uqqal) responsible for enforcing a strict code of moral and ethical behavior. The Druze played an integral role in the formation of the modern state of Lebanon. They have long concealed the more esoteric aspects of their beliefs for fear of persecution.

Four additional relatives of Ribal Btaddini claim to have memories from previous lives. Samar Barakat remembers drowning while trying to save her daughter who had fallen from a window into the sea. Ragheed Chehayeb remembers piloting a plane that was hit by a missile and crashed in Israel. Chérine Barakat remembers being tall, wearing long skirts with her hair tied up, and having many homes, including one in London as well as a palace. Amal Btaddini remembers the necklace she used to wear as Najla Daou and the names of several people in Daou family photographs whom she has never met. She was born on the same day that Daou passed away. It is assumed that if a child has no memories from a previous life, then that life contained no noteworthy events or something interfered with the child's memory.

a. Said Bou Hamdan reenacting his death as Najib Al-Awar. Bou Hamdan claims he drowned in his previous life as Al-Awar, following an airplane crash. *Deauville Beach, Khalde.*

a.

d.

d. Nazih Al-Danaf reenacting his death as Fuad Khaddage. Al-Danaf claims he was assassinated in his previous life as Khaddage while at his desk at the Dar El Taifeh in Beirut. *Al-Risala Social Union Hall, Aley.*

f.

f. Sheikh Naim Hassan, Druze spiritual leader. *Dar El Taifeh, Beirut.*

g. Milhem Btaddini's identification papers and Ribal Btaddini's
 Lebanese passport. Ribal is believed to be the reincarnation of
 his paternal grandfather, Milhem. *Family file, Aley and personal
 document, Dubai.*

26. Btaddini, Feras (بتديني، فراس), 01 Jan. 1
Senior facilities officer, *Aspire Academy*
Sports Excellence, Doha, Qatar

27. Btaddini, Yara (بتديني، يارا), 20 Oct. 20
Student, Doha, Qatar

28. El-Btaddini, Iad (بتديني، اياد), 04 Feb. 1
Human resources and administrative m
Maatouk Factories L.L.C., Abu Dhabi,
United Arab Emirates

29. Btaddini, Malaika (بتديني، مالايكة), 26 Ma
Student, Manila, Philippines
[Unable to participate]

30. Btaddini, Julian (بتديني، جوليان), 16 Feb.
Student, Manila, Philippines
[Unable to participate]

31. Btaddini, Ribal/Btaddini, Milhem
(بتديني، رئبال/بتديني، ملحم),
16 Mar. 1986/22 Dec. 1897
Computer engineer, Dubai,
United Arab Emirates

32. Btaddini, Fouad (بتديني، فؤاد), 04 Dec.
Owner, *5 Continents,* Aley, Lebanon

33. Btaddini, Feras (بتديني، فراس), 01 Jan. 1
Senior facilities officer, *Aspire Academy*
Sports Excellence, Doha, Qatar

34. Btaddini, Yara (بتديني، يارا), 20 Oct. 20
Student, Doha, Qatar

35. El-Btaddini, Iad (بتديني، اياد), 04 Feb. 1
Human resources and administrative m
Maatouk Factories L.L.C., Abu Dhabi,
United Arab Emirates

36. Btaddini, Malaika (بتديني، مالايكة), 26 Ma
Student, Manila, Philippines
[Unable to participate]

37. Btaddini, Julian (بتديني، جوليان), 16 Feb.
Student, Manila, Philippines
[Unable to participate]

38. Btaddini, Ribal/Btaddini, Milhem
(بتديني، رئبال/بتديني، ملحم),
16 Mar. 1986/22 Dec. 1897
Computer engineer, Dubai,
United Arab Emirates

39. Btaddini, Fouad (بتديني، فؤاد), 04 Dec.
Owner, *5 Continents,* Aley, Lebanon

40. Btaddini, Feras (بتديني، فراس), 01 Jan. 1
Senior facilities officer, *Aspire Academy*
Sports Excellence, Doha, Qatar

41. Btaddini, Yara (بتديني، يارا), 20 Oct. 20
Student, Doha, Qatar

Unable to participate]

Btaddini, Ribal/Btaddini, Milhem
(بتديني، رئبال/ابتديني، ملحم)
16 Mar. 1986/22 Dec. 1897
Computer engineer, Dubai,
United Arab Emirates

Btaddini, Fouad (بتديني، فؤاد), 04 Dec. 1953
Owner, 5 *Continents*, Aley, Lebanon

Btaddini, Feras (بتديني، فراس), 01 Jan. 1979
Senior facilities officer, *Aspire Academy for
Sports Excellence*, Doha, Qatar

Btaddini, Yara (بتديني، يارا), 20 Oct. 2003
Student, Doha, Qatar

El-Btaddini, Iad (بتديني، اياد), 04 Feb. 1981
Human resources and administrative manager,
Maatouk Factories L.L.C., Abu Dhabi,
United Arab Emirates

Btaddini, Malaika (بتديني، مالايكة), 26 Mar. 2000
Student, Manila, Philippines
[Unable to participate]

Btaddini, Julian (بتديني، جوليان), 16 Feb. 2003
tudent, Manila, Philippines
Unable to participate]

Btaddini, Ribal/Btaddini, Milhem
(بتديني، رئبال/ابتديني، ملحم)
16 Mar. 1986/22 Dec. 1897
Computer engineer, Dubai,
United Arab Emirates

Btaddini, Fouad (بتديني، فؤاد), 04 Dec. 1953
Owner, 5 *Continents*, Aley, Lebanon

Btaddini, Feras (بتديني، فراس), 01 Jan. 1979
Senior facilities officer, *Aspire Academy for
Sports Excellence*, Doha, Qatar

Btaddini, Yara (بتديني، يارا), 20 Oct. 2003
Student, Doha, Qatar

El-Btaddini, Iad (بتديني، اياد), 04 Feb. 1981
Human resources and administrative manager,
Maatouk Factories L.L.C., Abu Dhabi,
United Arab Emirates

Btaddini, Malaika (بتديني، مالايكة), 26 Mar. 2000
Student, Manila, Philippines
[Unable to participate]

Btaddini, Julian (بتديني، جوليان), 16 Feb. 2003
tudent, Manila, Philippines
Unable to participate]

Btaddini, Ribal/Btaddini, Milhem
(بتديني، رئبال/ابتديني، ملحم)
16 Mar. 1986/22 Dec. 1897
Computer engineer, Dubai,
United Arab Emirates

Human resources and administrative manager,
Maatouk Factories L.L.C., Abu Dhabi,
United Arab Emirates

106. Btaddini, Malaika (بتديني، مالايكة), 26 Mar. 2000
Student, Manila, Philippines
[Unable to participate]

107. Btaddini, Julian (بتديني، جوليان), 16 Feb. 2003
Student, Manila, Philippines
[Unable to participate]

108. Btaddini, Ribal/Btaddini, Milhem
(بتديني، رئبال/ابتديني، ملحم)
16 Mar. 1986/22 Dec. 1897
Computer engineer, Dubai,
United Arab Emirates

109. Btaddini, Fouad (بتديني، فؤاد), 04 Dec. 1953
Owner, 5 *Continents*, Aley, Lebanon

110. Btaddini, Feras (بتديني، فراس), 01 Jan. 1979
Senior facilities officer, *Aspire Academy for
Sports Excellence*, Doha, Qatar

111. Btaddini, Yara (بتديني، يارا), 20 Oct. 2003
Student, Doha, Qatar

112. El-Btaddini, Iad (بتديني، اياد), 04 Feb. 1981
Human resources and administrative manager,
Maatouk Factories L.L.C., Abu Dhabi,
United Arab Emirates

113. Btaddini, Malaika (بتديني، مالايكة), 26 Mar. 2000
Student, Manila, Philippines
[Unable to participate]

114. Btaddini, Julian (بتديني، جوليان), 16 Feb. 2003
Student, Manila, Philippines
[Unable to participate]

115. Btaddini, Ribal (بتديني، رئبال), 16 Mar. 1986
Computer engineer, Dubai,
United Arab Emirates

116. Barakat, Samar (بركات، سمر), 19 Nov. 1960
Homemaker, Aley, Lebanon

117. Barakat, Chérine (بركات، شيرين), 26 Oct. 1991
Student, Aley, Lebanon

118. Barakat, Sameeh (بركات، سميح), 27 Apr. 2000
Student, Aley, Lebanon

119. Chehayeb, Samer (شهيب، سامر), 05 Feb. 1962
Automobile dealer, Aley, Lebanon

120. Chehayeb, Hatem (شهيب، حاتم), 15 Feb. 1967
Aley, Lebanon

Detail, Chapter XIV Annotation Panel

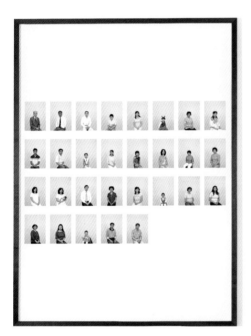

Chapter XV

Framed archival inkjet prints and text
84 x 118 ⅓ inches (213.4 x 301.7 cm)

XV

China's State Council Information Office (SCIO) was solicited in 2009 to select a multi-generational bloodline that would "represent China" for this project. The SCIO selected the family of Su Qijian from Beijing, for its large size. The office declined to provide further reasoning for its choice.

Previously known as the Office of Foreign Propaganda, the SCIO researches, develops, and manages China's external publicity activities. It directs government departments, including those that oversee customs, finance, security, sport, and trade. Additionally, the SCIO instructs Chinese media on all potentially controversial issues, including Tibet, Xinjiang, ethnic minorities, human rights, religion, democracy movements, and terrorism. Its supervisory role includes monitoring foreign journalists in China, foreign research about China, and the Internet.

Only the Xinhua News Agency, the official press agency of the People's Republic of China, is granted authority to cover issues of national importance. When disseminated, its reports must be used in their original form. The Xinhua News Service supplies free content to Chinese-language news media outside China.

China disseminates information to the Chinese community abroad through Chinese-language radio, television stations, the Internet, and newspapers. These distributions have undergone several reforms, including avoidance of the term *propaganda* in foreign-language publications that discuss China's media management. Instead, words and phrases such as *cross cultural communication*, *information*, *publicity*, *public relations*, and *public diplomacy* are used to describe activities still referred to in Chinese-language publications as propaganda.

17. Zhang, Jing (张, 菁27 July 1975. Homemaker. Qingdao, China.

18. Ma, Yucheng (马, 誉诚), 06 Sept. 2009. Qingdao, China.

19. Zhang, Qun (张, 群), 27 Mar. 1979. Advertising designer, *Beijing Gotwin Culture Communicate Limit Company*. Beijing, China.

17.　　　　　　　　　　18.　　　　　　　　　　1

a. China Central Television Tower, selected by the State Council Information Office to be photographed for this work. *Beijing.*

b. Gift bag from the State Council Information Office (SCIO). *Product of the SCIO, Beijing.*

b.

Ordering Principle

Portraits are arranged in a linear format. They are read in rows from left to right, top to bottom.

Each collection of portraits is based on a limited genealogy of a single bloodline. The genealogy originates from one individual—the point person—and includes only living ascendants and descendants.

The ordering of each bloodline begins with the direct living ascendants, if any, of the point person. These ascendants are followed by the point person, if he or she is still alive. Descendants of the point person are then presented beginning with the oldest generation to have a living member. Members of that generation are sequenced by age from oldest to youngest, with every individual directly followed by his or her descendants, each of whom is in turn followed by his or her own descendants. This pattern repeats until all living descendants have been presented. If any member of a generation descending from the point person is dead, his or her living descendants are presented before the next oldest member of the deceased's generation.

Ordering Diagrams

Generations in descending order

Oldest ▪ ▪ ▪ ▫ Youngest

Point Person (if living)

Indicates missing ascendant(s) [deceased]

Point Persons

I	VII
Dhanaiy Yadav	Nezir Nukić
VI.A	XI
No. 1624 (wild rabbit)	Hans Frank
VI.B	XIV*
No. 2146 (wild rabbit)	Fahim Chehayeb
	*Bloodline follows a reincarnating pattern.
VI.C	
No. 1628 (wild rabbit)	XV
	Su Qijian

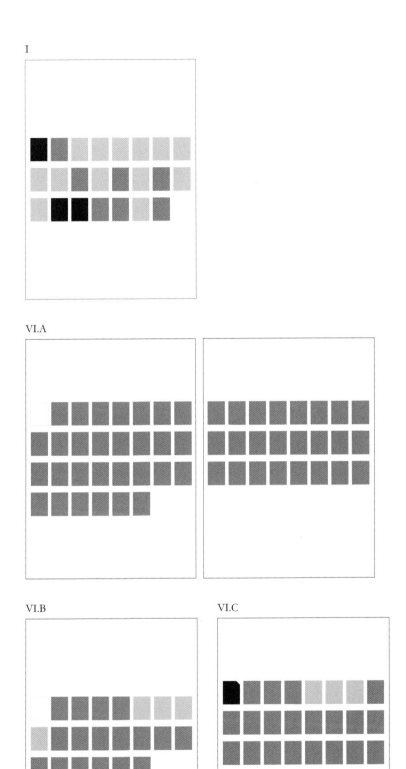

I

VI.A

VI.B VI.C

VII

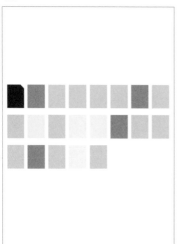

XI

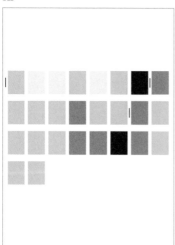

XIV

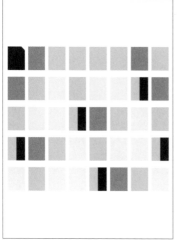

XIV (continued)

XV

Beyond Photography

Homi Bhabha

A precarious sense of survival holds together the case studies encompassed by Taryn Simon's *A Living Man Declared Dead and Other Chapters*. The notion of survival is frequently associated with what Giorgio Agamben calls "bare life", with a zero-degree existence, with a life rendered negligible and nugatory by adverse, antagonistic forces. *A Living Man Declared Dead* proposes a different ethic and aesthetic of survival. Survival here represents a life force that fails to be extinguished because it draws strength from identifying with the vulnerability of others (rather than their victories), and sees the precarious process of interdependency (rather than claims to sovereignty) as the groundwork of solidarity. We are neighbours not because we want to save the world, but because, before all else, we have to survive it.

War, violence, land appropriation, environmental abuse, the problems of cultural identity, and the expropriation of personhood – these conditions, amongst others, repeat relentlessly across the chapters. The idea of the bloodline as a narrative thread of order, continuity and seriality – an undeniable measure of relationship and descent – runs through every chapter. Yet, the diversity of geography, and the locality of cultural choice, prevent the dominance of *blood*, or any other instance of causal determinism, to be the elected vehicle of fate.

Survival, by contrast, is the art of learning how to conjure with contingency and circumstance. It is more dependent on practice and performance than on the articulation of principle. The agent of survival, whether individual or group, is fraught with an awareness of his or her own internal disjunctions, where rationality and affect cross paths, and leave anxiety and ambivalence in their wake. Such precarious conditions of life inhabit each of Simon's case studies and speak of the profound polarities of a dire modernity, where "opposites touch".[1]

Two chapters are particularly effective in articulating the sense of precariousness that haunts this book. It is the extremity of such precariousness that sets the stage upon which the human drama of survival unfolds. Hans

Frank, Hitler's governor-general to Poland, played a deadly role in the Third Reich, which requires no further elaboration. However, certain of Simon's photographs in *Chapter XI* shed a different light on his character. Frank had either an extremely sophisticated artistic sensibility or a desire to possess art of great value. He surrounded himself with the very finest works appropriated from the Czartoryski Museum – Leonardo, Rembrandt, Rubens. His choice of Leonardo's sublime *The Lady with an Ermine* to adorn his home suggests a conflict, a person whose love of human artistry could hardly be at peace with his barbarism towards human beings.

In *Chapter X* Simon illustrates the practice in the early decades of the twentieth century where tribals, aboriginals, and colonial "natives" were put on public display to entertain and instruct the metropolitan visitors to the various World Fairs. The narrative is devoted to Cabrera Antero, a member of the Filipino Igorot peoples, who was exhibited at the 1904 St. Louis World's Fair. The *Louisiana Purchase Exposition* drew special attention to the U.S.'s acquisition of the Philippines, while celebrating, in the spirit of the World's Fairs of that time, the triumph of Western Imperial progress and conquest. One of the signs of such progress, at the cost of the de-humanisation of the colonised, was to insist that the Igorot entertain the crowds by eating dogs. Dog eating amongst the Igorots was primarily a ritual practice; the fair organisers, however, compelled the Igorots to eat approximately 20 dogs a week to keep the crowds amused.

Under the eye of Leonardo's ethereal *Lady* and other master works, Hans Frank meticulously administered a diabolical, fascist regime. A world away in terms of the scale and quotient of evil is the demonstration of America's industrial and cultural modernity that required Antero to be on display in an anthropological exhibition designed to instruct the public on theories of evolution and racial hierarchy in the midst of the modern garden of Progress. There is an important lesson to be learnt from the dramatic disproportion between these two instances. It lies in the fact that the propinquity of barbarism and civility, its precarious proximity, makes it difficult to discern at what point in time some small and apparently innocuous forms of evil will surreptitiously turn into an unmanageable monstrosity. Simon turns the reader of images into a conceptual and speculative agent involved in the fate of photography as it confronts history.

The frailty of the art of photography is its tendency to fetishise what is seen as foreign, exotic, alien, or other. Photography's voyeurism becomes exacerbated in the face of racial, cultural or sexual differences. Prejudice and desire, fear and pleasure are frequently projected onto "subjects of difference", turning them into alien and anomalous objects whose identities, nonetheless, provide perverse excitations. Simon avoids such problems by activating a more primitive desire to appear both *in* and *as* a photograph, as is often experienced in fair-ground photo booths where the backdrop represents a scenario – the Taj Mahal or Versailles – that is quite out of keeping with the lives of those posing in the foreground of the image. *A Living Man Declared Dead* creates something of the same effect by throwing the spectator, time after time, into the midst of a world that is alien and unsettling. The *mise-en-scène* is even more complicated than that suggests, because Simon's chapter has several sections that abut each other and foreground different forms of signification: the bloodline photograph with the unchanging blank background, a kind of neutral non-place; the narrative that makes a more direct address to the spectator; and the footnote photographs that are, in a sense, metonymic materials that belong to

both other sections. The spectator is at once located *within* the work and, as a result of its shifting scenes, displaced from it.

This non-naturalistic *mise-en-scène,* with its long history in the annals of photography, has generated little theoretical interest. But it may just serve as an antidote to the voyeurism/fetishism paradigm because those who are photographed, quite out of context, are also spectators of themselves. By placing themselves in such a surreal situation they are subjects of a fantasy of displacement and aspiration. They know they do not belong *there* – it is only a painted backdrop anyway – but strangely, at the level of fantasy, they are seen to *be* there. They participate in the ambiguity of their photographic representations – no doubt with irony and humour. And yet, in a simple sense, once your shadow has fallen on a place – be it a page, a photographic print, a real location – you become part of its mystery and ambiguity, its fantasy and its history. It is in this way that Simon's photographs capture us. They make us part of her world of the hidden or secret; they make us part of the lives of others we will never encounter nor fully understand. Our shadows, however, have fallen on these peoples and places; and in our attempt to understand and interpret their complex circumstances, our own dark outlines develop new and unfamiliar profiles. Or such is the hope.

Against Realism

The majority of the critical writing on Simon's work places her art within one or another mode of realism – the hyperreal or aestheticised realism.[2] The critical response to her work – the story people tell about its aesthetic address and intentionality – is frequently a description of a visual practice committed to the revelation of secret places or the disclosure of unfamiliar things.

For instance:

> She gives photography back to its lost labour, and its substance, by finding a real subject matter, which demands representation and gives a disposable medium a new visual anchor.[3]

Or:

> A desire to uncover unknowns, understand their purpose, and display their majesty motivates much of Simon's work.[4]

Whatever the sophistications of different styles of realism, they are founded on a hermeneutic of "stop and search" where the referent, which is concealed on the body of the text or image *in any number of ways,* can and must be found before the "whole thing" falls into place. The visual anchor of realism is an epistemological process of *making visible* or *bringing to light* an object which is accompanied by an ethical and political commitment to a "liberatory spirit".[5] A representative reading of Simon's political vision commends her for "transforming that which is off-limits or under-the-radar into a visible and intelligible form, [confronting] the divide between the privileged access of the few and the limited access of the public."[6] True as this is, it is

not the end of the story. The resonance of her work does not fade into the virtuous visibility of aesthetic realism.

In one of Simon's hyperreal images in *An American Index of the Hidden and Unfamiliar* we enter one of the least visible and most mythical places in the American psyche, the C.I.A. Headquarters Building. Simon's tableau-format photograph of the main entrance hall is a study in formal symmetry and spatial balance. If the image were vertically divided into two sections, each would look like a mirror reflection of the other. There is indeed a central line embedded in the tiled floor, visible in the foreground of the photograph, which cuts the image in two. It is this line that *aligns* the viewer within the frame, prescribing the correct depth, from back to front, and providing a fine balance between the symmetric halves, from side to side. From this viewing position the hyperrealist perspective prevails, a visual anchor is provided, and the rightly-angled viewing subject is awed, as Salman Rushdie beautifully puts it, "by the black beauty which she so brightly, and brilliantly, reveals."[7]

However, the dazzling light that reveals, also conceals. The dark symmetry of spaced columns makes for repetitious surfaces of reflection; the *mise en abyme* of ceiling lights disappear into a seamless distance of mirrored images; sections of blinding light spill over like a wash of paint blurring the sharp symmetry of the image and creating areas of *white out*. Too much light creates its own blindness. The viewing subject is now displaced from the stable, centered position at the mid-point of the photograph, no longer monarch of all she surveys. Her view of Langley is impeded by a pattern of *blind spots* created by the excessive lighting. It is almost as if these white outs and blind spots create a new invisibility that causes the image to lose its visual anchor and its real subject matter. Suddenly, instead of revelation or disclosure, we are confronted with darkness at noon. Simon's subtle and crucial insistence on the emergence of occlusion or obscurity at the point at which we expect to experience full, unfettered visibility – to discover the secret of things – takes various forms.

Simon's *Nuclear Waste Encapsulation and Storage Facility* is another example of a *factual* photograph coming to assume a spectral, surreal presence. The blue radioactive glow creates a pattern strangely reminiscent of a map of the United States. As the image emerges to meet the eye, the blind spots (electromagnetic radiation emanating through stainless steel capsules), submerged in water, create the structural pattern of the photograph. The blind spots appear as if they are controlling the light and emitting it, at the same time. It is this movement of the image – its dynamic of displacement – that somehow prefigures its danger even before we read that "it is amongst the most contaminated sites in the United States."[8]

The political semiotic of these photographs suggests that what is widely known and feared in the public sphere can rarely be seen in the public realm. Strategically blocking our sight lines with blind spots and white outs, Simon mobilises the viewer's attention by *displacing* it, even disorienting it. Something similar to this dynamic of displacement between the two surfaces of the image has been well described by Michael Fried as an "internal division [between antitheatrical absorption and the 'stagedness' or 'to-be-seeness' of the image] characteristic of advanced photographic or pictorial art in the present moment."[9]

Blind Spot

Blind spots resist the logic of the main frame and go beyond the viewer's need *to see* (what is secret or foreign). Their provocation lies in creating a desire *to know and to act* in a way that both *reads* the photograph and resists its way of looking. The desire that the photograph evokes in the viewer – and the desire that shapes photography's work of representation, its apparatus of attractions – surpasses the demand to disclose the real thing as image (however magical) or object (however indexical).

What I have detected as the blind spot in Simon's work is close to what Roland Barthes describes in *Camera Lucida* as the obscure "blind field" of the "punctum".[10] The punctum is Barthes's version of what I have called the dynamic of displacement. An errant or marginal element within the main frame of the photograph, the blind spot (or blind field) turns viewers from passive recipients of the *truth* of the image, to active agents involved in various kinds of critical interventions: reading the picture against the grain; questioning the *framing* of the truth; interrogating the representational limits of the photographic medium. Displacing the viewer's angle of vision, the blind spot (blind field) creates desires for new knowledges, experiences and affects with which to reconstruct (or deconstruct) the image. The blind field, Barthes writes, exposes the *liminal* nature of photography; and in that breach of the frame – a moment of negation – the spectator takes on an interactive and interrogative role:

> The presence of this blind field … takes the spectator outside its [the photograph's] frame, and it is there that I animate this photograph and it animates me. The punctum, then, is a kind of subtle beyond – as if the image launched desire *beyond* what it permits us to see. …[11] [my emphasis]

Stare long enough at a photograph and you will see its historical past almost touching its technological future – that missing link is the present tense of photography. On the one side of photography lies the history of painting; on the other side, the adventure of cinema; a third side faces the complications of literature; and a fourth confronts the story of everyday life. Wandering like a ghost, back and forth across this transitional terrain, is it a surprise that the desire of photography (as Walter Benjamin and Roland Barthes suggest) leads the image beyond its frames and frontiers?

Fifty years before Barthes's *Camera Lucida*, Walter Benjamin had also grappled with "something that goes *beyond* the testimony to the photographer's art …" [my emphasis] in *The Little History of Photography*. This is how he saw the problem:

> With photography, however, we encounter something new and strange: In Hill's Newhaven fishwife, her eyes cast down in such indolent, seductive modesty, there remains something that goes beyond testimony to the photographer's art, something that cannot be silenced, that fills you with an unruly desire to know what her name was, the woman who was alive there, who even now is still real and will never consent to be wholly absorbed in 'art' … Immerse yourself in such a picture long enough and you realise to what extent opposites touch, here too: the most precise technology can give its products a magical value. …[12]

The unruly desire incited by the fishwife's veiled, yet winsome, eyes is not

simply an appeal for greater biographical detail or historical specificity to establish her living presence. The question is not *Who is she?* It is a desire for a story; a desire to ensure the survival of those eyes, that image – "who even now is still real ..." – with all the ambiguity of times and tenses that this simple phrase allows, prolonging the long lost past into the present ("even now"), and giving the image a veracity beyond its half-acknowledged artefactuality ("is it still real"). The question is *What has become of her?* This demand for narrative is an acknowledgment of two things. First, that outside the frame of photography there is a temporal desire to extend the moment of the *shot* in terms of a narrative both speculative and specific. As significant, however, is the ethical nature of the desire that extends *beyond* the testimony of photography, which is a desire for *alterity*, not simply continuity or closure.

The desire for alterity – the contradictory movement in which "opposites touch" – opens photography into the realm of inter-textual and intermediatic translation. Translation, as Benjamin describes it in *The Task of the Translator*, is not so much resemblance as re-location or displacement.

> Instead of resembling the meaning of the original, [a translation] must lovingly and in detail incorporate the original's *mode of signification*, thus making both the original and the translation recognisable as fragments of a greater language, just as fragments are part of a vessel.[13]

What is *within* photography that reaches *beyond* its limits in order to animate other desires – of alterity – as well as the desire of the Other, is its mode of signification, not its mimetic resemblance as image. By re-situating or re-locating photography in yet another representational or narrative medium – be it history, fiction, literary narrative, cinematic form, biography – the subject gains another life, and the photographic image survives as itself, in a different form. It is the on-going measure of meaning and value *in transition*, as translation, that transfers modes of signification across cultural media, and that represents the culminating move of the dynamic of displacement.

Text and Image

It is, indeed, such an "unruly desire" that governs Simon's coupling of text and image – a moment when "opposites touch". Her profound ambivalence towards the testimony of photography's *truth* prevents her from being, in Benjamin's terms, wholly absorbed in *art*. This doesn't mean that she opposes art to some naïve, empirical notion of reality; nor should her case studies of individuals, geographic locations and local histories, be taken at face value as anchors in history, politics, or the lives of peoples and things. Difficult though it may be to imagine this process, image and text develop their conjoined meanings because they are both articulated through that virtual, contradictory space that opens up in-between the fading of photography and the emergence of the written text.

This is the space of displacement where opposites touch; this is the time of the liminal and the *beyond* that stages photography's desire for translation. Invisible yet articulate, virtual yet material, what does it take to make concrete this concept of an interstitial, *negative* space which is the connective tissue that articulates image and text in Simon's art?

Simon juxtaposes the visual and the textual in a kind of montage which is neither totalising nor teleological. Her critique of progressivism leads her to describe her concatenation of image and text in the following way:

> There is no end result. There is only disorientation or the unknown. It's an equation that folds out on itself again and again. X + Y does not equal something. It doesn't equal infinity either. It just mutates into another question.[14]

Such a statement is difficult to reconcile with an art that has demonstrated a sustained formal interest in lists, catalogues, indexes, collections, case studies and assemblages.[15] Can these modes of mustering lead to an extreme indeterminacy of form, or the dereliction of order, to which Simon declares her allegiance? The dynamic of displacement emphasises the importance of the iterative and interstitial.

There is no closure to Simon's coupling of image and text – and hence "*X + Y does not equal something.*" This liminal, signifying space, in between the *edge* of photography and the emergence of other representational forms, is open to the desire for translation. And in disseminating photography's mode of signification across other aesthetic media and cultural practices, translation ensures the survival of the *image*. Simon is right to suggest that it is the nature of photography to mutate into other questions and discourses.

A Living Man Declared Dead and Other Chapters I – XVIII

Survival, be it aesthetic or political, is the issue at the heart of Simon's *A Living Man Declared Dead*. If *American Index* exposed the secret *topoi* of America's mythic and mundane life, *A Living Man Declared Dead* is a log of the artist's wayward *Wanderjahre* on a global scale, unearthing case studies of injustice, violence, disease, exploitation, oppression, religious devotion and reincarnation. Simon's acute awareness of cultural differences and normative anomalies, coupled with her ethnographic intelligence, prevents the project from becoming a sentimental catalogue of victims and disasters. Her culling of case studies has a curatorial reserve that avoids delivering value judgments, or repeating the platitudes of cultural relativism.

Simon's case studies are meditations on the touching of opposites – order and disorder, civility and barbarism, violence and aspiration – in the inscription of the human condition. Each chapter is a triptych to be read sequentially from left to right. The panels containing portraits of individuals belonging to a bloodline are by far the largest component of the installation. These portraits are plain, face-on photographs taken in the same style against the same background. Their insistent formal equivalence, and the repeated rhythm of the appearance and disappearance of individual faces, creates a pattern of descent and inheritance that follows the structure of the bloodline.

What is significant, however, given Simon's penchant for the catalogue, is the strict order of descent to which she has to adhere. This means that members of the bloodline who are absent or missing are represented by blanks – blank screens on which one can, and must, project the circumstances of loss. The large panels of portraits are a curious, paradoxical thing. In spatial terms, it is a paragon of order, sequence and descent. However, the

Empty portrait. *A Living Man Declared Dead and Other Chapters I – XVIII*, 2011
Archival inkjet print, 8 x 6 inches (20.32 x 15.25 cm)

temporality of the bloodline is a continual looping of the past-in-present, while the future nests in the moment of shooting the portrait. The relentless surge and ebb of the bloodline is fixed, at the moment of making the image, in a particular face at a particular time. And yet, the fixity of the photograph, as Benjamin proposes, is an illusory thing:

> [N]o matter how carefully posed his subject, the beholder feels an irresistible urge to search such a picture for the tiny spark of contingency, of the Here and Now, with which reality has, so to speak, seared the subject, to find the inconspicuous spot where the immediacy of that long-forgotten moment, the future, subsists so eloquently that we, looking back, may discover it.[16]

It is within the second panel of the installation that the "tiny spark of contingency" becomes visible, or readable, as Simon narrates the circumstances that led her to choose her subject of study. The contingency does not merely lie in the narrative. Contingency is also a formal condition of the relationship of image and text; their conjunction in that interstitial space that opens up in between the photograph and the narrative and prepares the ground for a translation of image *into* text, and *vice versa*.

The second text panel is the place in which Simon's thematic and political concerns become visible. It is here that the bloodline becomes flesh and blood. In India, the living are certified as dead in the pursuit of agricultural land; in Kenya, the practice of polygamy as an alternative to infidelity is seen both as preventing HIV/Aids and encouraging it; in Nepal, young girls are cultivated to become nubile goddesses until they are replaced by others and sent back to their humble homes; in Ukraine, children from orphanages are targeted for human trafficking, prostitution and child pornography; in Tanzania, albinos are hunted for their body parts because they are believed to bring good luck and good health. It could be argued that Simon's interest

lies in the banality of evil, but even that is a simplification. Each chapter may seem arbitrary and incidental and yet it leaves you with an unmistakable sense that this is a work about the fragility of human fate, and happenstance; but it is also a work that has been fortunate in finding the hidden signs that slowly bring to life the image of an age.

For our own times, there is a cluster around the question of identity that is of particular interest to the art of photography. If the photograph often has a double exposure – the main frame and the blind spot – then it is significant to see how circumstances create double lives for individuals who have to live uneasily between them. A double life is then no literary trope or symbolic image. It is often a matter of survival; at times a matter of life and death. Shivdutt Yadav, from Uttar Pradesh, and several members of his family, were listed as dead in official records. As a result of an act of bribery, his ancestral land was transferred to his father's other heirs. A living man declared dead cannot get himself registered as the rightful owner of his land. Neither living nor dead, occupying his own land without owning it, the double man lives a half-life. Another kind of half-life was the fate of Latif Yahia who was chosen by Iraqi security forces to be the "body double" of Saddam Hussein's son, Uday. Threatened with imprisonment and the rape of his sister if he refused, Yahia had to undergo reconstructive surgery in order to credibly impersonate Uday Hussein. Do you have a life if you are the shadow of another person, the mask of another's life?

There are others who share something of the same shadow existence: Ribal Btaddini who is believed to be the reincarnation of his paternal grandfather; or Leila Khaled, the Palestinian hijacker who had plastic surgery to disguise herself before her second hijack. However, Yadav and Yahia most clearly show how "opposites touch" when the most intimate part of one's person – one's identity, one's being – is stolen by the powers of the state. In Yadav's case it is India's endemic corruption that declares a live man dead while the courts collude in the living death; in Yahia's case, as has been said through the ages, despots are blind to all but themselves, the people do not exist.

It is the third section of the installation – the footnote images – that plays a marginal and translational role, all at once. This third space is arranged with a kind of randomness that falls somewhere between digital accumulation and a family photograph album. It occupies a liminal, disordered space in the triptych; a repository of displaced materials that frustrates any attempt at creating a comprehensive archive. Here you will find, for instance, a photograph of the record of land ownership that lists Yadav as being dead; it is here that you will see photographs of Yahia impersonating Uday Hussein. It is not the content of this marginal space that is its most significant feature. It is the role it plays in relation to the conjunction of image and text that makes its marginality the pivot on which the whole work turns.

The footnote column inserts itself in the interstitial space established by the bloodline portraits and the narrative texts. It confronts the sanguine seriality of the bloodline with random and contingent events, accidents and violence. The disorder of the footnote photographs stands in contrast to the ineluctable order of the bloodline; but the truth is that the visible messiness of life stands up quite well to the blind authority of the bloodline. In relation to the narrative text, the footnote photographs reference events and objects mentioned in the story, and lend them some evidentiary proof.

However, their randomness contests the linearity of the prose, and opens it up to further interpretation and interrogation.

The fragmented footnotes graphically represent the dynamic of displacement that enlivens Simon's entire work. Their fragmented and partial form may not add up to a total image or a whole story. A deeper truth is conveyed in their partial presences. They signify the bits and pieces, the presences and absences, the fading in and fading out, that mark the memory of man. Footnotes emerge from the past, broken and bedraggled, to claim their place in the present. These fragments will establish other stories, images and bloodlines.

Notes
1. Walter Benjamin, "Little History of Photography," *Walter Benjamin: Selected Writings, Volume 2: 1927-1934*, ed. Michael W. Jennings (Cambridge: Belknap Press of the Harvard University Press, 1999) 510.
2. Hans Ulrich Obrist's lively and inventive essay, "Ever Airport" (London Heathrow, May 2010), is an exception to this tendency, in Taryn Simon, *Contraband* (Göttingen: Steidl, 2010).
3. Dr Sarah Edith James, "Taryn Simon, Photography Between the Image and the Word," *The Deutsche Börse Photography Prize 2009*, ed. Stefanie Braun (London: The Photographers' Gallery, 2009) 134.
4. Elisabeth Sussman and Tina Kukizelski, "Foreword," Taryn Simon, *An American Index of the Hidden and Unfamiliar* (Göttingen: Steidl, 2007) 11.
5. Ibid., 13.
6. Ibid., 15.
7. Salman Rushdie, "Introduction," *An American Index of the Hidden and Unfamiliar*, 7.
8. *An American Index of the Hidden and Unfamiliar*, 19.
9. Michael Fried, *Why Photography Matters* (New Haven: Yale University Press, 2008) 246.
10. Roland Barthes, *Camera Lucida: Reflections on Photography* (New York: Hill and Wang, 1981) 55-59.
11. Ibid., 59.
12. Benjamin, "Little History of Photography," 510.
13. Walter Benjamin, *Illuminations* (New York: Schocken Books, 1969) 78.
14. Private correspondence between Homi K. Bhabha and Taryn Simon.
15. Obrist, "Ever Airport."
16. Benjamin, "Little History of Photography," 510.

Originally published in Taryn Simon, *A Living Man Declared Dead and Other Chapters I – XVIII*. Exh. cat., Tate Modern/Neue Nationalgalerie. Berlin/London: Nationalgalerie Staatliche Museen/MACK, 2011

Revenant

Geoffrey Batchen

Taryn Simon's *A Living Man Declared Dead and Other Chapters* is an extended meditation on the political economy of fate. It brings together those things we can not do anything about (our genetic inheritance) with those we can (its consequences). Photography is the major vehicle for this meditation, although this too is put under interrogation, having been turned here into a visual formula as much as an art form. The confrontation of science and art is also made manifest in the work's structure, which contrasts periodic tables of individual portraits with images that evoke social and political narratives, along with annotations to explain the connection of the two.

Consider, for example, the section of *A Living Man Declared Dead* simply titled *Chapter XIV*. Most prominently, it shows us a grid of photographs of every person from a particular bloodline. Each of these individuals is shown sitting in a chair, hands in lap, obediently staring straight ahead, looking blankly at the camera. Evenly lit and with the most neutral of backgrounds, the subjects of these portraits, if that is what they are, reside in some kind of non-place, having been captured with the serial dispassion of an academic experiment. There are 120 individuals represented in this particular sequence, arrayed on panels in 15 horizontal groups of eight vertical cells, to be read from left to right, in rows, from top to bottom. The regularity of the arrangement and repetition of form suggests that these portraits should be perused as collective evidence rather than for signs of personal character. Each photograph comes with identifying information: name, date of birth, profession, current place of residence. Some of the cells are empty, filling in for a body that for one reason or another could not be present at a shoot. The subjects vary widely in age and gender, from an 85-year-old man to a newborn. What they share is a common genetic inheritance: they are all related to Ribal Btaddini. An attendant number and caption tells us: Btaddini, Ribal/Btaddini, Milhem (بتديني. رئبال/ابتديني. ملحم) 16 Mar. 1986/22 Dec. 1897 Computer engineer, Dubai, United Arab Emirates.

The man has two names and two birth dates. Upon looking again you can see that his portrait also appears more than once in the sequence. As do the portraits of a number of other people in this particular line-up. The text that accompanies *Chapter XIV* tells us that Ribal Btaddini believes himself to be the reincarnation of his paternal grandfather, Milhem Btaddini. And that he belongs to a religious sect based in the Middle East called the Druze, who accept intra-community reincarnation as a matter of faith and can recall memories from their previous lives. To reiterate the point, a supplementary photograph shows Ribal Btaddini re-enacting his memory of the death of his other self in a *tableau vivant* played out on a stage. Having been mortally wounded in a bomb attack, Milhem's body is being vainly dragged to safety by his wife. The surreal quality of the image seems appropriate, given that what we are seeing is the depiction of a memory, and perhaps also of a man's desire to remember, to remember the scene of his own death. Haunted by an endless return from beyond the grave, this is truly a ghost story.

A Living Man Declared Dead is full of such stories, and of such ghosts. Over a four-year period, Simon has put together 18 photographic records of similarly striking bloodlines and their related stories. From feuding families in Brazil to victims of genocide in Bosnia, from human exhibitions in the United States to the living dead in India, Simon has formed a collection of genealogies that is at once bounded and arbitrary, in each case mapping the personal and social relationship between blood relations and lived experience. Each portrait sequence began with a single person from whom a bloodline was traced backward and forward to encompass every living person in it. The one exception was the section devoted to Bosnia, where the sequence also includes individuals killed in the Srebrenica massacre, represented by photographs of their remains (DNA testing has ensured their authenticity). In another case, featuring the inhabitants of an orphanage in Ukraine, the sequence of portraits aims to make visible the consequences of the *lack* of a bloodline. One section, under the heading *Chapter VI*, depicts, not people, but three separate bloodlines of rabbits—adding up to over one hundred photographs. Each of these rabbits has been injected with a lethal disease to test its virulence on the rabbit population in Australia, where they are classified as an invasive species.

Getting permission to make all these pictures required a huge amount of preliminary research, undertaken by the artist along with her sister Shannon Simon and assistant Douglas Emery. The name, story and place of every participant in a sequence had to be determined, and then each of these people had to be located and persuaded to sit for a portrait. Translators and "fixers" had to be found who could help organize the actual portrait sessions, which often took place in more than one location. If another link in a bloodline was suddenly discovered, then a further shoot had to be organized. This was especially complicated in countries like India, where some participants had no access to telephones or the internet.

Simon and her assistant travelled with a large-format view camera, a high-resolution digital camera and a substantial lighting set-up, to ensure that every image would look the same. An ivory backdrop was part of the basic equipment, along with three pieces of wood hinged together to slip over her camera case and thereby provide a seat for each subject. Another important piece of equipment was a sheet of plastic to be put on the floor, with spots marked on it for the positions of the tripod, chair, lights and so on. Wherever possible, the portraits were shot indoors in a room with a

Plastic sheet with placement marks for photographic equipment,
A Living Man Declared Dead and Other Chapters I – XVIII, 2011

white ceiling at a standard height, allowing the same amount of light to be cast over each subject. Sometimes, such as in Tanzania, all this equipment had to be sneaked in and out of the country (through Kenya in this case), to avoid the displeasure of the authorities. Three copies of each image were then distributed in different suitcases, in case of accident or robbery. Other images—for example, the landscapes that sometimes appear among the supplementary pictures—were exposed on film in a 4 x 5-inch view camera, allowing a more lush pictorial aesthetic to prevail.

This, then, is the story behind these other stories, a saga that is almost deserving of a documentary of its own. The sheer scale of Simon's ambition conjures *The Family of Man* exhibition, first shown at the Museum of Modern Art in New York in 1955. Edward Steichen and his team spent three years winnowing down two million pictures to the 503 (from 68 countries, by 273 photographers) that were eventually shown in that exhibition.[1] Privileging a humanist style of black and white photography, designed to induce sentiment and empathy in the viewer, Steichen himself claimed that his exhibition "was conceived as a mirror of the universal elements and emotions in the every-dayness of life—as a mirror of the essential oneness of mankind throughout the world."[2] This claim has attracted its fair share of criticism.[3] But still, the notion that we all share a common oneness—that the words "human condition" do have some universal meaning—remains a seductive one.

Simon's work exploits that seduction, but only to call it into question. Her portrait photographs, for example, in their repetitive, deadpan matter-of-factness, steadfastly refuse to offer the usual artistic pleasures of affect, exoticism or even horror—all convenient escapes for a viewer from further thought. There is certainly none of that fantasy of emotional attachment we feel in front of the kind of photographs shown in *The Family of Man*. Faced with the obdurate opacity of Simon's pictures, we are forced to seek meaning elsewhere, to look, in the first instance, to a series of texts supplied by the artist. But they too are deadpan in style, giving us information without the shading of interpretation or the welcome release of some greater didactic purpose. This sets up a distinctive viewing rhythm; you see the pictures

from afar, and, intrigued, step in close to read the text, and then step back to look again, more closely and with a more informed eye.

A Living Man Declared Dead's strategic co-dependence of image and text poses other challenges too. On the one hand, it seems to imply a lack of trust in the ability of these photographs on their own to do the work that Simon requires. But equally, it suggests that these texts may not be quite believable without the certification provided by their attendant photographs. This interactive combination of text and photograph is typical of Simon's work; it, rather than photography, is her true medium. In most cases, both text and photograph are undemonstrative in tone, as if anxious to persuade through their sheer objectivity of form. And yet the photographer's various choices can't help but intrude on this impression. She, after all, has chosen these subjects and stories over other ones, and has implemented this particular mode of presentation. Even her choice of photographic style is periodically disturbed by small idiosyncratic touches (most frequently exercised in the supplementary images on the right of each panel, like the one of Ribal Btaddini performing his own death, or the enigmatic water scene above it).

As a total ensemble, *A Living Man Declared Dead* locates the photograph's capacity to record exactly what is seen within the classification processes of the archive, a system of knowing that feigns neutrality while quietly imposing a framing decided in advance.[4] Hundreds of individuals have been photographed for this particular archive in exactly the same way (note again the imposed order of hands held in lap and the absence of smiles). The individuality of each person depicted is thereby simultaneously affirmed and denied. Everywhere one looks, Simon shows objectivity and subjectivity to be indivisible entities, a visual analogue for the similarly complex interrelationship of biology and destiny—*A Living Man Declared Dead*'s central concern.

This interrelationship is represented in Simon's work as a weave of certitude, chance and choice. The first two seem straightforward enough, but the last is more problematic. We like to think that choice is something available to all of us, a simple enough matter of exercising our free will. However, this myth of Western liberalism is constantly refuted in these panels. Mediated by circumstance, human agency in *A Living Man Declared Dead* is shown to be already shaped by cultural, social and political context, the context that makes any thought or action possible in the first place.[5] As Simon documents how, for example, someone born with the genetically determined condition of albinism, resulting in a lack of pigmentation in skin or hair, faces a much more limited set of options in Tanzania than if they'd been born in the United States or Europe. To recognize this difference—to see that fate is a situated discourse, to be able to separate it from the wanton will of the gods—is to make "the human condition" a politically navigable term rather than a mere platitude.

Roland Barthes says something similar in his trenchant response to the showing of *The Family of Man* in Paris:

> Birth, death? Yes, these are facts of nature, universal facts. But if one removes History from them, then there is nothing more to be said about them; any comment about them becomes tautological. The failure of photography seems to me to be flagrant in this connection: to reproduce death or birth tells us, literally, nothing. For these natural facts to gain access to a true language, they must be inserted into a category of knowledge which means postulating that one can transform them, and precisely subject their naturalism to your human criticism. For however universal, they are the signs of an historical writing.[6]

This, then, is the challenge taken up by Taryn Simon—to give the apparent transparency of the photograph a social thickness and make the natural read as historical. Walter Benjamin argues for a similar outcome in his 1931 essay, "Little History of Photography". Written as a surrogate critique of the social effects of capitalism, Benjamin's essay surveys the history of photography up to that point and finds most of it wanting:

> As Bertolt Brecht says, "The situation is complicated by the fact that less than ever does the mere reflection of reality reveal anything about reality. A photograph of the Krupp works or the AEG tells us next to nothing about these institutions. Actual reality has slipped into the functional. The reification of human relations—the factory, say—means that they are no longer explicit. So something must in fact be built up, something artificial, posed."[7]

Interestingly, one of the photographers Benjamin recommends in this context is August Sander—an artist whose work was also chosen for inclusion in *The Family of Man*. "Photography is like a mosaic that becomes a synthesis only when it is presented en masse," declared Sander, as if he were speaking about Simon's work as much as his own.[8] Producing thousands of likenesses between 1924 and 1933, Sander planned a comprehensive social register of the German people, to be titled *Citizens of the Twentieth Century: A Cultural History in Photographs*. At one point he proposed organizing it under seven sections, arranged by cities, comprising about 45 portfolios, each of which would contain 12 photographs. This imposed order is what gave his otherwise varied images the heft of a social science; as Benjamin puts it: "one will have to get used to being looked at in terms of one's provenance. ... Sander's work is more than a picture book. It is a training manual."[9]

The people depicted by Sander are named as generic social identities ("The Master Tiler", "Beggar", "Society Lady", "The Artist") and placed in his taxonomy to represent this identity, rather than themselves. One consequence is that the same person can fill different taxonomic categories; the Dada artist provocateur Raoul Hausmann, for example, appears in a number of different guises in different sections.[10] Sander reduces even himself to a type, "The Photographer", methodically making pictures that eschew artistic personality or style, aiming, as he put it, "to see things as they are and not as they should or might be."[11] As in Simon's presentation, each individual in Sander's archive only takes on meaning in relation to the entire taxonomy, thus calling any distinction between the individual and their social milieu into question. Simultaneously, the taxonomy itself is made visible as "something artificial, posed", as something ideological.

Simon's project reiterates several aspects of Sander's, offering us, perhaps, one possible version of a *Citizens of the Twenty-First Century*. If anything, she takes the logic of his project to a hyperbolic extreme, making her images more numerous and seemingly mechanical than his and inscribing the conceptual architecture of ethnography (the national types, the comparative grid of images, the disinterested informational caption) directly onto the wall, where we can see it for what it is. Even the space of exhibition has been turned into a kind of laboratory, with the walls repainted Super White rather than their usual cream, and the lighting turned up, at the artist's insistence, to seven times its normal level. But whereas Sander devotes his energies to a depiction of his own society, and thus of himself as a social being, Simon's gaze encompasses the whole globe and seems, at first glance, to look only at the lives of others. And where his choices

of subjects and their arrangement were decided on the basis of presumed social hierarchies, hers have been stratified by such categories as blood, ethnicity and nation. This difference deserves some reflection. Indeed, it seems to mark a significant departure for Simon, whose previous bodies of work have always concentrated on the social systems of her own culture, of the United States.

Her first book, *The Innocents* (2002), comprised interviews with and photographs of Americans convicted of violent crimes they did not commit.[12] A powerful condemnation of the American justice system, this project was also a critical commentary on the power of the photograph to distort memories and facilitate mistaken identifications. Many of these men had been convicted after eyewitnesses, having been shown portraits of suspects by the police, thought they recognized them. Simon photographed her subjects at sites that had particular significance to their illegitimate conviction: the scene of a misidentification, the scene of an arrest, the scene of a crime or the scene of an ignored alibi. These are pictures, then, that return us and them to the starting points of a brutal reality based on a fiction. Simon's own photographs share this ability to blur truth and fiction. They sometimes show her subjects posing self-consciously at the scene of the crime they didn't commit, as if to demonstrate their ability to trump the fiction of the police charge with the non-fiction of Simon's photograph. Once again, we encounter role play substituting for reality.

This uneasy play of fiction and non-fiction is repeated in a more recent project, *An American Index of the Hidden and Unfamiliar* (2007).[13] Once again a telling symbiosis of image and text, this work compiles an inventory of what lies hidden and out of view within the borders of the United States. Connecting the realms of science, government, medicine, entertainment, nature, security and religion, the 57 subjects Simon photographed ranged from the C.I.A.'s abstract art collection to a woman about to undergo a hymenoplasty operation in Fort Lauderdale, Florida, so that she could adhere to traditional cultural expectations regarding virginity and marriage. Simon's project exploits the several meanings of the word "index", from its association with a comprehensive cataloguing of a particular subject, to what is often considered photography's own most distinctive pictorial attribute, the fact that, through the chemical agency of photography, the world gets to make its own visual imprints. The exposure of these particular subjects came at a time when the United States government looked for secret sites outside its own borders (caches of unfound weapons, hideouts of wanted enemies, foreign jails that would allow torture, unsupervised nuclear facilities). Simon turned this national paranoia inwards, producing a collective portrait of the American psyche through a documentation of its repressed places.

Repression shifts to exclusion in *Contraband* (2010), a book and exhibition consisting of 1,075 photographs Simon took continuously over five days from November 16 through November 20, 2009, in the Customs and Postal areas of John F. Kennedy International Airport in New York.[14] These photographs, presented like forensic evidence with neither aesthetic embellishment nor editorial comment, documented the items detained or seized from passengers or express mail entering the United States from abroad during that period. These items included animal parts, fake handbags, recreational drugs and drug paraphernalia, pirated movies, Cuban cigars, firearms, gold dust, plants, sausages, cow dung toothpaste, and sexual stimulants. This miscellany of prohibited objects—from the everyday

to the illegal to the unexpected—attests to a growing worldwide traffic in counterfeit goods and natural exotica. More importantly, and in line with the aspirations of *An American Index*, the project offered a sidelong snapshot of the United States as seen through its fears and desires.

There is an echo of some of these strategies in *A Living Man Declared Dead*'s combination of a prescribed conceptual structure with a photographic style and mode of presentation that gives Simon's images the authority of documents. Each photograph is exhibited in a specially designed frame that allows them to fit together like a minimalist jigsaw puzzle. The panels they create are as large as any of the current crop of celebrated art photographs, and yet each of the individual images remains small and intimate. The texts are treated in similar fashion, having been given the visual form of a list and turned into a slim, tall art object to be looked at as well as read. The regulated tables of portraits are punctuated with empty cells, creating a pattern of absence and presence that, from a distance, might be mistaken for a sample of scientific code. The order of this layout contrasts with the random and disorienting arrangement of images in the supplementary panels, again suggesting two very different discursive modes and offering two very different visual experiences.

The stories being conveyed by this armature obey this same oscillation between order and disorder. Indeed, every aspect of *A Living Man Declared Dead* is fraught with a tension that Simon's installation can only temporarily hold in suspension. Think, for example, of how the predictable rhythms of the portrait panels deny the tales of violence, corruption, survival and duplicity that these bloodlines often embody. At first, Simon's choice of subjects and topics seems serendipitous, ranging widely in place and date and seemingly having no connection with one another. The stories are often extreme, fantastic, hard to believe. But they're also somehow familiar, as if their narrative structures have been plucked from the myths of the ancient Greeks or a lost Shakespearean play, or perhaps from a contemporary parallel, a melodramatic soap opera or newscast. This notion is underlined by Simon's choice of title and by the use of numbered chapters as section headings, suggesting a gigantic book that has fallen open to these random pages, or a vast catalogue of which only these fragments have survived. Soon we begin to see a pattern in Simon's choices; in fact, we begin to see pattern itself, a persistent logic of repetition and return, as evident in the stories as in the infrastructure she has used to convey them.

Under *Chapter XII*, for example, we are told about a blood feud between the Novaes and Ferraz families in Pernambuco, Brazil, that has claimed the lives of more than 40 people since 1991. This particular feud is one of a number from this part of northeast Brazil that has engulfed generations of participants, pointing to an absence or corruption of state justice in the region. Simon accompanies the usual array of stoic portraits with a group of images that elucidate this story, some of them reproductions of historic pictures, some of them showing the scenes of shootings, some of them enigmatic still lifes. One of them even shows a marked man—the next in line to be killed, according to the internal logic of the feud. The portraits imply the certainty of a science, a genetically determined tabulation of a particular bloodline. These other images offer the subjective, partial, untrustworthy view of an oral history, or perhaps mimic the partial, sensationalized version of such stories we tend to get in the mass media. Neither approach seems capable of explaining how these subjects came to live such lives, but

together they at least give us a parallax view, as if we are simultaneously looking at the situation along two different lines of sight.

This kind of juxtaposition is repeated in the section titled *Chapter X*. This chapter's story centers on the display of over 1,100 Filipinos at the 1904 St. Louis World's Fair, where they were required to eat dogs on a regular basis for the entertainment of passersby. This spectacle of the primitive was staged in part to justify the violent annexation of the islands of the Philippines by the United States in 1902, the advent of an era of American preeminence now, one might argue, finally drawing to its close. Having photographed all the living descendants of Cabrera Antero, one of the men placed on display, Simon again adds a group of related images, as if to underline the force of her tale with further evidence. A photograph of a skull taken from a slain enemy by a headhunting Filipino, the ground plan for the Fair's Ethnological Exhibits, a group of photographs of people put on display as part of those exhibits, a view of Cabrera Antero's home village, and finally a group portrait of Antero and his companions as exhibited at another World's Fair, this time in Seattle in 1909: the selection suggests the careful accumulation and preservation of information, such as one expects from an archive. But this archive remains enigmatic, piecemeal, elusive, detached from the living history represented by Antero's descendants.

What becomes clear, as one moves from panel to panel, is that these tales have been very carefully selected, with each group of portraits being representative of a particular social situation, or a particular historical scenario or political crisis. It turns out, in fact, that the second of Sander's titles—*A Cultural History in Photographs*—is as pertinent to Simon's project as the first. But whereas Sander sought to document the German people in all their diversity, Simon sets out to record the peculiar ways in which history comes to repeat itself, like a record on skip. The temporal experience offered by *A Living Man Declared Dead* is in this sense a peculiarly photographic one. A photograph we see in the present is always of the past, making the passing of time between past and present this medium's constant subliminal message. We witness time's passing while looking at any particular photograph and can't help but shudder at an imaginary future where we too will have passed on. In this context it is worth noting that a number of the people depicted in *A Living Man Declared Dead* have died since they were photographed, making these panels a freeze frame of a moment in each bloodline that has already come and gone.

If *A Living Man Declared Dead* shows that the present is continually haunted by the past, it also reveals the degree to which the nation state has become a porous, perhaps even illusory entity. The 158 individuals represented in *Chapter X*, for example, reside not only in the Philippines but also in the United States, Canada, Vietnam, the United Kingdom, Saudi Arabia, Guam, Australia and Kuwait. A tracing of this one bloodline, therefore, also tells a story about global immigration patterns and economic opportunity (or the lack of it), with these expatriates joining the eleven million other Filipinos who currently work outside their home country.

It is striking how often Simon finds herself tracking down a portrait subject in a place far removed from the story he or she embodies. Latif Yahia, for example, now lives in Ireland, after surviving a period spent in Iraq as a body double for Saddam Hussein's son Uday. His portrait is joined by three supplementary images of him posing in character as Uday, another one of these bizarre role-playing episodes that punctuate the solemnity of

Simon's work. The rabbits photographed in Australia exemplify this flow of bodies in reverse, with these animals introduced by English settlers in 1859 for sporting purposes and now regarded as a threat to both native ecology and prosperous farming. Ironically, these animals represent another survival story, having quickly developed various levels of resistance to every disease they have so far been exposed to. Other portrait series touch on Cold War conflicts (the abduction of South Korean citizens by North Korea), terrorism (Leila Khaled, who hijacked her first airplane on behalf of the Popular Front for the Liberation of Palestine in 1969), genocide (explicitly in the killing of approximately 8,000 Muslims in Bosnia by Bosnian Serb soldiers in 1995 and implicitly in the story of Hans Frank, Hitler's personal legal advisor and the governor-general of Nazi-occupied Poland), pharmaceutical disasters (the effects of thalidomide on children born under its influence), and Zionism (in the person of Arthur Ruppin, a key figure in the establishment of the Israeli state).

This otherwise overwhelming cavalcade of history is given an illusory order and coherence by the imposed discipline of Simon's photography and her mode of presentation. The photography too is a repetition of a sort. Debates about the artistic potential of photography in the nineteenth century often contrasted a desirable picturesqueness with a frontal and therefore unthinkingly mechanical symmetry; in short, a creatively subjective picture was preferred over a mere document.[15] However, in more recent years this binary has been reversed, with artists as diverse in ambition as Bernd and Hilla Becher, Ed Ruscha, Hans Haacke, Martha Rosler, Rineke Dijkstra and Waalid Raad deliberately eschewing pictorial variation in their photography in favor of rigorous serial form and deadpan images.[16] Simon joins them in this preference, consistently placing her camera lens parallel to her subject and offering us flat, frontal pictures with no particular aesthetic elaboration; as a consequence, she transforms her portraiture into a form of still life. The systematic reiterations and semiotic concerns of Conceptual art are thereby married to the documentary photographic style pioneered by Walker Evans in the 1930s.

The end result is a photography that proffers transparency, a utopian promise of liberal democracy, but then renders that transparency opaque, even reflective. This makes both documentary photography and the American liberalism it manifests two more of the subjects of Simon's work. We are asked to see them as things, as historical objects within a taxonomy of other such objects. We look for the truth of that taxonomy within her photographs but are continually turned back on ourselves by Simon's dogged refusal to provide either cause or meaning. Among other effects, this kind of refusal shifts the burden of assigning that meaning from the artist to a viewer, making us all complicit in the act of signification, and indeed in the histories we are asked to witness. Individuals are never autonomous in these histories, appearing always in terms of their imbricated relations with others. Otherness itself is given a diminished status within a world conflated by the internet and a global economy but also by an increasingly shared heritage, genetic and otherwise. *A Living Man Declared Dead* may seem to be about others, but is equally about us.

Although refusing to give us what we want—to tell us what it all means, to explain the vicissitudes of fate—Simon nevertheless succeeds in making visible what is otherwise not able to be seen: the lived traces of history, power and desire. The real substance of Simon's work is therefore to be

found, not in any of these particular pictures or texts, but in the spacing that simultaneously separates and joins them, first to each other, and then to the larger political economy of which they, and we, are all a part. It was Susan Sontag who called photography "a grammar and, even more importantly, an ethics of seeing."[17] Taryn Simon's work pursues both these aspects of photography with equal rigor. Indeed, in so many respects her work exemplifies the ambivalent character of much of today's more interesting photographic art. She is, at one and the same time, overtly skeptical about the medium's capacity for revealing truth, while nevertheless totally dedicating herself to this same possibility.

The ramifications of *A Living Man Declared Dead and Other Chapters* reverberate far beyond the confines of the art world. Its complex, sometimes even contradictory dissemination of form and content recalls the equally troubling historical discourse that Michel Foucault once called *genealogy*: "gray, meticulous, and patiently documentary", recording "the singularity of events outside of any monotonous finality", "a profusion of entangled events", demanding "relentless erudition", seeking "not the anticipatory power of meaning, but the hazardous play of dominations".[18] Like Foucault's work, *A Living Man Declared Dead* offers us an experience "situated within the articulation of the body and history".[19] Simon's assembled subjects, inscribed here between word and image, are the embodied manifestation of this articulation. They have been made to appear before us as flesh and blood but also as "the signs of an historical writing", displacing any hard and fast distinction between the two.[20] This displacement may well be Taryn Simon's greatest achievement, challenging us all to consider what is preordained in our own lives and what is still to be determined.

Notes
1. See the exhibition's catalogue: Edward Steichen, *The Family of Man* (New York: Museum of Modern Art and Simon and Schuster, 1955). For detailed descriptions of, and commentaries on, the exhibition, see also Eric Sandeen, *Picturing an Exhibition: The Family of Man and 1950s America* (Albuquerque: University of New Mexico Press, 1995); John Szarkowski, "The Family of Man", in *The Museum of Modern Art at Mid-Century: At Home and Abroad* (New York: Museum of Modern Art, 1994), 12–37; and Eric Sandeen, "'The Show You See With Your Heart': The Family of Man on Tour in the Cold War World" (2004), in Jorge Ribalta (ed.), *Public Photographic Spaces: Exhibitions of Propaganda, from Pressa to The Family of Man 1928–55* (Barcelona: Museu d'Art Contemporani Barcelona, 2008), 471–486.
2. Edward Steichen, "Introduction", *The Family of Man*, 4. See also Edward Steichen, "Photography at the Museum of Modern Art" (1952) and "Photography: Witness and Recorder" (1958), from Peninah R. Petruck (ed.), *The Camera Viewed: Writings on Twentieth-Century Photography* (New York: E.P. Dutton, 1979), 1–10.
3. See, for example, Allan Sekula, "The Traffic in Photographs" (1981), *Photography Against the Grain: Essays and Photo Works 1973–1983* (Nova Scotia: Press of the Nova Scotia College of Art and Design, 1984), 77–101: "The Family of Man universalizes the bourgeois nuclear family, suggesting a globalised, utopian family album, a family romance imposed on every corner of the earth."
4. Simon's engagement with the form and functions of the archive makes her work very much of its moment and links it to a particular artistic genealogy. See, for example, Charles Merewether, *The Archive* (Documents of Contemporary Art) (Cambridge, MA: The MIT Press, 2006), and Sven Spieker, *The Big Archive: Art from Bureaucracy* (Cambridge, MA: The MIT Press, 2008).
5. See Karl Marx, The Eighteenth Brumaire of Louis Bonaparte (1852), as reproduced in Robert C. Tucker (ed.), *The Marx–Engels Reader* (New York: W.W. Norton & Co., 1978), 595. "Men make their own history, but they do not make it as they please; they do not make it under self-selected circumstances, but under circumstances existing already, given and transmitted from the past. The tradition of all dead generations weighs like a nightmare on the brains of the living."
6. Roland Barthes, "The Great Family of Man" (c.1955), *Mythologies*, trans Annette Lavers (New York: Hill and Wang, 1972), 101.
7. Walter Benjamin, "Little History of Photography" (1931) in Walter Benjamin, *The Work of Art in the Age of its Technological Reproducibility and other writings on media*, edited by Michael W. Jennings, Brigid Doherty and Thomas Y. Levin (Cambridge, MA: Harvard University Press, 2008), 293.
8. August Sander (1951), as quoted in Graham Clarke, "Public Faces, Private Lives: August Sander

and the Social Typology of the Portrait Photograph", in Graham Clarke (ed.), *The Portrait in Photography* (London: Reaktion Books, 1992), 72.

9. Benjamin, "Little History of Photography", 287.

10. "Armed with a letter of recommendation from Franz Wilhelm Seiwert—one of the chief initiators of the progressive artists circle who had been a friend of the photographer since the early 1920s—Sander approached the Dadaist painter Raoul Hausmann in Berlin and took several portraits of him. He assigned these photographs to various portfolios of his work *People of the 20th Century*. Hausmann is included in Group VI, 'The City', in the pose of a dancer, whereas, in Group III, in the 'Woman and Man' portfolio, he is pictured with his wife and girlfriend (Hedwig Mankiewitz and Vera Broido). A third photograph, which August Sander assigned to Portfolio 12, 'The Technician and Inventor', portrays him as 'Inventor and Dadaist'. This portrait differs from the others in that they predominantly embody the classic type of the engineer or related occupations." See Susanne Lange and Gabriele Conrath-Scholl, *August Sander's People of the 20th Century: II The Skilled Tradesman* (New York: Harry N Abrams, Inc., 2002), 16–18. Thanks go to Cory Rice and Gabi Conrath-Scholl for their assistance with this commentary on Sander.

11. August Sander (1927), as reproduced in Christopher Phillips (ed.), *Photography in the Modern Era: European Documents and Critical Writings, 1913–1940* (New York: Metropolitan Museum of Art, 1989), 107.

12. Taryn Simon, *The Innocents* (New York: Umbrage Editions, 2003).

13. Taryn Simon, *An American Index of the Hidden and Unfamiliar* (Göttingen: Steidl, 2007).

14. Taryn Simon, *Contraband* (Göttingen: Steidl, 2010).

15. See Steve Edwards, *The Making of English Photography: Allegories* (University Park, Pennsylvania: The Pennsylvania State University Press, 2006), 241–244.

16. According to Charlotte Cotton's book *The Photograph as Contemporary Art* (London: Thames & Hudson, 2004), "the deadpan aesthetic became popular [in art photography] in the 1990s, especially with landscape and architectural subjects." Cotton describes it as "the most prominent, and probably most frequently used, style ... a cool, detached and keenly sharp type of photography." For more examples, see her chapter titled "Deadpan", 81–112.

17. Susan Sontag, "In Plato's Cave", *On Photography* (New York: Farrar, Straus and Giroux, 1973), 3.

18. Michel Foucault, "Nietzsche, Genealogy, History" (1971) *Language Counter-Memory, Practice,* edited by Donald F. Bouchard (Ithaca: Cornell University Press, 1977), 139–140.

19. Ibid., 148.

20. Barthes, "The Great Family of Man", 101.

Originally published in Taryn Simon, *A Living Man Declared Dead and Other Chapters I – XVIII*. Exh. cat., Tate Modern/Neue Nationalgalerie. Berlin/London: Nationalgalerie Staatliche Museen/MACK, 2011

Taryn Simon in China

Philip Tinari

In 2013, the Ullens Center for Contemporary Art in Beijing mounted an exhibition of Taryn Simon's *A Living Man Declared Dead and Other Chapters I – XVIII.* I first encountered this body of work at Tate Modern in 2011, one of the many major international venues at which it appeared. At first glance, its combination of investigative and methodological rigor with subject matter that unearthed histories on every continent made me think it was urgent to show this work in China. I was most interested in how, structurally, the string of chapters is able to create an entire discursive system; it seemed that that would allow the work to be seen, read, and interpreted in a radically different context. The biggest issue, in that early assessment, was how we would go about translating into Chinese the texts that form an integral part of this work. In reality, we were embarking on a much larger and more fraught process of modulating an existing body of work to fit a very particular set of social and political circumstances.

Dealing with the government is as much a part of running a museum in China as preparing sponsorship proposals or signing loan agreements. Any art that is legally imported into the country for public display must be submitted to the Ministry of Culture or its local subsidiaries for approval. Without the permits they issue, works simply cannot clear customs. (There is a parallel process with China Customs for the actual importation of work; this focuses more on guaranteeing that the work in question will not be sold or remain permanently in China without having paid the necessary duties. Even for temporary imports, a deposit or guarantee in the amount of the tax putatively owed on the work's sale must be put down.) Heeding the censors is not a matter of acquiescence or compromise, it is simply a precondition of working in the People's Republic. As a foreign-backed not-for-profit institution with an annual viewership of more than half a million visitors, UCCA enjoys something of a special status in relation to the Beijing cultural authorities—both watched more keenly than commercial galleries, yet often free to show work that would never find its way into more orthodox government-run museums.

In advance of any exhibition we do with work coming from abroad, we prepare detailed dossiers for the Ministry of Culture (or the Beijing municipal Cultural Bureau, depending on the overall number of works in the exhibition) with images, caption information, and translations into Chinese of any text which appears as part of a work. The officials then comb through these applications and issue verdicts in the form of *piwen*, or exhibition permits, which effectively cannot be appealed. The decisions which come down are fascinating for what they reveal about the sensitivities of the Chinese state at any given time. In advance of a 2012 exhibition of photographs from *The New Yorker*, a 2008 Platon image of Elsheba Khan at the grave of her son Kareem Rashad Sultan Khan, an American soldier killed in Operation Iraqi Freedom and buried in Arlington National Cemetery, was denied. One doubts the censors understood the distinctly American complexities of the underlying situation—they instead saw a woman embracing a tombstone bearing a crescent moon and thought of suicide bombers or the Arab Spring. A Platon portrait of the late Gaddafi was similarly withheld. In an exhibition of Indian contemporary art later that year, an oversized Bharti Kher sculpture of an anatomical heart covered in bindis was denied, on the grounds that it looked like a giant penis. No amount of additional images of the heart from different angles could convince the Ministry to overturn that decision.

In the case of Simon's *A Living Man Declared Dead*, the calculations were even more subtle and interesting, particularly because the chapter touching on China was realized with the support of (or rather under the orchestration of) the State Council Information Office, the highest-ranking government news/propaganda office in the land. In the footnote panel for that chapter, Simon included just two images: one of the paper bag distributed at all SCIO press conferences and bearing an image of the winged stone columns in front of the Tiananmen rostrum that symbolize imperial authority, the other of the utterly unremarkable Beijing Television Tower (not Rem Koolhaas's CCTV Tower, but an unloved Alexanderplatz-like antenna on the far west side of town), which was where they pointed her when she asked deadpan for a site that could "represent Beijing." The former image was censored. It must have proven sensitive to the Ministry of Culture, which despite being part of the central government, still ranks well below the SCIO in proximity to the highest leaders. Owing to the physical nature of the work, having one image in a multi-image panel censored means that the entire panel must be excluded, as single photograph cannot be removed or blacked out. The other censored images were a corpse from the titular chapter about an Indian land dispute, and the entirety of another chapter about a South Korean seaman abducted by North Korea in 1977. That latter instance was the most explicit and complete, the only chapter to be denied in full.

In addition to the panels eliminated by outright censorship, we made a tactical decision when preparing the application to the Ministry of Culture not to apply for import of the text panels as artwork. Would we have done this, I strongly believe that many more of the images from throughout the cycle would have become controversial in the eyes of the officials—take for example the images of human remains that serve as portraits of individuals killed in the Srebrenica massacre, which came through the censorship process unscathed. When installing the exhibition, in place of all the panels that were not ultimately present in the exhibition, we painted black blocks onto the walls in their exact proportions and positions. The device, which

Simon conceived after long discussions about how to account for the missing panels, does several things at once, referring to abstract painting even as it echoes the moments in the work where individuals who cannot be photographed are represented by blank backgrounds. The effect in the space was chilling, beautiful, and extremely strong.

In order to restore the substantive integrity of the work on view despite these physical and visual lacunae, we produced a special booklet, about the size of a magazine, which reproduced the full text of each chapter in English, accompanied by a Chinese translation. It also included images of all works, even those which were censored. This substantial publication mirrors the design of the massive book Simon published when the series was first completed. It was subsidized by UCCA and distributed to every member of the public who purchased a ticket for RMB 10 (about $1.60). It is an unofficial publication, without a Chinese ISBN number, which means it did not have to go through any censorship process at all. Ironically there were no issues with this arrangement, and it created an intriguing scenario wherein the galleries were filled with viewers, noses are buried in the booklet, reading the texts that would have otherwise appeared on the wall. Such a publication would have been necessary even had the panels been physically present, as a way to contain the Chinese translations.

The exhibition managed to transcend itself, creating a public discussion and generating public accounts in media including the *Financial Times* about how cultural censorship works in China. In the end, what interests me most in this story is not the absoluteness of censorship but rather the way this particular system provides a set of constraints which, like most constraints, can be short-circuited to different effect. Certain panels may not have entered China, but the images and information they contain could not

Installation view. Chapter V, *A Living Man Declared Dead and Other Chapters I – XVIII*
Ullens Center for Contemporary Arts, Beijing, 2013

Many of the works in A Living Man Declared Dead and Other Chapters I – XVIII were refused entry
for exhibition in China, including: the text panels for all 13 chapters on view, Chapter V (South Korea)
in its entirety, Chapter I (India) footnote panel, and Chapter XV (China) footnote panel.

be kept out. We were not so brash as to even mention the blackout blocks or the questionably legal booklet on our website, and some viewers were surely confused by the absences. Many more, however, were able to piece together an understanding of the work every bit as complete as those who encountered it in London, Berlin, New York, or Los Angeles. For our institution, positioned precisely at the brink between a local Chinese context and the international conversation surrounding contemporary art, it is these moments when the limits become palpable, and yet art is still able to function aesthetically, that compel.

Cutaways

At the close of a video interview for Russia Prime Time
in Moscow, Simon was asked to sit in silence and stare
at the news casters for several minutes. She was told
this was standard practice and that the resulting footage
would be used in the editing process.

Simon's *Cutaways* (2012) presents this footage.

Cutaways, 2012

Single Channel Video (3:04 minutes) and Letraset on wall
Dimensions variable

Detail, "'Patterns' [Netherlands], 10/27/2014, 5:29 PM (Eastern Standard Time)," *Image Atlas* (2012)

Image Atlas

Created by Taryn Simon and programmer Aaron Swartz, *Image Atlas* (2012) investigates cultural differences and similarities by indexing top image results for given search terms across local engines throughout the world. Visitors can refine or expand their comparisons from the 57 countries currently available, and sort by Gross Domestic Product (GDP) or alphabetical order.

Image Atlas interrogates the possibility of a universal visual language and questions the supposed innocence and neutrality of the algorithms upon which search engines rely.

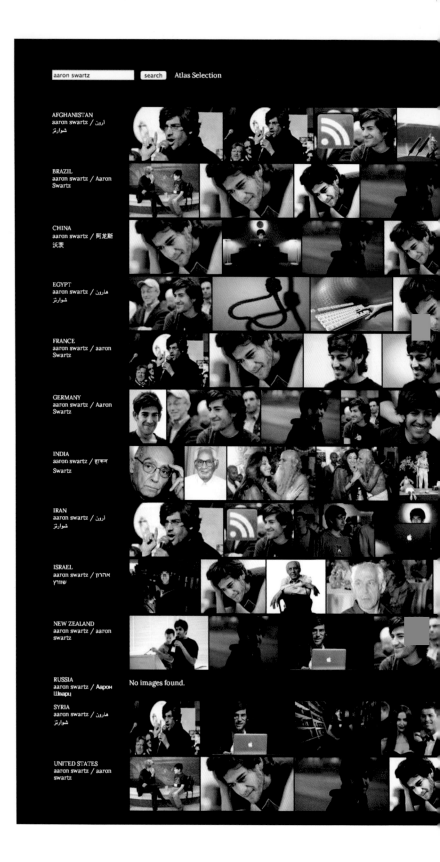

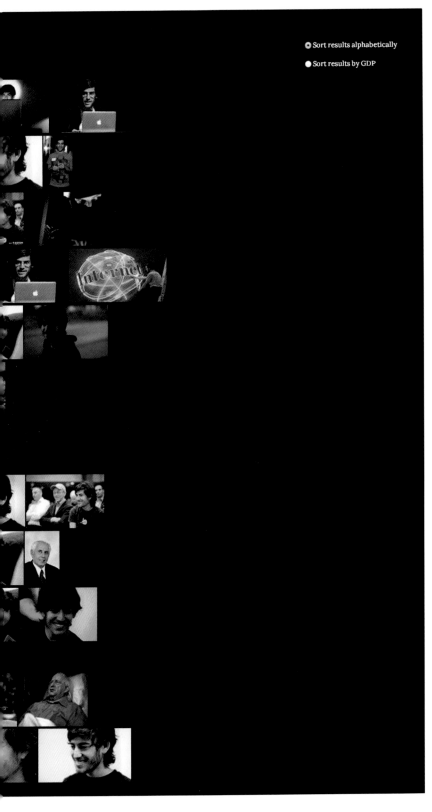

"Aaron Swartz, 2/26/13, 3:29 PM (Eastern Standard Time)", *Image Atlas*, 2012
Website view, dimensions variable

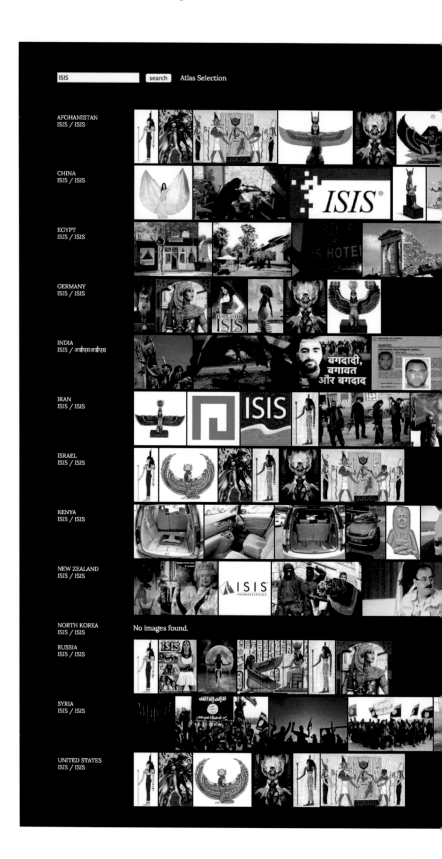

"ISIS, 8/1/14, 6:08 PM (Eastern Standard Time)", *Image Atlas*, 2012
Website view, dimensions variable

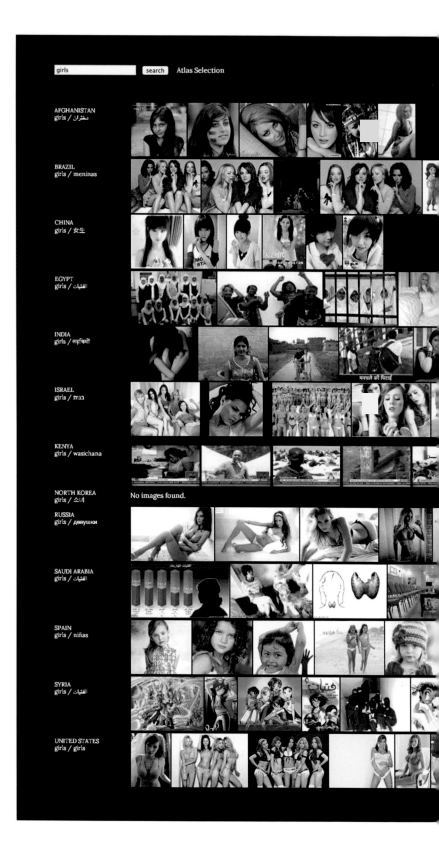

"Girls, 9/30/14, 4:45 PM (Eastern Standard Time)", *Image Atlas*, 2012
Website view, dimensions variable

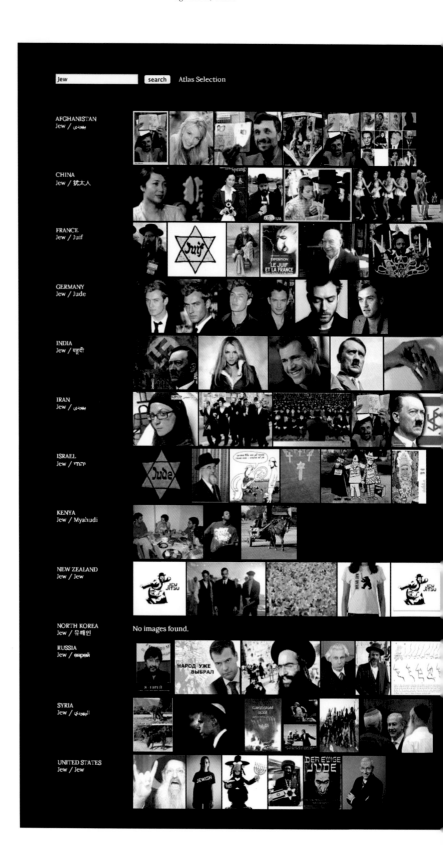

Sort results alphabetically

Sort results by GDP

"Jew, 8/20/2012, 4:45 PM (Eastern Standard Time)", *Image Atlas*, 2012
Website view, dimensions variable

Image Atlas, 2012

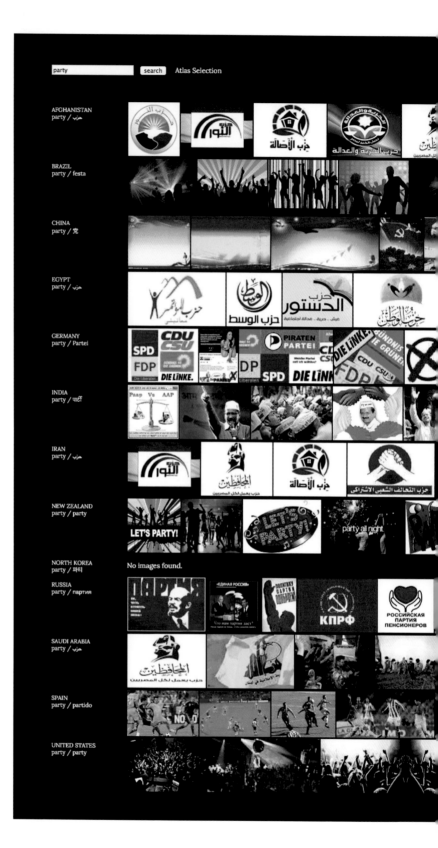

266

Sort results alphabetically

Sort results by GDP

"Party, 1/4/2013, 11:21 AM (Eastern Standard Time)", *Image Atlas*, 2012
Website view, dimensions variable

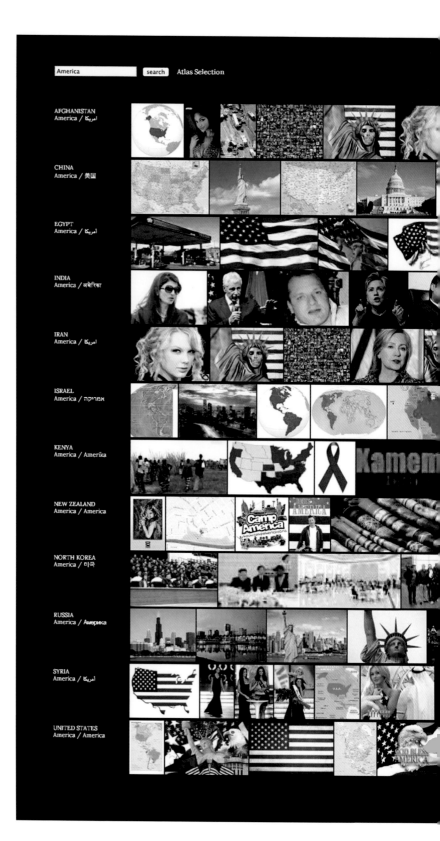

Sort results alphabetically

Sort results by GDP

"America, 6/21/2013, 8:18 PM (Eastern Standard Time)", *Image Atlas*, 2012
Website view, dimensions variable

Aaron Swartz & Taryn Simon in conversation

New Museum of Contemporary Art,
Rhizome Seven on Seven Conference, April 14, 2012

TARYN SIMON: Aaron and I have been working together for the last twelve hours. I never imagined this pressure; my work usually takes years to complete so it's a little bit gut wrenching to go public with something after a 12-hour run.

In the end we decided to stick with simplicity. When we initially met in our room and were bouncing ideas back and forth, we were aiming to create a spectacle – an experience – something that wasn't related to an app or a consumer item. We spent a lot of time generating a project over the course of the day and acquired data and background information about every single individual in the audience. In the end, we learned our idea was not possible for legal reasons. (Laughs).

So, I guess this is an important aspect of art and technology colliding, because there are all of these possibilities that we could achieve but there are boundaries. These boundaries are becoming more and more clear and defined. That failure occupied a big chunk of our day. Then, after having spent so much time thinking about creating an experience within this space and contemplating the diversity of that experience, we started thinking about the diversity of experience across other spaces, which led us to a discussion on cross-cultural communication.

AARON SWARTZ: I should say as the nominal technologist that one of the interesting transitions for me was coming to this with the perspective of making something that is not purely an app or a program, as Taryn said, but provocative, something that is not only useful but raises deeper questions, and I think that is one of the interesting mergers we realized.

TS: But we couldn't do it. So here we were, end of the day last night; we took several walks, there were several moments of complete despair.

AS: It did not get videotaped, just to be clear. (Laughs). Do not try to search for the reality show.

TS: And then at around 8pm last night we arrived at what we will be presenting today. I have some notes here that we wrote at one in the

morning so forgive me if I look at my computer from time to time. The project that we developed is investigating cultural differences and similarities through indexing visual material from different nations. This visual material is established through mediated filters. It's about how supposedly neutral and statistical analyses construct visions of ourselves.

AS: One of the things that people are paying more attention to, is the way that these sort of neutral tools, like Facebook and Google and so on, claim to present an almost unmediated view of the world all through statistics and algorithms and analyses, but in fact these are programmed and programming us. We wanted to find a way to visualize that, to expose some of the value judgments that get made.

TS: With all the claims of a homogenizing culture due to global economies and global financial systems and cultural systems imposing this exercise, we are forcing the user to search for difference or disconnects and making the viewer acknowledge the residual force as a cultural phenomenon. The project statistically looks at images associated with words – it can be descriptions, expressions, feelings – and it examines the differences and repetitions in popularly distributed visual material associated with these terms. The implications of technological advancements, economics, aesthetics, religion, governance, power, customs and other influences on cultural difference can be imagined through the comparison of images in local searches. Basically, at the end of it all, we tried to give the hidden space between cultures a visual route in a simple and easy-to-use form, and to highlight the complexities surrounding the possibility of a visual language.

AS: So, in more technical terms, what we tried to do was to use the image searching tool of various local search engines to try to pick up what those search engines say are sort of the top, the most definitive images for a topic. And then we wanted to juxtapose those next to each other so you could see, you know, ok if this is the image in one country, what is it in another country and another and another. And of course to do that we also had to translate the query, so we composed, in the same way we were composing images, we composed these search tools to translate your query from one language to another and another so you see the word in that language, in that country and translated into a series of images.

Aaron Swartz and Taryn Simon, Rhizome Seven on Seven Conference,
New Museum of Contemporary Art, April 14, 2012

TS: Yeah, so should we ... We are just going to show it to you now. It's roughly built; it will eventually include all nations. For now we are giving you an abridged look for this experience. So let's try "painting." (Scrolls through images) And, "freedom."

AS: I like the distinction between freedom in Brazil and Syria. (Laughs) And in Kenya, if you notice, apparently it means lots of meetings.

TS: "Crazy." In Russia it's a headless man looking at rows of heads to choose from.

AS: In France, "crazy" apparently means Homer Simpson.

TS: "Sadness." "Beauty." Too fast? Sorry.

AS: I think that one of the interesting distinctions is between human beauty and natural beauty.

TS: "Death."

TS: "America."

AS: The distinction between the US and Iranian views of America is striking.

TS: "Celebrity." In Syria it's the Mona Lisa and Marilyn Monroe and Arthur Miller. And in the US it's Paris Hilton.

"Jew." The word in German is "jude" so Jude Law's image surprisingly trumps any searches for Jew.

"Party." "Masculinity." Should we do me? Aaron did this yesterday and discovered for some reason in Israel I'm a hotdog.

AS: To be fair, they love you everywhere else.

TS: Should I keep going? Or does the audience want to yell out any? "Sex." Oh, this is interesting, "Obama." You will notice in North Korea, there is no image.

AS: Also, in Spain, Obama smokes.

TS: "Management." Syria is kind of interesting.

AS: In Syria, management comes from the barrel of a gun.

TS: "Luck." "Hairstyle." "Luxury." That's a good one.

AS: This is "corruption."

TS: So we'll just do a few more. "Riot." "Terrorist."

AS: So PETA is a leading terrorist in the United States.

TS: In Brazil it is a baby with a grenade.

AS: The baby has a bomb. Let's be clear.

TS: "Woman." "Family." Ok we can stop there.

AS: You are all welcome to continue playing along at home. Thank you.

The Picture Collection

On the third floor of the Mid-Manhattan Library on 5th Avenue at 40th Street are housed 1.29 million prints, postcards, posters, and images carefully clipped from books and magazines. Organized by a complex cataloguing system of over 12,000 subject headings, it is the largest circulating picture library in the world.

Since its inception in 1915, the Picture Collection has been an important resource for writers, historians, artists, filmmakers, designers, and advertising agencies. Diego Rivera, who made use of it for his Rockefeller Center mural, "Man at the Crossroads" (1934), noted that the scope of this image archive might go on to shape contemporary visions of America—suggesting that today's "accidents" might be the basis for tomorrow's collective understanding. Andy Warhol was also a frequent user of the collection, with a particular interest in advertising images—many of which were never returned.

The Picture Collection's content and categories follow a crude algorithm, reactive to the happenstance of image donations over time, the interests of librarians, and the specific requests of library users. The collection serves as a space where images that are historically inscribed and validated exist beside those that are not. This flattening of hierarchies positions generic advertising pictures next to photographs by Weegee or Steichen, and a Rauschenberg or Malevich reproduction next to a travel postcard or an anonymous artist's work.

Romana Javitz, head of the collection from 1929 to 1968, recruited 40 artists through the Works Progress Administration during the 1930s to help clip, cull, and catalogue the collection. In the 1940s, Roy Stryker of the Farm Security Administration donated nearly 40,000 photographic prints to the collection, concerned for the images' safety in the face of a Congress that might disapprove of their content. Only during the mid-1990s were these pictures, including works by Walker Evans and Dorothea Lange, removed from the Picture Collection's public folders and placed under the protection of the Division of Arts, Prints and Photographs, in direct response to rising market prices for the artists.

In *The Picture Collection* (2013), Taryn Simon highlights the impulse to archive and organize visual information, and points to the invisible hands behind seemingly neutral systems of image gathering. Simon sees this extensive archive of images as a precursor to Internet search engines. Such an unlikely futurity in the past is at the core of the Picture Collection. The digital is foreshadowed in the analog, at the same time that history—its classifications, its contents—seems the stuff of projection.

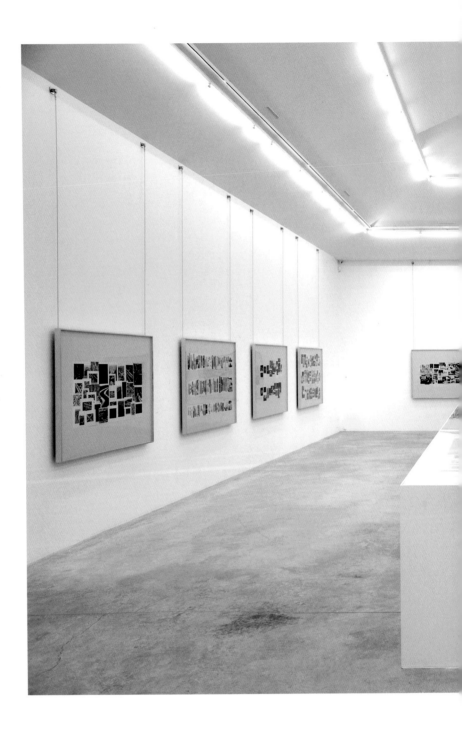

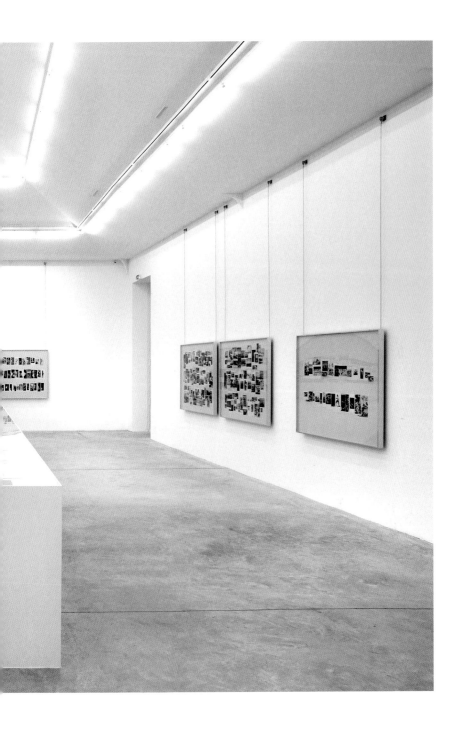

Installation view. *The Picture Collection*
Almine Rech Gallery, Paris, 2013

Folder: Abandoned Buildings & Towns

Each: framed archival inkjet print and Letraset on wall
47 x 62 inches (119.38 x 157.48 cm)

Folder: Cats

Folder: Costume — Veil

Folder: Express Highways

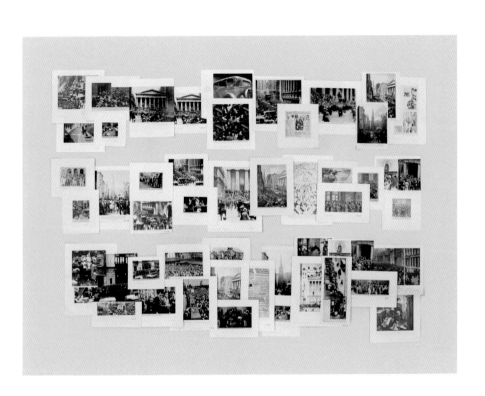

Folder: Financial Panics

Folder: Paper — Endpapers

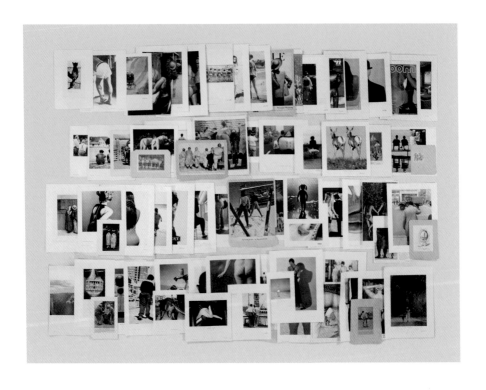

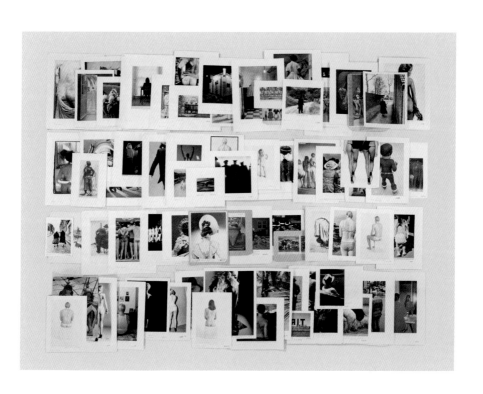

Folder: Rear Views (2 of 3)

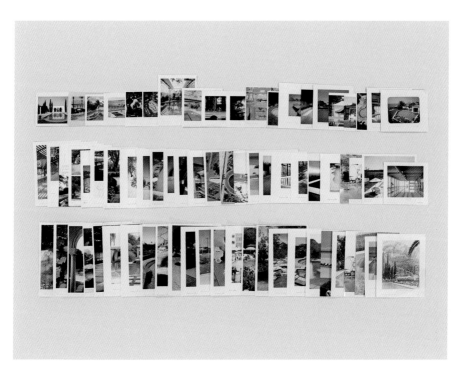

Folder: Swimming Pools

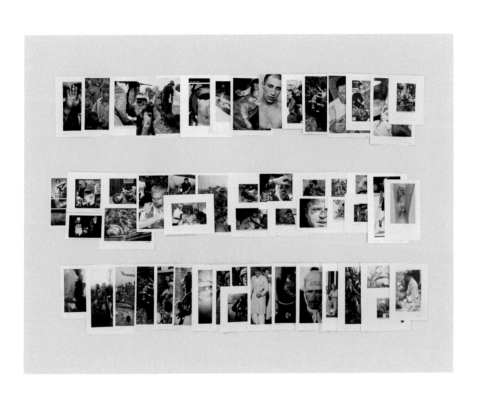

Folder: Wounded

Correspondence and Documents

From the Picture Collection records, the Manuscripts and Archives Division of the New York Public Library, and The Andy Warhol Museum.

Picture Collection folder "Financial Panics."

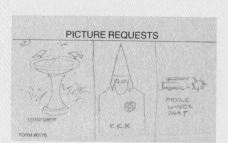

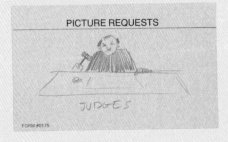

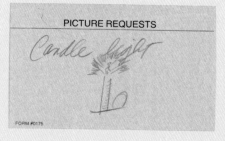

Picture Requests made to the Picture Collection. 1948.

THE P I C T U R E C O L L E C T I O N

THE E N E M Y loomed large as the most popular subject in picture
requests all during the year. Since a soldier is taught to bayonet the
enemy and not some undefined abstraction, he must learn to recognize that
enemy; he must go into battle armed with visual knowledge of the face of
the enemy and the contour of his lands. A bombardier must be able to
visualize the appearance of the factory which is to be his target; a
designer of camouflage must have the specific knowledge of the shape of
forests in the battle area as seen from the air.

Since this war is fought far from our familiar soil, in places and among
and against peoples whose appearance is unknown to us, we need full
training in the recognition of these places and these peoples. Pictorial
records borrowed from this collection helped impart the visual facts and
experience which are necessary equipment for warfare of global extent.

Preceding invasion and bombing, preceding decisions of strategy and
action, war leaders require pictorial surveys. Direct information for the
use of the Army, Navy and Marine Corps was supplied through photographs
of territories along the routes of planned action. Just before the attack
at Pearl Harbor, the travel bureau of an Axis country donated its
photographic collection to this department. In January these photographs
were turned over to the Army Air Corps headquarters for filming and
enlargement: they were "of immense value in the prosecution of the war".

Long before the invasion along the Mediterranean became a reality, our
leaflets, clippings, photographs and post cards were consulted by the
information services of the War Department for pictorial facts about North
Africa - air views of railroad terminals, shapes of the leaves of poisonous

"Annual Report 1942, the Picture Collection."

Letter from Walker Evans, Photographer, to Romana Javitz,
Superintendent of the Picture Collection. 8 Dec. 1947.

PROCESS March 1958

6

	Done	To Do		Directions
10,552		✓	Polish Embassy	G photo file - Poland
10,690	✗	✓	Jackson, W.H. G. Photo file	Mexico
10,720			Hiroshima bombing	G. Photo file Japan x bomb
10,957		✓	PM Photofile - Events - 1930s	
1100.1		✓	LC (Detroit views by Jacksons)	SEE RJ
11,066	✓	✓	Grossman Jan 1958 except	G Photo file Mexico / Washington D C
11,126		✓	Photo file - Aeronautics	Photofile - Aeronautics
			8th Air force 2 folders	
11,152	✗	✓	Comfort G. Photo file	NYC Bronx

Photographers

Beaton	Loch	Storey
Bourke-White	Mydans	Wolcott
Cutler	Odell	Vachon
Collier	Osborne	Weegee
Delano	Palmer	
Evans	Rothstein	
Henle	Parks	
Jackson	Post see Wolcott	
Jung	Rosskam	
Lange		
Lee	Shahn 2 folders (1 done)	

List of photographers represented in the Picture Collection. Mar. 1958.

Pittsburgh Photographic Library
University of Pittsburgh
Pittsburgh 13, Pennsylvania
March 8, 1951

Miss Romana Javitz
Picture Collection, Room 73
The New York Public Library
Fifth Avenue and 42nd Street
New York 18, New York

Dear Romana:

You have showered me with most interesting material. Thank you so much for the copy of the Picture Post pictorial library information. It was an intelligent report, and I am glad to have this kind of material in my file--not that I'll ever use it, but at least I can read it and realize how complicated picture files can be.

And then the copy of the American Processional. It is an excellent job. I am already well into it, and you're right. Elizabeth did herself a magnificent job of writing. What a shame this exhibit could not have been travelled out over the country for the next couple years, or perhaps the Freedom Train could have incorporated a little material of this sort. It would have made a trip through those cars far less boring. I kick myself that I didn't just pick up and go down and see this exhibit. Many, many thanks for this. Maybe Pittsburgh will decide it should have a localized American Processional out here. Who knows?

I will be in New York again the week of the 27th. This time I am not going to make any specific dates but will call you as soon as I get in town. I called the Mayflower Sunday in Washington, but they said you weren't registered. I had a lousy cold anyway so decided I would do better to stay away from as many people as possible.

A friend of mine called me yesterday from Washington to inform me that Senator Hickenlooper was attacking the old Resettlement pictures again. Too bad that Congressmen haven't anything to do but go back and dig up silly things like this. I suppose if you take some advertising agencies' approach, any publicity is good publicity and we ought to be glad.

Best regards,

Roy E. Stryker

R. Stryker — directed the Farm Security Administration Photographs

Letter from Roy Stryker, Founder of the Farm Security Administration's photography project, to Romana Javitz, Superintendent of the Picture Collection. 8 Mar. 1951.

The New York Public Library

RE: FSA photographs DATE: February 25, 1997

To: Mr. T. Alrutz FROM: Constance Novak
Picture Collection

CN

Attached is a catalog which I received today. I thought you might be interested in seeing the prices which FSA photographs are getting in today's market.

I am also attaching some examples of Picture Collection's FSA photographs (unfortunately examples of neglect and deterioration).

Is there some way we could expedite a transfer to Photography before it's too late to save these valuable items?

Memorandum from Constance Novak, Supervising Librarian of the
Picture Collection, to Thomas Alrutz, Associate Director of Central Library Services
of the New York Public Library, regarding market prices of Farm Security
Administration photographs. 25 Feb. 1997.

Collage (Coca-Cola advertisement) [recto] by Andy Warhol, Artist.
Collection of The Andy Warhol Museum, Pittsburgh. Ca. 1961–1962.
"Advertising – Soft Drinks" picture taken from the Picture Collection.

Collage (Campbell's Soup cans) [verso] by Andy Warhol, Artist.
Collection of The Andy Warhol Museum, Pittsburgh. Ca. 1961–1962.

An Unlikely Futurity:
Taryn Simon and The Picture Collection

Tim Griffin

Surely among the most charming—if also humbling—passages in recent art theory arises at the beginning of Douglas Crimp's *On the Museum's Ruins* (1993), in which the art historian tells the story of his Idaho-based grandmother asking to read one of his recent essays. Satisfying her request only grudgingly, because he has no idea what she could possibly glean from his specialized prose, Crimp presents her with a text on Degas and photography, which concludes with a particularly important discussion of a picture featuring the artist's niece. This image, the scholar writes, neatly encapsulates Degas's modernist reflexivity about his medium by virtue of correspondences found among the picture's lace background, the girl's lace dress, and, significantly, the gaps in her smile—suggesting a pun in French between lace (*dentelle*) and tooth (*dent*) that provides a subtle metaphor for the photographic medium's singular intertwining of positive and negative, presence and absence. Suffice to say, such Derridean wordplay does not capture the attention of Crimp's grandmother, who still makes a crucial observation: the girl is not wearing lace, she notes, but instead eyelet embroidery. And Crimp, grasping that his linguistic construction has come tumbling down through an insight provided by someone experienced in needlepoint, quilting, and braiding, nevertheless comes away with a realization that will pave the way from considerations of modernism to those of postmodernism and, more important, of a postmodernist conception not steeped in totalizing theorizations. As he famously writes, "What any of us sees depends on our individual histories, our differently constructed subjectivities."[1]

What seems of particular importance about Crimp's anecdote today—a historical moment when the field of art is widely understood to be at an impasse—is its appearance as the scholar seeks to revisit photography's radical reevaluation during the late 1970s.[2] At that watershed moment, he observes, the medium occupied a particularly embattled place in the art world. On the one hand, it was finally recognized as being on par with its disciplinary peers, becoming newly subject to principles of connoisseurship

and increasing market values. On the other hand, its unique and continuing access as an artistic medium to the "world outside" necessarily afforded it critical perspective within an increasingly mediated society.[3] Significantly, questions of representation were subsequently brought to bear not only on the modernist myth of the creating artist but also on the universal human subject who would be there to behold any artwork.

Yet if the latter scenario (and the dismantling of conventional notions of artist and viewer) lends greater specificity to Crimp's postulations for postmodernism in *On the Museum's Ruins*, precisely this character of photography—or, more accurately, of the photographic image—as it stands in relation to the world outside suggests that another framing for Crimp's observations might now be necessary. Indeed, looking at the current distribution and circulation of photographic images, as well as at the seemingly novel quality of our present encounters with those images, one is tempted to introduce a literal valence to Crimp's understanding of individual history's role in determining what any person perceives. For that role could now be said to extend not just to what one sees but also to what one encounters at all: In another kind of watershed moment for photography, its images are increasingly found online, where what is made available to different users depends ever more on what they have previously sought. What one chooses to read or see draws similar information to one's screen as sites customize themselves continuously for specific users, effectively reinscribing taste and desire. Or perhaps more accurately, such operations displace, redirect, and reshape those things, as images are encoded, or tagged, in an effort to anticipate desires before they are expressed in so many keystrokes, rising to the fore in order to give them new pictorial form. In such an arena, sometimes one's history seems only to arrive in advance of experience.[4]

It is such a paradox that subtly courses through Taryn Simon's *The Picture Collection*, which puts forward so many arrangements of images drawn from files of an eponymous department of the New York Public Library, featured in this book alongside reproductions of files, librarians' notes and correspondence, and catalogues of visitor requests over the years. As the artist frequently does in her various projects, Simon presents this material in the relatively straightforward manner redolent of the archival impulse prevalent in art shortly after the turn of the millennium—particularly as she is gathering documents whose sheer existence may strain belief, seeming to straddle fact and fiction or, better, to underscore the fictional dimensions of factual information. Time and again, in fact, the artist presents work in organizational systems that seem grounded in scientific methodology but that reveal themselves finally to be nothing other than either arbitrary or products of her own invention.[5]

In this respect, one must note that Simon is unique among her peers for frequently negotiating a kind of interface between different contemporary notions of representation and, more precisely, of what may be seen: Schiller's politicized aesthetics, as extended discursively by Jacques Rancière in his formulation of "the distribution of the sensible," is taken up in tandem with the bureaucratic administration and control of photography that legislatively determines our actual access and recourse to pictures.[6] To wit, consider Simon's *An American Index of the Hidden and Unfamiliar*, a 2007 work arising through her interest in discovering how far a private citizen can go in obtaining access to observe and document areas and objects restricted from view—whether a nuclear waste facility, a contraband room, or the broadcast

studio of Alhurra TV, a United States government-sponsored, Arabic-language television station that is not rendered visible within the popular conscious of American society. The last example is especially significant for showing Simon's ability to give the politics of aesthetics, with its taut weave of fact and fiction, concrete parallels in culture. The Alhurra broadcast is legal only for distribution abroad, such that the artist's image gives sight to blindness at home regarding a program that ostensibly gives sight—with geopolitical consequences—to those who would be blind.[7]

But in *The Picture Collection* such matters of presentation and classification take on a different quality along the axis of history, partly by virtue of the sheer idiosyncrasy of what is on display. Simon's individual images feature numerous pictures of seemingly haphazard origin, with, say, an early-twentieth-century, fine-art photographic plate placed alongside an illustration from a recent fashion periodical, while the actual names of the various picture files seem rather far-fetched in rationale, organized under headings such as *Alley, Snow—Avalanches, Beards & Mustaches,* and *Rear Views.* (Simon takes the contents of files found in the Collection and arranges them for her artworks, never changing the file's title.) Similarly, the artist's photographs situate the viewer on ambiguous ground in relation to these images, as Simon places each of her works in wire-hung frames more associated with the era of photography's inception than with the museum or gallery environment today. In fact, although so many of the images she depicts conjure a sense of the past—featuring the styles and events of generations long deceased—they nonetheless seem oriented toward the future. However many pictures are available to be seen, scores of others are obscured in overlapping piles or arrays, not reframed or contextualized by the artist so much as shown ready to be sifted through and seized on, awaiting their different histories. (Even if it is a history posited by the individual viewer, as in *Folder: Abandoned Buildings,* whose images are almost entirely occluded—and yet so familiar as to make it all too easy for audiences to fill in the blanks.) Their arrangements occasionally even

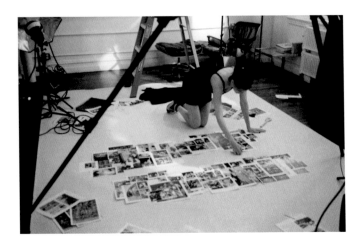

Taryn Simon arranging and photographing the contents of
"Folder: Television Programs", *The Picture Collection,* 2013

bring to mind image carousels one sees online. Precisely such an unlikely futurity in the past seems at the core of *The Picture Collection*. The digital is foreshadowed in the analog, at the same time that history—its classifications, its contents—seems the stuff of projection.

2.

To grasp this anachronism as it plays out in Simon's project, however, one must first grapple with the history of this often-overlooked department of the New York Public Library, the Picture Collection itself, which has a Borgesian, fable-like flavor in its dizzying attempt to create an exhaustive catalogue of the living world—a project that is mystifying in light of the Collection's circuitous path and yet strangely prophetic of image resources and licensing today.[8]

As told by associates of the New York Public Library, the Collection was conceived when, immediately after the opening of the library in 1911, the institution's Print Room found itself overwhelmed by requests for images "strictly from a subject point of view."[9] This development was driven by an exponential expansion of New York's printing industries (both in terms of capacity and, given the day's influx of immigrants, demand) and, equally significant, of publishing's graphic components as printing processes evolved to allow for photographic reproduction and color. Designers and illustrators were thus in need of source material on which to base and design their own work. With such an expansion also came the requirement among other industries—wanting to remain apace with the times—to generate graphic material, such that the library's Print Room was approached by leagues of professionals in not only the realm of publishing but also advertising, movies, theater, architecture, and fashion.[10] Such demands could not possibly be satisfied by the facility's archives, which in any case were organized by artist name, as opposed to subject. And so, in 1914, the library "began saving plates, posters, postcards, and photographs for the new sort of 'reader,'" who was just as literate in pictures as in language—perhaps even more so.

Thousands of donations of material quickly followed as word of mouth spread, and the Picture Collection opened its doors the following year with roughly one and a half million different images in a full spectrum of media, from photographic print to magazine clipping, and an equally diverse range of genres, from fine art to the sciences. This trove would only expand over time: it was estimated by the 1940s that, in addition to donations from benefactors, images clipped from more than sixty publications were being added to the collection each week by library staff. As Romana Javitz, legendary curator of the collection during its crucial period of development between 1929 and 1968, would write, "The entire panorama of the history of the world, its architecture, science, people, apparel, art, and everything that has been recorded graphically make up this collection."[11]

Javitz's writing on the Picture Collection is invaluable regarding its conception and, over time, its changing complexion. But her accounts are most resonant within the larger expanse of photography's history for a fundamental bond she posits between the medium's indexicality and its instrumentalization by those who visit the Collection. In this respect, Javitz goes so far as to say in a 1942 essay that the collection is a "comprehensive, unbiased record of the visual aspects of human knowledge ... consulted and borrowed for information, to answer specific search[es] for facts."[12] All questions of the Collection's ontology aside, there is, in truth, some entertainment to be

found in this perspective. "Was Cleopatra beautiful?" Javitz asks rhetorically in a magazine piece.[13] (We'll never know, she says, because the ancient Egyptians had no cameras.) And how would the New York Central Railroad ever have arrived at the correct yellow for its coach seats, if not for a picture of forsythia borrowed from the Collection and passed around at the company's board meeting?[14]

Yet by maintaining such a strict delineation of the photograph as a document—as something pointing to the outside world—the Collection begins to obtain a kind of photographic quality in its own right, insofar as it offers fleeting portraits of its living context and assumes sociological dimensions, in both its content and its use. Javitz writes in 1933:

> As in other years, requests kept apace with newspaper headlines. In the wake of Repeal, came search for images of whiskey flasks and Burgundy labels ... Mae West brought requests for mustache cups ... Picture requests for pogroms, burning of books in other days, revolutions ... round out the year's interests.[15]

By 1942, the premonitions laid out by her last notes on such "interests" become manifest in the United States military's requests for images of the Japanese landscape. The curator again leans on the premise of photographic factuality in her assessments, writing:

> Since a soldier is taught to bayonet the enemy and not some undefined abstraction, he must learn to recognize that enemy; he must go into battle armed with visual knowledge of the face of the enemy and the contour of his lands.[16]

Taking into consideration such developments, one sees that the ebb and flow of image requests—in sheer scale and administration—frequently reflect larger societal forces, as when, for example, the military finally removes and classifies all images related to its enemies so as to leave no trace of its searches.[17] Or when, during the early 1930s, there is a nearly 43 percent increase in image requests, arising almost exclusively from the needs of artists newly hired by the Works Progress Administration to decorate buildings under construction and renovation throughout the city.[18] Notably, in response, Javitz hired dozens of Works Progress Administration artists to assist in the organization and circulation of pictures in the library. And this move, over time, would have the added effect of introducing works by such artists as Walker Evans and Dorothea Lange into the collection as just so many more documents alongside mass-produced illustrations. (Brought into contact with the Collection through the WPA, Roy Stryker of the Farm Service Administration donated nearly 40,000 such prints, fearing their destruction by a Library of Congress that might not approve of the images' content.[19]) Only during the mid-1990s were these pictures reclassified by the New York Public Library as photographs, and handed over to the Photography Department in direct response to rising market prices for the artists.[20] As Simon notes, in a statement that has significance for her arrangements of pictures from the Collection files, "Those works that later became 'valued' were mined out of this public collection and relegated to an exclusive space, despite the artists' express wish for their images to be democratically available."[21]

Ironically, it is perhaps this last detail—a change in terminology prompted by societal causes from without—that best underscores a fundamental stress point within the Picture Collection pertaining to its internal

organization. Or, more specifically, to a relationship forged there between image and text. For this relationship is tenuous at best, given that Javitz herself seems deeply doubtful of language's capacity, to say nothing of its privileged place, as a structuring device in culture.[22] "Pictures in print have become as common as words," she writes in a magazine piece titled "Pictures from Abacus to Zodiac," years before any such articulation among artists.[23] And elsewhere Javitz leaves little doubt as to which side of this equation will prevail, observing, in a 1940 text, that "many facts which require hours to be tracked down in texts can be swiftly and simply discovered by consultation with pictures," given that, for instance, there is no word that can truly describe a color.[24] Such an attitude obviously inflects the idiosyncratic classification of the images in the Collection. To rehearse them once more: *Alley, Avalanche, Mustache, Rear Views, Costumes—Veils ...* The list goes on, nearly self-fulfilling with respect to Javitz's summations on the shortcomings of language, as evidenced by the numerous textual skips and jumps found in file after file, often flagged by the directive *see* or *see also*, as in: "Ghost towns, see Abandoned buildings & towns," or "Accidents, See also Airplanes—Wrecks, Ambulances, Automobiles—Wrecks, Explosions ..." and, curiously, "LOVE, see also Leap year."[25] Time and again, the categories fail to contain.

By contrast, Javitz is willing to make the bold claim, "Pictures are now a universal form of communication."[26] Yet, one notes, the form taken by such communication is decidedly contingent—determined, in other words, entirely by use. In fact, explicating the collection's changing classification scheme, Javitz states plainly at one juncture that the Collection's subject headings should follow demand—an assertion that suggests what is, in fact, most prescient about the Collection and its conception of photography.[27] For if the pictures retained here are intended to circulate—such that they effectively anticipate their continuous recontextualization through time—the same may well be said of the Picture Collection itself. Just as the meaning of any of its images is yet to be formed, so the Collection awaits meaning in reception, with the terms set by reception itself reflected in the Collection's classifications. If its contents point us to the "world outside," so the institution itself is acutely sensitive to the shifting terrain of that larger arena. Roughly contemporaneously with Javitz's writings, theorist Walter Benjamin would suggest about photographs, "For the first time, captions have become obligatory. And it is clear that they have an altogether different character than the title of a painting."[28] In the case of the Picture Collection, it is clear that such captioning will always be transitional, with pictures and institution alike migrating in a crude algorithm, reactive to the movements of the populace who would draw on them—of those, in so many words, who would initiate a search.

It should hardly come as a surprise that the very notion of classification here should seem at once so haphazard and overdetermined in both presentation and reception, even while the photograph ostensibly retains its *retardataire* status as a document. In the fabric of sober regulation is the weave of sheer volatility. As Javitz observed in 1940 about the Collection's composition, "The type of picture included in this Collection and the subjects represented have both depended upon the accident of the gift."[29] And, as she conveyed the experience of artist Diego Rivera when using the files as studies for his murals in New York City, "The form of his conceptions was often fixed by the accident of the material available in its files."[30]

3.

Notably, Rivera would also express his belief that the scope and limits of the Collection might shape contemporary visions of America—suggesting that today's "accidents" might be tomorrow's conventions for the popular conscience. Such inconsistency in, and potential consequences for, classification seems very much in keeping with Simon's long-standing interests. Interrogating the relationship of photographic image to material world is, after all, one of the basic premises of her oeuvre to date. Consider *The Innocents* (2002), whose portraits depict individuals wrongly convicted of crimes at the locations of their supposed offenses or sites of particular significance to their conviction. All of these people were mistakenly identified by their accusers through photography, suggesting a relationship between representation and reality that is tenuous at best. And yet, taking into account Simon's exploration of the Picture Collection, one notices that the instability of the image even here is necessarily bound up with its reception. In fact, the question of representation is of less concern to Simon than is its relationship to memory and, more precisely, to how "the photographs replaced the memory of the actual perpetrator."[31] The status of the image is contingent not only on circumstance, but also on subjectivity and projection, such that the picture may take on the ambiguous role of placeholder—providing the viewing subject with a sense of history where it is, in fact, absent. If Crimp writes that what each of us sees is necessarily one's own history, the basic desire (if not need) to attribute a history, or determinacy, carries some weight as well.

Indeed, the question of projection also provides a significant thematic thread through Simon's oeuvre, most literally, perhaps, in her *Black Square* pieces (2006–), for which she sets individual images within black frames and backgrounds matching the dimensions of Kazimir Malevich's famous work. Often her subjects are troubling in nature—a book falsely purported to contain the minutes of a meeting among Jews planning to take over the world; male mosquitoes engineered to kill their offspring by passing along a lethal gene; Ethel and Julius Rosenberg's final letter to their children, written the day of their execution. But these subjects are taken out of context and, in fact, framed by a work residing at the borders of representation. In other words, they reside in a space devoid of directions or, more precisely, devoid of captions beyond the most basic contextualization offered by Simon's titles. (The one instance where a picture and text meet—fully "developed," as it were, with internal and external conditions finding explicit correlation—is in the image of a parrot suffering from Feather Destructive Disorder, wherein depression is made visible in the form of plucked feathers.) Given Simon's gesture to Malevich, one might usefully compare her maneuver to that of another artist at the inception of modernism, Wassily Kandinsky, who once asserted that he liked to leave a part of every canvas blank, or unfinished. As art historian Benjamin H. D. Buchloh explains:

> That "empty space" ... was conceived of as ... negating aesthetic imposition, functioning as a spatial suture that allowed the viewer to situate himself or herself in a relationship of mutual dependence with the "open" artistic construct. The empty space functioned equally as a space of hermetic resistance, rejecting the assignment of ideological meaning and the false comforts of convenient readings alike.[32]

The potential implications—and precise nature—of such a "mutual dependence" today seem especially relevant for Simon's engagement with the Picture Collection. To what extent, in other words, do they announce their classifications—and to what extent do we project our preexisting ones upon them? Partly this question revolves around recognition. And true enough, one is bound to recognize a few images throughout her various compositions—in *Folder: Costume—Veil*, for example, where a famous Edward Steichen photograph appears in a couple of iterations in the midst of other pictures featuring cultural figures, from model to movie star, some likely familiar to present-day, acculturated audiences and others not. (In such instances, one is able to receive with some accuracy the historical information within the image—and yet, in tandem with this connection, one must think of the significant role of projection underlined by "empty space" in Simon's other works such as *Folder: Abandoned Buildings*.) More abstractly, one also inevitably grasps a flattening of hierarchies that seems of a priori value to the Picture Collection, to say nothing of its jumble of genres, from fashion photograph and head shot to photojournalism and sociological study.[33] And here again arises a kind of futurity in the past. Dialogues around such erosions of high and low, even within the museum, are by now long-established for contemporary audiences. But Simon seems to reanimate such a tension of hierarchies ever so lightly by marking our historical remoteness from this earlier moment. For if the discourse of High and Low seems largely settled today, the contents of the Picture Collection exceeds such categorizations—but notably before the discourse ever took place. And so audiences inevitably recognize themselves in the Collection's disorder even while seeking to differentiate themselves from it. Surveying chronologies in art, one typically imagines oneself at a natural end point or culmination of a centuries-long trajectory, but the Picture Collection skews any such comfortable perspective lines by which the present might be seen in relation to a distant past.[34] Even with respect to critical technique, the Collection seems to figure in advance artistic innovations that developed only generations after the department's inception. It can seem as though a Baldessari-like figure had already passed through the files to erase the images' immediate functionality.

But if that artist's Conceptualism was steeped in structures of signification—how the meaning of an image or object shifts according to context—most important here is the impact of time on that operation. Indeed, Simon suggests as much with her purposeful inclusion of *Folder: Cats*. The file 'Cats' likely seemed little more than another heading when the Picture Collection was created, but today is all but impossible not to view through the prism of search engines and cats as an online craze. One might again consider Simon's *Black Square* works, in particular the image there of a manual for learning the English language, buried in a time capsule during the 1939 World's Fair, made with the intent of teaching those people centuries from now who will have never read or heard it. But the work most illuminating for *The Picture Collection* is another project that Simon developed contemporaneously—and, one suspects, in reply to the library's collection—with the late programmer Aaron Swartz. For this project entwines any relationship of mutual dependence between viewer and image with the question of use. Titled *Image Atlas*, the work consists of an algorithm that harnesses local search engines throughout the world in order to compare search results from different countries including Brazil, China, Egypt, India, Iran, New Zealand, North Korea, Russia, and

the United States. (An atlas key enables searches in still other countries.) Users enter keywords of their choice, which are then translated into the relevant languages by Google Translate; the regional algorithms subsequently present the top image results from local search engines around the world. Regarding these images, Simon and Swartz indicated their desire to reintroduce a sense of difference into contemporary understandings of the global—reasserting, in effect, a concrete sense of gaps into utopian discourses around the free exchange of information on the brave new highways of digital communication. Accordingly, searches might well give rise to similarities, but they will just as often generate highly divergent results for even the most banal of terms. For example, *groceries* will summon pictures of a fruit stand in France, a bag of wheat in Russia, and, strangely, a robot in Syria, while North Korea offers no image whatsoever. The term *revolution* is perhaps even more telling, with political parties across the centuries arising in Chinese and Russian search engines, while the top picture in the United States comes from an eponymous television program about the end of organized society.[35] In their brief mission statement for the project, Simon and Swartz accordingly employ language far different from that used by Javitz decades ago, saying that *Image Atlas* "interrogates the possibility of a universal language and questions the supposed innocence and neutrality of the algorithms upon which search engines rely."[36]

In this regard, Simon is quick to outline the subtle administration (intentional and not) of photographic images by every society, and, for that matter, by every online corporation, as is rendered apparent in their project. Among the various components she draws attention to are such factors as the actual languages available for translation by Google—a tacit judgment of relevance on the global stage regarding any region—and, of course, the accuracy of such translation across idioms. (As she says, again touching on the "empty space" between work and user: "I'm ... interested in the invisible space between people in communication; the space guided by translation and misinterpretation. This space highlights the inevitability of solitude and the impossibility of true understanding."[37]) And, as emphasized above, the algorithms themselves guide users to different results, frequently giving visible form—almost a kind of portraiture—to belief systems fostered within specific locales. If words have different meanings in different geopolitical areas, such valences are often at the service of governing systems, to say nothing of prevailing manners and custom. Indeed, whereas Roland Barthes's deconstructions of myth in culture during the 1950s revolved around the identification of visual signs, today these could be called so many notations embedded in code. (Surmising a photograph of a politician looking into the distance, Barthes might call attention to the sign of futurity and progress that had been choreographed for instant recognition within the collective, mediatized conscience. Now, such shared codes are redoubled in tags, and reshaped by algorithm. As Simon notes of *Image Atlas*, the "top results" for any search often grow more powerful as more new users are guided to top results.[38]) Arguably, then, with search engine optimization, the very notion of searching is rendered tautological; one gains only a false sense of discovery with any given search for images, since these are often tailored in anticipatory fashion. Accordingly, in *Image Atlas*, deconstruction as a critical model gives way to the passage of time, allowing users to see how the same search renders different results from day to day, as an interplay among users and algorithms unfolds globally.[39]

4.

Such a postulation resonates strongly with another recent project by Simon, *A Living Man Declared Dead and Other Chapters I–XVIII* (2011), for which she traced different bloodlines throughout the world—effectively diagramming how the stories of individuals are continually reshaped as they come into contact with larger cultural narratives and societal currents. What becomes palpable here are the various gaps—the people who could not be pictured, the stories that trail off, the strands that rise to the surface in a given historical context—all of them subject to contingency. In this regard, Simon is remarkably astute in her selection of the Picture Collection as a subject, since it mirrors her oeuvre to date—providing evidence of inevitably failed attempts to organize the world in images and text—while at the same time being rich with implications for the organization of society more generally. If the Picture Collection has assumed sociological dimensions, so here does Simon's own methodology. As Hal Foster writes in "An Archival Impulse," conjecturing on various artists' desire to delve into the idiosyncratic histories of modern art and philosophy, seeking out new ways of ordering both civilization and experience: "Perhaps, like the Library of Alexandria, any archive is founded on disaster (or its threat), pledged against a ruin that it cannot forestall."[40] Alternatively, it is precisely such ruin, or erasures, that might be most intriguing. As Simon has said regarding her work with archives, "Something is said in the gaps and shifts among all the information that's collected."[41]

And, in fact, Simon surveys an institution that is perpetually being reorganized, continually giving new meaning to the context of photography and, moreover, of that medium's evolving status as a document. For what, after all, is a library? Perhaps no public institution is so fundamentally paradoxical in its constitution. It is ostensibly devoted to the preservation of cultural materials across the centuries, but only in tandem with the tenet of accessibility and the continuous distribution or circulation of those contents. And the latter makes this reservoir for knowledge (and, indeed, this basis for knowledge itself) uniquely subject to the whims of history, standing at a perpetually renegotiated interstice of governance, technology, and, most important, actual use. Even the modern library's roots in the singular constellation of circumstances around the Enlightenment suggest such delicate contingency or, better, an acute sensitivity to epochal shifts in society. The august institution as we know it emerged only when the principle of rationalist egalitarianism—according to which the library was a sphere suffused with the potentiality of reference and research—coincided with technical innovations in publishing that altered the fundamental character of books as precious objects collected privately, to say nothing of the emergence of copyright laws that provided a formal basis for information's more widespread dissemination and exchange.

As Simon's project suggests, one need look just at the continuing evolution of the New York Public Library—a relatively youthful institution, by any historical measure—in order to grasp the provisional character of any such entity.[42] Today, little more than a hundred years after opening its doors, the library is embroiled in a controversy surrounding a new configuration, called the Central Plan, which its trustees consider less a radical reimagining than a necessary reflection of a changing weave in the fabric of society at large. Implicitly acknowledging the absence of civic funding to preserve aging volumes in existing facilities on the one hand—the library has openly

proposed to clear its rooms by shipping the contents of its stacks to sites outside the city—and seeking to accommodate a digital age on the other, the embattled plan retools the library's spaces for online facilities and, as significant, for social interaction among generations for whom the bound page, let alone the written word, might increasingly seem a figure of the past.[43] If this comes to pass, Javitz's assertions about photography might well seem from another time, but only one to come.

Notes

1. Douglas Crimp, *On the Museum's Ruins* (Cambridge, MA: MIT Press, 1993), 4. It bears mentioning that this passage is all the more important for underscoring the importance Crimp ascribes to the task of arriving at nontotalizing theories of postmodernism that still avoid an air of "anything goes" in art. This discussion remains increasingly relevant as the photographic medium's form and distribution system grows ever more varied.

2. The desire among art historians and critics to posit an end for art today is legible everywhere in recent publications, including David Joselit's *After Art* (2013) and Pamela M. Lee's *Forgetting the Art World* (2012), suggesting that a new discursive mode might be wanted to describe contemporary models of cultural production. The simple question is then prompted: How have conditions around photography shifted since its reevaluation in tandem with the first utterances of postmodernism, and what productive observations can we make about the field of art in turn?

3. Per Crimp: "Its meanings were secured not by a human subject but by the discursive structures in which it appeared." And, he continues, "[S]ubjective expression is an effect, not a source or guarantee, of aesthetic practices." Crimp, *On the Museum's Ruins*, 16.

4. I have touched briefly on this idea in a recent essay considering how such operations might impact the possibility of critical dialogue and exchange in art, and ask for a reconsideration of the very term *art world*. See Tim Griffin, "Notes on an Art Domain," *Texte zur Kunst*, September 2012, http://www.textezurkunst.de/87/bemerkungen-zu-einer-kunst-domain/. Taryn Simon's current project is exceptional for the correlations it establishes between analog and digital photographic practices and, more important, their classification, which I will engage below.

5. I borrow the description of fact's underpinnings in fiction from Hal Foster as he outlines artistic practices in "An Archival Impulse," *October*, Fall 2004, 3–22. His observations there also seem relevant for Simon's expressed interest, among her various projects, in considering the precariousness—if not outright arbitrariness—of order in the face of chaos. As he writes of Tacita Dean, Thomas Hirschhorn, and others, "For why else connect so feverishly if things did not feel so frightfully disconnected in the first place?"

6. As Rancière writes: "The distribution of the sensible reveals who can have a share in what is common to the community based on what they do and on the time and space in which this activity is performed ... it defines what is visible or not in a common space, endowed with a common language, etc. There is thus an 'aesthetics' at the core of politics that has nothing to do with Benjamin's discussion of the 'aestheticization of politics' specific to the 'age of the masses' ... It is a delimitation of spaces and times, of the visible and the invisible, of speech and noise, that simultaneously determines the place and the stakes of politics as a form of experience. Politics revolves around what is seen and what can be said about it, around who has the ability to see and the talent to speak, around the properties of spaces and the possibilities of time." See Rancière, *The Politics of Aesthetics: The Distribution of the Sensible,* trans. Gabriel Rockhill (London: Continuum, 2004), 12–13. As one might expect, genre and classification of images play a role in this distribution, as he once suggested by pointing to Jean-Luc Godard's observation about the rise of the epic or documentary in different geopolitical regions in the Middle East. See Fulvia Carnevale and John Kelsey, "Art of the Possible: Jacques Rancière interviewed by Fulvia Carnevale and John Kelsey, *Artforum*, March 2007, 256–69.

7. As Simon's caption for the image reads: "Section 501 of the U.S. Information and Education Exchange Act, passed by Congress in 1948, authorizes the U.S. government to disseminate information abroad about the U.S. and its policies. Section 501 also prohibits domestic dissemination of that same information. It is therefore illegal to broadcast Alhurra domestically. Alhurra is Arabic for 'the free one.'" In effect, Simon provides viewers with a document of a storytelling device whose effectiveness depends at once on its factual, and matter-of-fact, appearance abroad, and its imperceptibility at home. And she both declassifies images and "de-classifies" them, rendering them newly subject to a proliferation of potential readings and meanings.

8. Originally published in 1941, Jorge-Luis Borges's story "The Library of Babel" describes an endless expanse of interlocking hexagonal rooms containing innumerable books. Apparently organized at random (and mostly composed of pure gibberish), these volumes nevertheless, it is thought by Borges's narrator, must contain all possible combinations of letters, spaces, and punctuation—meaning, by extension, that they contain every possible permutation of each book and, moreover, contain all potentially useful information, including predictions of the future. While Borges's thought experiment was influential for many artists at the beginnings of postmodernism—consider, for example, Robert Smithson's numerous engagements with the notion of the labyrinth—it seems particularly relevant for this real-life consideration of the

Picture Collection, particularly given how Borges's library implies there is no steady, meaningful distinction between truth and fiction.

9. Anthony T. Troncale, "Worth Beyond Words: Romana Javitz and the New York Public Library's Picture Collection," originally published in *Biblion: The Bulletin of the New York Public Library* 4, no. 1 (fall 1995). Available at www.nypl.org/locations/tid/45/node/62019.

10. The Picture Collection curator Romana Javitz herself points to the Collection's role in the design of jewelry, clothes, window displays, and fabrics, saying, "American creative output is influenced by this picture service." See Romana Javitz, "The PICTURE COLLECTION of The New York Public Library," 1940, Picture Collection records, Manuscripts and Archives Division, New York Public Library.

11. Javitz, "The PICTURE COLLECTION of The New York Public Library."

12. Ibid.

13. Javitz, "Pictures from Abacus to Zodiac," in *The Story of Our Time, an Encyclopedia Yearbook* (New York: Grolier Society, 1955), 335.

14. Javitz, "Annual Report 1939, Picture Collection," Picture Collection records, Manuscripts and Archives Division, New York Public Library.

15. Javitz, "Annual Report 1933, Picture Collection," Picture Collection records, Manuscripts and Archives Division, New York Public Library (p. 161 in the present volume).

16. Javitz, "Annual Report 1942, the Picture Collection," Picture Collection records, Manuscripts and Archives Division, New York Public Library (p. 194 in the present volume).

17. Ibid.

18. Javitz, "Annual Report 1934, the Picture Collection," Picture Collection records, manuscripts and Archives Division, New York Public Library (p. 74 in the present volume).

19. Such reasoning is stated explicitly by the FSA's Lenore Cowan in a letter dated July 26, 1983. Picture Collection records, Manuscripts and Archives Division, New York Public Library (p. 310 in the present volume). See also James Estrin, "A Historic Photo Archive Re-emerges at the New York Public Library," *New York Times*, June 6, 2012, http://lens.blogs.nytimes.com/2012/06/06/ahistoric-photo-archive-re-emerges-at-the-new-york-public-library/.

20. A memorandum from the Picture Collection's Mildred Wright notes that the FSA images are "'works of art' and are not only of significant historical importance, but are of monetary value as well. Many of them are worth several thousand dollars in today's Photography market. With continuing budgetary cuts, it becomes increasingly difficult to plan a future for these photographs within the Picture Collection." Memorandum from Mildred Wright to Robert Foy, January 13, 1992, Picture Collection records, Manuscripts and Archives Division, New York Public Library. A New York Public Library memorandum from the Picture Collection's Constance Novak makes a formal request for such a transfer by saying: "I thought you might be interested in seeing the prices which FSA photographs are getting in today's market. I am also attaching some examples of Picture Collection's FSA photographs (unfortunately examples of neglect and deterioration). Is there some way we could expedite a transfer to Photography before it's too late to save these valuable items?" Memorandum from Constance Novak to Thomas Alrutz, February 25, 1997, Picture Collection records, Manuscripts and Archives Division, New York Public Library (see p.305 in the current volume).

21. E-mail from the artist, August 9, 2013.

22. In light of the Collection's content, her suspicion seems valid. Accidents, for example, is apt to have one image of a car accident beside another of spilled ketchup or a kitten knocking over a vase. Even a word, it seems, awaits its history here and is given different meaning according to context, putting the very notion of specificity at risk. Every file, it seems, stands at the crux of difference and "anything goes," that embattled position recalled by Crimp at the inception of postmodernism.

23. Javitz, "Pictures from Abacus to Zodiac," 334.

24. Javitz, "The PICTURE COLLECTION of The New York Public Library."

25. Notably, author Art Spiegelman once penned an essay for the New Yorker considering such idiosyncrasies in the collection, noting that Kant, Kandinsky, and Boris Karloff could be found here, but only under P for "Personalities." See Art Spiegelman, "Words: Worth a Thousand," *New Yorker*, February 20, 1995, 196–99.

26. Javitz, "Annual Report 1942, the Picture Collection."

27. As Javitz writes about the determining factors for the labeling and classification of images: "Expediency demands that a subject heading should not be changed to a new form except when the older term fails to serve to locate the pictures or becomes quite incorrect as a description of the pictures ... " Javitz, organizational instructions for the Picture Collection, 1944, Picture Collection records, Manuscripts and Archives Division, New York Public Library. In a 1940 statement, she similarly writes, "It is a guide to the use of pictures files for the facts depicted and is a guide to the editing of pictures for such use." (Also, Javitz's 1940 "The Picture Collection," in which she says that the Collection "did not start with a plan. ... It grew haphazardly as the public came and asked for pictures.") In "Worth Beyond Words," Troncale also writes of shifts in classificatory schemes as they happened in 1934: "Any new system would need to reflect new commercial and industrial vocabularies and interests and the current nomenclature of artists."

28. Walter Benjamin, "The Work of Art in the Age of Mechanical Reproduction," in *Illuminations*, trans. Harry Zohn (New York: Harcourt Brace Jovanovich, 1968), 226.

29. Javitz, "The PICTURE COLLECTION of The New York Public Library."

30. Javitz, "Annual Report 1933, Picture Collection."

31. Taryn Simon, "Taryn Simon and Brian De Palma in Conversation," *Artforum*, summer 2012, 251 (see p.128 in current volume).

32. Benjamin H. D. Buchloh, "Warhol's One-Dimensional Art: 1956–1966," in *Andy Warhol* (October Files), ed. Benjamin H. D. Buchloh and Annette Michelson (Cambridge, MA: MIT Press, 2011), 16.

33. Intriguingly, Javitz, would in 1965 argue that this mix of pictures made it possible not to "become snobbish about art." At the same time, she makes a remarkable comment about how the context for—or text accompanying—an image gives it different meaning: "For example, you may see a picture of what you think is a very evil-looking man, but you will look at it in a different way if you are told it is a picture of the kindest priest in a diocese." "Library not art snob, picture chief says," *Toronto Globe and Mail*, November 30, 1965.

34. The discomfort prompted by the Collection is all the more compelling for its existence within an institution such as the New York Public Library. For a consideration of how such institutions have historically been designed to give audiences the sense of standing at the culmination of history, see Tony Bennett, *The Birth of the Museum: History, Theory, Politics* (London: Routledge, 1995).

35. Accessed August 3, 2013.

36. This statement accompanies the work as it appears on Simon's website, http://www.tarynsimon. com/. The duo made similar remarks as part of their conversation during the Rhizome "Seven on Seven" conference on April 14, 2012, available at http://vimeo.com/40651117.

37. See Lauren Cornell, "On Image Atlas: An Interview with Taryn Simon," *New Yorker*, http:// www.newyorker.com/online/blogs/culture/2012/08/on-image-atlas-an-interview-with-tarynsimon. html. Notably, Simon frequently asserts that images, like text, are subject to issues of mistranslation.

38. As Simon observed in her interview with Cornell, seeming to echo Javitz's remarks decades ago: "But really, 'top' images represent mass taste at a given moment that is inevitably shaped by political and cultural events, trends, etc." See Cornell, "On Image Atlas: An Interview with Taryn Simon."

39. Perhaps a better way to articulate the tautology of searching online is to consider a conflation of two senses of the term search. Etymologically, the word, arising in the fourteenth century, meant "to go about (a country or place) in order to find, or to ascertain the presence or absence of, some person or thing; to explore in quest of some object." Some fifty years later, such explorations would find an interior correlative in another usage: "to look through, examine internally ... in quest of some object concealed or lost." The expanse without is matched with the one within. *Oxford English Dictionary*, online edition, http://www.oed.com/view/Entry/174308?rskey=ithOc6&result=2&isAd vanced=false#eid.

40. Foster, "An Archival Impulse," 5.

41. E-mail from the artist, August 13, 2013. See also Taryn Simon, "The Stories Behind the Bloodlines," TED video, 17:59, filmed November 2011, posted April 2012, http://www.ted. com/talks/taryn_simon_the_stories_behind_the_bloodlines.html. On a more humorous note, one notes that ruin in the Picture Collection—and even the preservation of ruin—arises and becomes discernible through the archive's use. To wit, gaps in the Collection arise as Andy Warhol steals thousands of images to use as source imagery for, among other things, his Coca-Cola canvases. And these stolen items are preserved, ironically, in the Pop artist's archive today. See Susan Chute, "Pop! Goes the Picture Collection: Andy Warhol at NYPL," September 9, 2010, http://www.nypl.org/ blog/2010/09/09/pop-goes-picture-collection-warhol.

42. The library was first envisioned by New York governor (and onetime presidential candidate) Samuel J. Tilden, who at the time of his death in 1886 bequeathed most of his fortune to the city for the creation of a free library and reading room. Notably, however, the library finally came into existence only a decade later, when the Tilden Trust partnered with the libraries of John Jacob Astor and James Lenox—two private endeavors experiencing financial difficulties in their efforts to keep apace with the new century's growth in publishing.

43. This controversy continues. As biographer Edmund Morris argued at a legislative hearing this summer: "An exquisite repository is now going to be turned into a populist hangout, and have its former stack space stuffed with more and more and more and more miles of computer cable. That's O.K. for scholars whose attention span extends back no farther than the early 1980s. But those of us cognizant of what happened to civilization after the great library in Alexandria burned down can only think with trepidation of what the Central Plan is going to do to the historical memory of New York." See Robin Pogrebin, "Critics Prompt New Review of Library Plan," *New York Times*, June 27, 2013, http://www.nytimes.com/2013/06/28/arts/design/critics-prompt-new-review-oflibrary-plan.html.

Originally published in Taryn Simon, *The Picture Collection*.
Paris: Edition Cahiers d'Art, 2015

In 1936, an American ornithologist named James Bond (1900–1989) published the definitive taxonomy *Birds of the West Indies*. Ian Fleming, an active bird-watcher living in Jamaica, appropriated the name for his novel's lead character. He found it "flat and colourless," a fitting choice for a character intended to be "anonymous ... a blunt instrument in the hands of the government." This co-opting of a name was the first in a series of substitutions and replacements that would become central to the construction of the Bond narrative.

Conflating Bond the ornithologist with 007, Taryn Simon uses the title and format of the ornithologist's taxonomy for her two-part body of work *Birds of the West Indies* (2013–2014). In the first component of the work, Simon presents an inventory of women, weapons, and vehicles—recurring elements in the James Bond films made between 1962 and 2012. This visual database of interchangeable variables used in the production of fantasy examines the economic and emotional value generated by their repetition. It also underlines how they function as essential accessories to the myth of the seductive, powerful, and invincible Western male.

Maintaining the illusion upon which the Bond narrative relies—an ageless hero with an inexhaustible supply of state-of-the-art weaponry, luxury vehicles, and desirable women—requires a constant process of replacement. A contract exists between the Bond franchise and the viewer that binds both to a set of expectations. In servicing the desires of the consumer, fantasy becomes formula, and repetition is required; viewers demand something new, but only if it remains essentially the same.

Ten of the fifty-seven women Simon approached to be part of *Birds of the West Indies* declined to participate. Their reasons included pregnancy, not wanting to distort the memory of their fictional character, and avoiding any further association with the Bond formula. Simon represents each missing woman by reinserting the black rectangle cut from the mat to frame their would-be portrait, covering and at the same time representing their absence.

Simon's film *Honey Ryder (Nikki van der Zyl), 1962* documents the most prolific agent of substitution in the Bond franchise. From 1962 to 1979, Nikki van der Zyl, an unseen and uncredited performer, provided voice dubs for over a dozen major and minor characters throughout nine Bond films. Invisible until now, van der Zyl further underscores the interplay of substitution and repetition in the preservation of myth and the construction of fantasy.

The sequencing of women, weapons, and vehicles in *Birds of the West Indies* was determined using a random number generator called the Mersenne Twister, used for statistical simulations and in computer programming languages. By randomly reconfiguring the ordering of the works, *Birds of the West Indies* mimics a longing for endless reiteration unaffected by time and history.

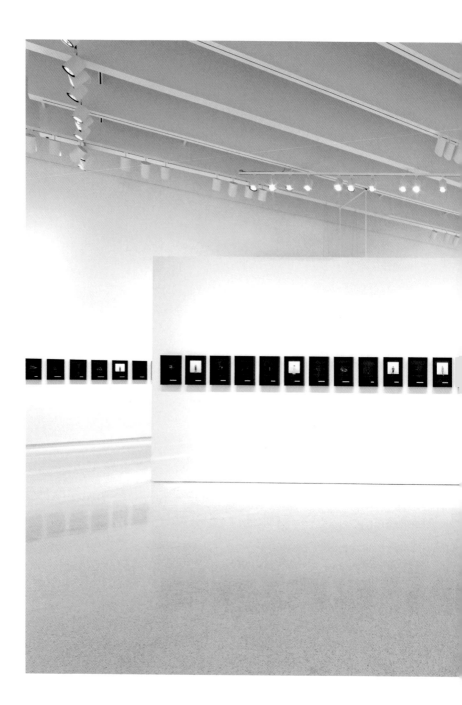

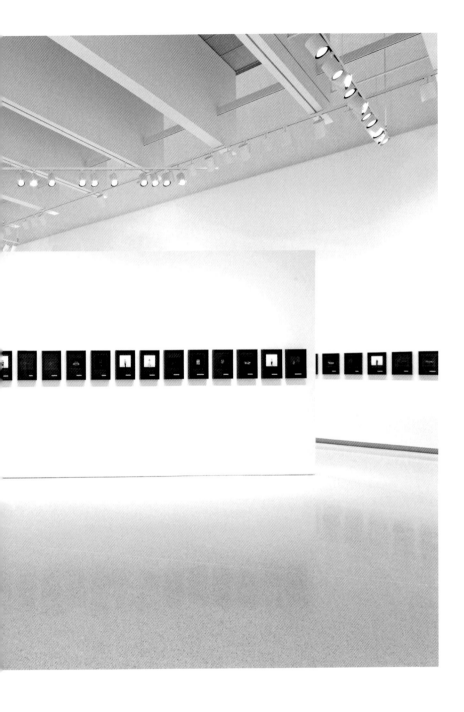

Installation view. *Birds of the West Indies*
Carnegie International, Pittsburgh, 2013

A.1 *Honey Ryder* (Ursula Andress), 1962

Framed museum board and text, 15 ¹¹⁄₁₆ x 10 ⁷⁄₁₆ inches (39.8 x 26.5 cm)

B.45 *Hasselblad Camera Signature Gun*, 1989

Each: framed archival inkjet print and text, 15 $^{11}/_{16}$ x 10 $^{7}/_{16}$ inches (39.8 x 26.5 cm)

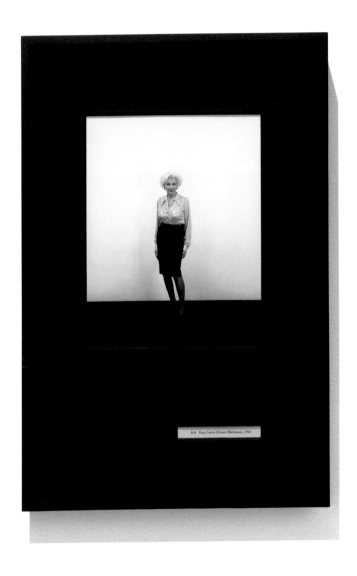

A.6 *Pussy Galore* (Honor Blackman), 1964

C.42 *2008 Aston Martin DBS* (with continuity damage), 2008

B.32 *Shark Brain Control Device*, 1983

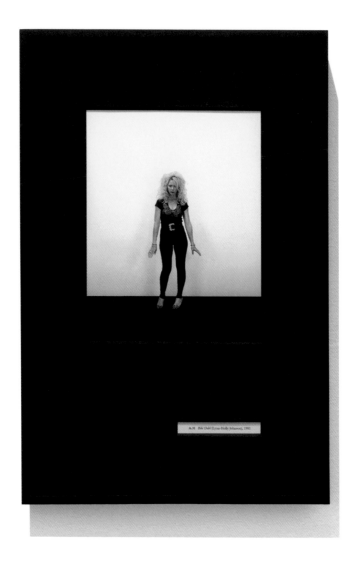

A.31 *Bibi Dahl* (Lynn-Holly Johnson), 1981

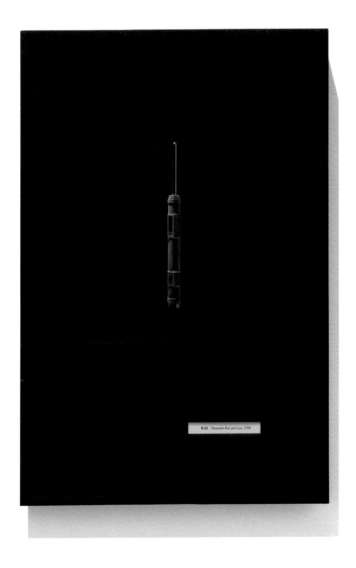

B.65 *Plutonium Rod and Case,* 1999

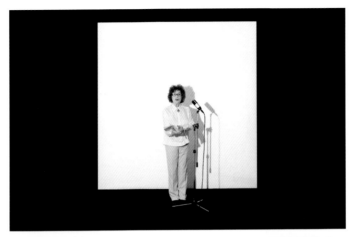

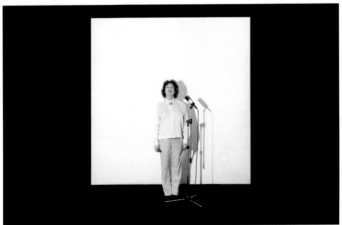

Honey Ryder (Nikki van der Zyl), 1962

Honey Ryder was portrayed by Ursula Andress in the 1962 film *Dr. No.* The character's iconic voice is not Andress's— her lines were dubbed by voice actress Nikki van der Zyl. From 1962 to 1979, van der Zyl voiced more than a dozen major and minor characters in nine Bond films: *Dr. No, From Russia with Love, Goldfinger, Thunderball, You Only Live Twice, On Her Majesty's Secret Service, Live and Let Die, The Man with the Golden Gun,* and *Moonraker.*

Honey Ryder (Nikki van der Zyl), 1962, 2013

Single Channel Video (8 minutes, loop) and Letraset on wall
6 x 73⁄4 inches

Birds of the West Indies, Part 2

In the second component of her two-part body of work *Birds of the West Indies*, Simon casts herself as James Bond (1900–1989) the ornithologist, and identifies, photographs, and classifies all the birds that appear within the twenty-four films of the James Bond franchise. The appearance of many of the birds was unplanned and virtually undetected, operating as background noise for whatever set they happened to fly into. Simon ventured through every scene to discover those moments of chance. The result is a taxonomy not unlike the original *Birds of the West Indies*.

Each bird is classified by the time code of its appearance, its location, and the year in which it flew. The taxonomy is organized by country: some locations correspond to nations we acknowledge on our maps, including Switzerland, Afghanistan, and North Korea, while others exist solely in the fictionalized rendering of James Bond's missions, including Republic of Isthmus, San Monique, and SPECTRE Island.

Simon's ornithological discoveries occupy a liminal space—confined within the fiction of the James Bond universe and yet wholly separate from it. The birds flew freely in the background of the background, unnoticed or unrecognized until they were catalogued by Simon. Sometimes indecipherable specks hovering in the sky or perched on a building, these birds will never know, nor care, about their fame. In their new static form, the birds often resemble dust on a negative, a once common imperfection that has disappeared in the age of Photoshop. Other times, they are frozen in compositions reminiscent of genres from photographic history. Some appear as perfected and constructed still lifes while others have a snapshot quality. Many appear in an obscured, low-resolution form, as if they had been photographed by surveillance drones or hidden cameras. These visual variations are also affected by feature film's evolution from 35 mm to high-resolution digital output.

Simon's taxonomy of 331 birds is a precise consideration of a new nature found in an alternate reality. Bird study skins, correspondence, awards, and personal effects of James Bond the ornithologist have been collected by Simon and are displayed in vitrines alongside the photographic works. These artifacts present remnants of the real-life James Bond in his parallel existence to the fictional spy who took his name.

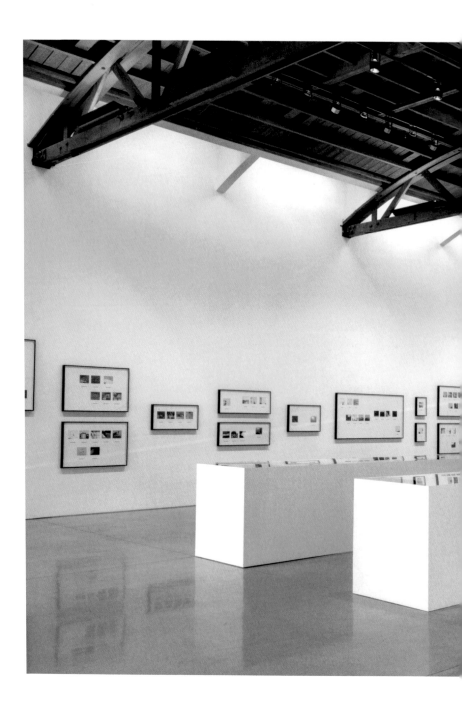

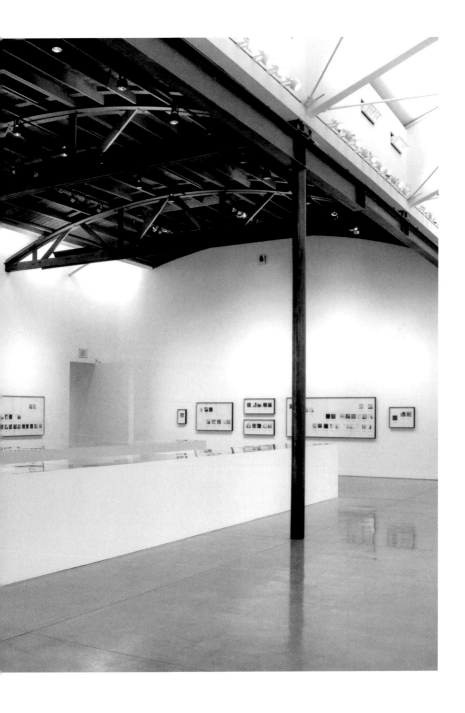

Installation view. *Birds of the West Indies*
Gagosian Gallery, Los Angeles, 2014

Italy

Framed archival inkjet prints and text, 189¾ x 39⅞ inches (482 x 101.3 cm) [two panels]

00:09:10 Siena, Italy. 2008

Detail, Italy

Each: archival inkjet print and text, 4¾ x 4¾ inches (12.1 x 12.1 cm)

00:40:55 Venice, Italy. 1979

Detail, Italy

Azerbaijan

Framed archival inkjet prints and text, 19¼ x 36¾ inches (50.2 x 93.3 cm)

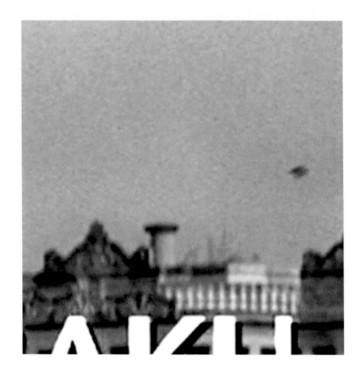

00:40:20 Baku, Azerbaijan. 1999

Detail, Azerbaijan

01:09:46 Baku, Azerbaijan. 1999

Detail, Azerbaijan

Switzerland

Framed archival inkjet prints and text, 79⁷⁄₁₆ x 39⅞ inches (101.3 x 201.8 cm)

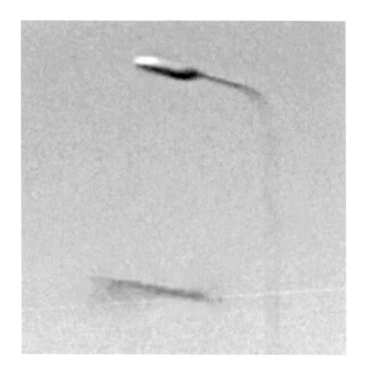

00:40:10 Geneva, Switzerland. 1964

Detail, Switzerland

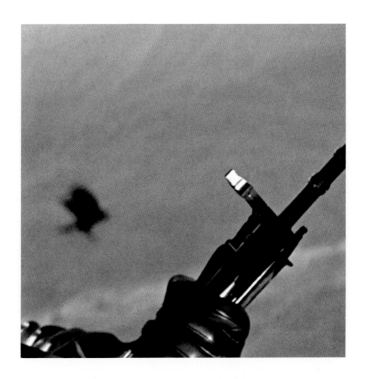

01:17:04 Swiss Alps, Switzerland. 1969

Detail, Switzerland

Victoria Harbour, Hong Kong

Framed archival inkjet print and text, 10⅞ x 16⅛ inches (41 x 27.6 cm)

00:45:57 Kobe, Japan. 1967

Detail, Japan

Correspondence and Bird Skins

From the archives of the Academy of Natural Sciences of Philadelphia

Tarpum Bay,
Eleuthera,
Bahamas,
July 12th 1955

Dear Mr Bond,

 The two specks in the air on
the enclosed photos are the Glossy Ibis I
wrote about a couple of weeks ago. I think
that, by using a magnifying glass, you will
be able to make them out. In each case the
bird was flying to the right of the picture.
Miss Morgan has, I believe, some pictures,
but so far I have not seen them. There has
been no further sign of the bird since I
last wrote.

 I did see a brown pelican two
weeks ago, it stayed around for about ten
minutes, but I heard that, the following
day, it was a star attraction at Governor's
Harbour for quite a time, fishing in the
harbour.

 Best wishes,

 Yours sincerely,

 Maurice Collett

 Maurice Collett.

Letter from Maurice Collett to James Bond. 12 July 1955.

September 13, 1965

Lukens, Savage & Washburn
Public Ledger Building
6th & Chestnut Streets
Philadelphia, Pa.
Att: Mr. Collins

Dear Mr. Collins:

 After talking to you about the theft of my double-barreled 12 gauge shotgun last July I stopped at M.& H. Sporting Goods Store to see if they could give me some idea of its value. New Fox-Sterlingworth guns are listed around $140. in the catalogue, but someone there said that $85. would be the minimum price for an old gun of this make in good condition. The value of the leather case, which was new and in which the gun was kept, is $10. Apparently nothing else in the house was stolen.

 Should you wish further information on the robbery I suggest you get in touch with the Detective Bureau, Northwestern Division.

 Yours faithfully,

 James Bond

JB/mh

Letter from James Bond to Mr. Collins. 13 Sept. 1965.

November 20, 1952

Mr. Alvin G. Whitney, Assistant Director
University of the State of New York
New York State Museum
Albany 1, New York

Dear Mr. Whitney:

 I have for a long time believed that the only
way to prevent extermination of some of the really rare birds
of the West Indies is through setting aside areas where no
shooting of any kind is permitted. The Luquillo National Forest
in northeastern Puerto Rico is a good example. To all intents
and purposes this is a wild-life sanctuary, and as a result of
its creation I have not the slightest doubt the Puerto Rican
parrot has been saved. I spent a few days in this forest last
January and was delighted to find considerable numbers of these
parrots which I believe do not occur elsewhere on the island.

 Most of the really rare West Indian species are
Lesser Antillean and these are in more need of protection than
those from elsewhere in this region. The "crown forests" in the
interior of the British islands were established primarily for
conservation of forest and water, but during my exploratory
travels I find that pigeon hunters were allowed to roam at will
in the interior, and although the splendid parrots were "protected",
I can assure you that many were shot by these men.

 As for the Black-capped Petrel, the precipitous
cliffs of the higher mountains of Hispaniola should offer this
bird some protection from mongooses and rats.

 Very few ecological studies have been made in
the West Indies in late years, and virtually nothing of importance
has been written on the rare endemic species.

 I am sending you an I. U. P. N. report by
Dr. Westermann entitled "Nature Preservation in the Caribbean".
I feel sure this will interest you. Kindly return it to me at
your convenience.

 Sincerely yours,

 James Bond
 Associate Curator of Birds

JB/c

Enc.

Letter from James Bond to Alvin G. Whitney. 20 Nov. 1952.

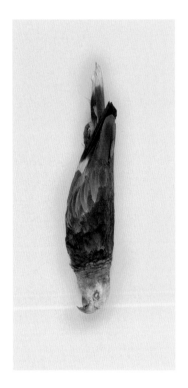 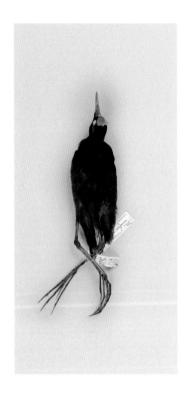

(left) Bird Skin: ANSP #88399; Common Name: St. Vincent Parrot; Genus: Amazona; Species: guildingii; Subspecies: –; Date Collected: 1/6/1930; Location: St. Vincent, British West Indies; Country: Lesser Antilles; Collector: Bond, J.

(right) Bird Skin: ANSP #82249; Common Name: Central American Jacana; Genus: Jacana; Species: spinosa; Subspecies: violacea; Date Collected: 2/4/1928; Location: Miragoane Lake, Haiti; Country: Hispaniola; Collector: Bond, J.

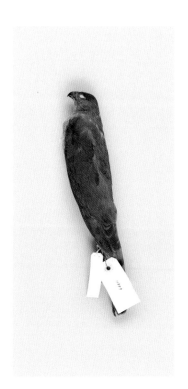 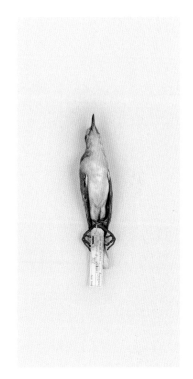

(left) Bird Skin: ANSP #111889; Common Name: Sharp-shinned Hawk; Genus: Accipiter; Species: striatus; Subspecies: fringilloides; Date Collected: 1/10/1933; Location: La Serrano Los Palacios; Country: Cuba; Collector: Bond, J.

(right) Bird Skin: ANSP #86434; Common Name: Southern Mockingbird; Genus: Mimus; Species: gilvus; Subspecies: antillarum; Date Collected: 3/9/1929; Location: –; Country: Lesser Antilles; Collector: Bond, J.

That Black Hole

Daniel Baumann

Secrecy is at the core of Taryn Simon's works, and few things are as seductive and powerful as secrets. They dominate politics, ruin lives, destroy countries, and change the fate of generations. As American philosopher and legal scholar Ronald Dworkin states in his commentary on Simon's work: "Secrecy is an enemy of justice and shame is its ally."[1] Through her collections of images and breathtakingly precise investigations, Simon interrogates not only the power and structure of secrecy, but also the way in which it is constructed: through the complex and sometimes dark dynamic between reality and fiction generating liminal spaces that cannot be defined as either.

In 1936, an American ornithologist named James Bond published the definitive study *Birds of the West Indies*. Ian Fleming, who was an active bird-watcher living in Jamaica, appropriated the name for the secret-agent hero of his novel, *Casino Royale*, because he found it "flat and colourless," which was fitting for a character intended as "entirely an anonymous instrument ... a cipher, a blunt instrument in the hands of the government."[2] This first of the Bond books was published in 1953. A year later, it made its US debut as a hardcover edition issued by Macmillan Publishing, but sold only 4,000 copies over the course of that year. In 1955, American Popular Library released a paperback version and, hoping to capture a larger domestic audience, replaced the title with *You Asked for It*. In the back-cover synopsis and marketing materials, the name James Bond was also changed to Jimmy Bond (it was not possible to alter the actual content of the novel). These were the first in a series of substitutions and replacements that would become central to the construction of the Bond narrative.

Substitution and replacement would also become central to Simon's approach in her dissection of the Bond films, a two-part project whose title, *Birds of the West Indies* (2013–14), she borrowed from the book by the original James Bond, and whose taxonomic approach, design, and layout mimic those of Bond's 1936 volume. The first element of the work

is a photographic inventory of women, weapons, and vehicles, recurring elements in the 007 franchise between 1962 and 2012 which function as essential accessories to the narrative's myth of the seductive, powerful, and invincible Western male. Perhaps more than in any other film series, these fixtures in the Bond movies are basic elements in building and controlling the relationship with the viewer. They effectuate an exercise in recognition, knitting our memories of past films to our expectations of the present one and our desire for the next. In this way, a contract has developed between the Bond franchise and the viewer, binding both to this set of expectations. In every film there is always a state-of-the-art gadget to help Bond out, a glamorous vehicle to enable his escape, and a beautiful woman to betray or assist him. It is the repeating pattern of these elements—all pressed into the service of an ageless Bond—that we desire. Our fantasies are skillfully structured and controlled by this formula; we demand something new, but only if it remains essentially the same. Continually performing and satisfying those obligations has allowed the Bond films to become "the most successful series in box-office history."[3]

The vehicles and weapons featured in the films reflect specific fashions and historical moments, such as the appearance of the then trendy Lotus Esprit Turbo in the early 1980s, or the nuclear devices that referenced the threats of the Cold War. Over the years, these fictional accessories have produced metanarratives in the real world, spawning products, sparking debates, and providing a document of how product placement became a general practice. In a surprising inversion of influence, the real MI6 admitted to seeking inspiration from the film's gadgets for its weapon development, and who can forget the uproar when the Aston Martin was replaced by a BMW at the end of the 1990s? *License To Kill*'s Hasselblad Camera Signature Gun (1989) made its entrance just before film was replaced by digital technologies. In a reversal of the film's famous initial signature motif of a gun becoming a camera, this camera could become a gun, suggesting a correlation between "shooting" a picture and shooting a weapon, and thus between preserving a moment and causing a death. As Roland Barthes wrote in his reflection on photography *Camera Lucida*

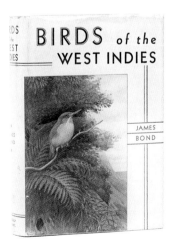

James Bond, *Birds of the West Indies* (Philadelphia: Academy of Natural Sciences, 1936)

(1980), every photograph freezes time but simultaneously illuminates the impossibility of breaking time's continuum. Therefore every photograph illustrates a moment's death.

Simon's visual database of these interchangeable variables examines the economic and emotional value generated by their repetition. Each of her pictures of vehicles and weapons floats in a black space, an imposed formula where fiction has been subtracted. In this way, they become time capsules, since all that they are (or were) is represented without context, blurring their relationship to the world and to the films. When, for example, she presents a photograph of Bond's Aston Martin DBS (2006) in impeccable condition and then in a damaged state, she does not present a before and after, but two fictional views, since different cars were used for each take. Their appearance in the context of *Casino Royale* blinds us to their differences and makes them appear as one. Fiction and reality also become one in *From Russia with Love* (1963). The film starts forty seconds after the credit sequence with a man following Bond in a park. By minute 2:32, the villain has strangled Bond, and lights go on in the background, illuminating a villa. A man walks into the scene, pulls out his watch, and at 2:49 dryly observes: "Exactly one minute and fifty-two seconds. That's excellent." One minute and fifty-two seconds is precisely the length of time the film has been running since the end of the opening credits; fictional and real time collide, a conceit also utilized in the early 1960s by experimental Structuralist films.

At first, the taxonomical organization in Simon's *Birds of the West Indies* seems elucidating, as all taxonomies should be, but in fact it creates an endless chain of fresh narratives: for each new exhibition of *Birds of the West Indies*, the images will be reshuffled and hung in different, arbitrarily determined sequences using a random-number generator called the Mersenne Twister.[4] Thus, while the elements of *Birds of the West Indies* remain constant, their endless possibilities of combination thwart any attempt to give them order, and keep them suspended between imaginary and material realms.

The second part of *Birds of the West Indies* pushes the question of taxonomy, its possibilities and failures, even further. Taking up the role of James Bond the ornithologist, Simon identified, photographed, and classified all the birds that appear within the twenty-four films of the James Bond franchise. Often the birds are incidental to the films; they function as background for the sets they happened to fly into. Simon analyzed every scene to discover these chance occurrences. The birds were then categorized by locations both actual and fictional: Switzerland, Afghanistan, and North Korea, as well as the mythical settings of Bond's missions, such as the Republic of Isthmus and SPECTRE Island. As with all other collections of images, this one is again built through and inhabited by twists and contradictions. It starts with the seemingly arbitrary decision to focus on a completely irrelevant detail: birds passing by chance in front of the camera that is recording the heroic endeavors of James Bond. This insignificant moment gets frozen, isolated, carefully cropped and beautifully framed. For a multimillion dollar franchise celebrating gadgets, stars, and stunts that leaves nothing to chance, this comes close to an insult. The effect is further increased by the fact that in their new static form, the birds often resemble dust on a negative, a once common imperfection that has disappeared in the age of Photoshop. From there, more doors to art and absurdity open as some birds are frozen in compositions reminiscent of different genres from photography's history, some appear as carefully conceived still lifes, while

others are picturesque or have a distinctive snapshot quality. Some look low-res or obscured, as though photographed by surveillance drones or hidden cameras that might have been used by MI6 within the context of the films. Many are quite frankly beautiful and one could easily call them works of art. In any case, the result is an elegant, almost poetic, yet absurd inventory of fleeting moments, a celebration of chance and an homage to 331 birds that will never know about their fame, nor care about it. So far, this is the most self-deprecating taxonomy in the artist's oeuvre, yet, as we will see later, it is far more than a joke or an "exercise de style."

Simon had investigated the power and failure of taxonomy already in *The Picture Collection* (2013) composed of forty-four images representing folders from The New York Public Library's picture archive, one of the impressive institution's lesser-known troves. Most of the archive's 1.2 million prints, posters, postcards, and other images were cut from books and magazines, and organized according to a complex cataloguing system of over 12,000 subject headings. From its beginning in 1915, curators have collected and culled images for the archive associated with specific terms. The collection has been an important resource for writers, historians, artists, filmmakers, fashion designers, and advertising agencies, and is the largest circulating picture library in the world. But *The Picture Collection* functions like an equalizer, where images that have historically been extolled and validated sit beside those that have not. Simon's arrangements of the photos, clippings, and cutouts all overlap, hiding parts of the images and blocking the viewer's potential to see the whole picture. The collection, like the reordering of parts in *Birds of the West Indies*, questions the hierarchies by which visual and cultural materials are categorized.

In the fifty-seven images of Simon's *An American Index of the Hidden and Unfamiliar* (2007), she again uses cataloguing, in this case to track power and secrecy at the level of institutions. The pictures document objects and sites throughout the United States that remain inaccessible or unknown, but are nevertheless integral to America's foundation, mythology, and daily functioning. *An American Index* opens up the space between public and privileged access and knowledge. The collection includes views of a nuclear-waste encapsulation facility, a cryogenics laboratory, a Braille edition of *Playboy*, a Palestinian woman undergoing hymenoplasty, a threatened rain forest harboring agents to fight cancer, a great white shark in captivity, and a forensic-anthropology research center. It also contains images of The Central Intelligence Agency's hallway in Langley, Virginia, in which hang two paintings by Thomas Downing of the Washington Color School. As revealed twenty years ago, throughout the 1950s and 60s the CIA had secretly promoted American abstract art as "a weapon in the Cold War ... Because in the propaganda war with the Soviet Union, this new artistic movement [Abstract Expressionism] could be held up as proof of the creativity, the intellectual freedom, and the cultural power of the US. Russian art, strapped into the communist ideological straitjacket, could not compete."[5] For decades, Abstract Expressionism was heralded as one of the most accomplished expressions of personal freedom and creativity, but it turned out to owe part of its success to the CIA, who recognized in abstract art a James Bond—"a blunt instrument in the hands of the government"—for a Cold War cultural policy.

In another project, *Contraband* (2010), Simon builds an extensive, machine-like, and potentially open-ended catalogue of yet another form of

secrecy. Compared with *An American Index of the Hidden and Unfamiliar*, *Contraband* is a more private, almost benign secret; it catalogues 1,075 items that were detained or seized from passengers and mail entering the United States. In this performance in documenting, Simon moved into John F. Kennedy International Airport and recorded impounded items nonstop for an entire working week. While we might imagine that guns and drugs would predominate—and they were among those items confiscated—the majority was counterfeit goods. As Simon notes, "The collection reflects an economic battle—one that involves the preservation of the original that Western economies rely upon. Photography itself produces a copy of what's before the lens. In this project I was making copies of copies—photographs of counterfeit pharmaceuticals, counterfeit Louis Vuitton bags, counterfeit Disney merchandise, pirated Hollywood films. The counterfeit goods couldn't pass customs, but the photograph could, and the photograph could be entered into yet another economy—the art economy."[6]

Contraband is also an exercise in repetition: for the photographer making 1,075 images, for the customs officer discovering yet another cache of khat (an amphetamine-like stimulant), and for the viewer seeing one more box of pills. Unlike in *An American Index*, we never learn the stories surrounding the objects, never see behind the curtain, but instead are left with a visual formula that repeats itself to the point of exhaustion. Structurally, *Contraband* follows the procedure by which secrecies are upheld. A formula (a picture of a seized object in front of a neutral background) is used over and over again until it becomes a self-sufficient taxonomy that pretends to provide order and clarity. We try to discern meaning in this pattern of images, losing sight of the fact that it is a curated subsection of information. Thus taxonomy becomes a ritualistic formula that in fact prevents clarification, in the same way that a secret often constructs narratives to create an alternative world that only pretends to be real.

Simon has commented on this recurring aspect of her work in reference to her recent web-based inventory, *Image Atlas* (2012): "It's linked to a continued struggle to find some sort of order or equation in chaos. I'm interested in the murky areas where there are no clear answers—or sometimes multiple answers. It's here that I try to imagine patterns or codes to make sense of the unknowns that keep us up at night. I'm also interested in the invisible space between people in communication; the space guided by translation and misinterpretation. This space highlights the inevitability of solitude and the impossibility of true understanding."[7] In *Image Atlas*, developed together with the late software engineer and activist Aaron Swartz, Simon penetrates cultural differences and similarities. This work indexes the top image results for given Internet search terms across local engines throughout the world to interrogate the possibility of a universal visual language and question the supposed innocence and neutrality of the hidden algorithms upon which search engines rely.

In Simon's earliest body of work, *The Innocents* (2002), truth is the secret. Here, Simon photographed wrongfully convicted men "at sites that had particular significance to their illegitimate conviction: the scene of misidentification, the scene of arrest, the scene of the crime or the scene of the alibi."[8] The series is as much a reflection on a judiciary system gone wrong as it is a critique of its (and our) trust in photography, since photography, in the form of mug shots, snapshots, and Polaroids, played a crucial role in the men's wrongful conviction.

Take the case of Frederick Daye. In 1984 a young woman in San Diego, California, was forced into her car, raped by two men, and robbed. That same day, Frederick Daye had been pulled over by a policeman for a minor violation and had his picture taken. The Polaroid was used in a photo array shown to the woman in order to identify her attacker. She picked out Daye as one of her assailants. Despite a mistaken identity defense, an all-white jury convicted Daye on two counts of rape, kidnapping, and vehicle theft. Finally, in 1990, the other defendant confessed that Daye had played no part in the crime. After he had served ten years in prison, DNA testing established Daye's innocence. It also identified the real perpetrator, a man named Smallwood. But the prosecutor was unable to try Smallwood because the victim refused to press charges. She claimed that the police had permanently altered her memory by convincing her that Daye was guilty. For her, the fiction could not be replaced by the reality.

Simon's works confront us with absence. In *An American Index of the Hidden and Unfamiliar* we never fully see the hidden or the unfamiliar. It is only *represented* in the image, and described by an accompanying text. Between text and image, a space is created. We move back and forth between what we see and what we absorb, only to realize that power is invisible, constantly obliged to represent itself through tradition, order, violence, weapons, and other status symbols. Thus Simon's use of a formulaic heightened reality exposes the fact that the power of the hidden and unfamiliar relies heavily upon, and virtuously performs, formula and heightened reality. It is an illusion to think that photographs show anything, Simon's work suggests: they translate reality into a formula, a composed image. We should not be surprised, then, that we see little in *Contraband*, or rather, we see only what there is: smuggled items of no great value. The story behind the objects is absent, only to be projected by the viewer onto the neutral background on which each article is displayed and photographed. We imagine the reasons why people were trying to get powders, fruit, or pills into the United States, and we imbue a simple banana with the weight of the forbidden. In *The Innocents*, the background is again the main actor. The people are innocent, but the location in which they pose has invaded their biography and changed it forever. In all three series, possibly in all of Simon's work, the background is the foreground, and the absent is the present. Secrecy is like air; it is invisible, both background and foreground.

A Living Man Declared Dead and Other Chapters I–XVIII can be understood within the same dialectic of showing and hiding, yet it goes further. It has been compared to August Sander's *People of the 20th Century*,[9] in which the photographer sought to obtain a cross-section of German society at the beginning of the twentieth century, and to Edward Steichen's landmark exhibition *The Family of Man*, which opened in 1955 at the Museum of Modern Art in New York, and was then presented in thirty-seven countries and seen by nine million visitors.[10] For *A Living Man Declared Dead*, Simon traveled around the world researching and recording, often under the most difficult conditions, selected bloodlines and their related stories. The eighteen sections or "chapters" of this investigation, spanning from 2008 to 2011, cover five continents, the majority of the world's religions, and some of the most pressing topics of the early twenty-first century, such as human trafficking, dictatorship, racism, biogenetic interventions, genocide, pharmaceutical disasters, colonialism, deadly feuds, sectarian beliefs, and LGBT rights. While Steichen's *The Family of Man* tended toward faith in humanity,

Simon's panorama of our time is black, skeptical, and dystopian. There is no space for a family of man, no reconciliation between the people of the twenty-first century, no comforting universalism, but merely the possibility of a thoroughly coded life: "This mass pile of images and stories forms an archive. And within this accumulation of images and text, I'm struggling to find patterns and imagine that the narratives that surround the lives we lead are just as coded as blood itself."[11]

A Living Man Declared Dead maps the relationships among chance, biology, and the "political economy of fate."[12] Building on extensive research and portraying hundreds of people from all over the world, this panorama not only is ambitious in size, but also proposes a different relationship with the viewer. As in previous series, Simon developed a formula for acquiring her material and for its display. Intellectually accomplished and exquisitely executed, her presentation structures a potentially entropic situation in a new way. However, pushing this structure to perfection risks making it a goal in itself. Taxonomies are not objective, are not given, but invented—in this case, by Simon, and here she perfects them to the level where, as a spectator, one has to take a step back to ask whether a fine line has been crossed between creating one's own structure to manage the confusion of life and its reversal into a private mythology or obsession.

One way to mitigate this is to allow in other voices by attributing an active role to the viewer. *The Innocents, An American Index,* and *Contraband* provide us with historical facts while at the same time inviting us to fantasize: Who was the real murderer? What unfolds in these hidden places? Why do they bring unidentified powder into the country? In *A Living Man Declared Dead*, however, the emphasis lies elsewhere. Portraits of people we do not know, with purposely neutral expressions that refuse to guide interpretation, are lined up in front of a cream-colored background. The few illustrative pictures included by the artist in her "footnote panel" further the ambiguity. The accompanying text uses language to illuminate the visual voids that she has constructed. We are asked to process data in order to map these relationships and our position within them. Fantasy gives way to history and it is, as Geoffrey Batchen observes, a tough transition. "[It] shifts the burden of assigning that meaning from the artist to the viewer, making us all complicit in the act of signification, and indeed in the histories we are asked to witness."[13] But it is not only a burden; it is also an act of understanding and emancipation. As Homi Bhabha writes: "Simon turns the reader of images into a conceptual and speculative agent involved in the fate of photography as it confronts history. The frailty of the art of photography is its tendency to fetishize what is seen as foreign, exotic, alien, or other. Photography's voyeurism becomes exacerbated in the face of racial, cultural, or sexual differences."[14]

This brings us to the question of the relationship between the viewer and the artwork. The avant-garde movements of modernism not only invented new artistic languages, championing experiment, process, transparency, and an expanded notion of art, but they also asked for and helped to create a new active, critical, and emancipated spectator. Modernism sought not just to shock viewers, but also to present them with a liberating catharsis. Bertolt Brecht's *Verfremdungseffekt* (distancing effect) is a good example of this new relationship: spectators must regularly be made aware that they are sitting in a theater assisting an illusion created by art. The "distancing effect" is there to break the illusion of reality and enable the viewer to develop a

critical understanding of the work and the world. This considerably changes the work itself, because if a successful reception depends upon the spectators' active cooperation, they ultimately finish the work. This process is described by Umberto Eco in his books *The Open Work* (1962) and *The Role of the Reader* (1979), where he writes how, in the case of James Joyce's *Ulysses* for instance, the text itself is laid out in such a way that interpretation becomes "a structural element of its generative process,"[15] and the reader is "inscribed within the textual strategy"[16] from the beginning. Whenever we start reading a text, stand in front of an artwork, listen to music, or watch a film, rules are established to which we consciously or unconsciously subscribe in order to continue, or not, our exposure to the work. There are many tricks to sustain this implicit contract, and the Bond films, with their constant rearranging of essentially the same elements, offer a perfect example of how it is built and maintained.

The opening sequence of a Bond film starts with the now legendary shot of Her Majesty's secret agent shooting into a gun, into whose barrel, we, the spectators, look. Blood runs down the screen, the barrel turns into the lens of a camera, and the first action sequence begins. This shot, transforming the barrel into a lens, is nothing less than a shot into the spectator's eye by which the retina becomes the screen for the film: reality is replaced with fiction. As Eco notes in "Narrative Structures in Fleming,"[17] the structure of the Bond film remains unchanged, and the same goes for the introductory scenes that lay out the basic ingredients: recurring elements such as danger, death, style, sex, games, politics, and luxury form patterns that are skillfully varied and provide pleasure to the viewer. We ask for this repetition, which is part of the game that keeps our desire—and the franchise—running. Repetition is an efficient tool to renew the contract with the viewer so that each new film is also an adventure in comparison. As much as Bond lives in a constant balance between life and death, the film itself balances between repetition of and rupture with our expectations. Yet the rules are never fundamentally broken; after all, this is not a film by Jean-Luc Godard, who stands at the other extreme in film, taking corrosive pleasure in constantly altering the contract with the viewer. Eight minutes into his film *Band of Outsiders* (1964), for instance, Godard, as the narrator, tells the audience: "For latecomers arriving only now in the movie theater, we offer a few words chosen at random. Three weeks earlier. A pile of money. An English class. A house by the river. A romantic girl." The film suggests that things could have been different, that contingency rules not just our lives but also the making of a movie. With the Bond series, quite the opposite is true: here the film is bound to a certain plot, and the women and other accessories are key aides to this plot—with the exception of the birds.

The inanimate objects—the cars and weapons—were submissive sitters, willing to be portrayed by Simon. But it became more complicated with the women. Simon has become known for gaining access to inaccessible places and getting past barriers between experts and the public, but in *Birds of the West Indies* she met perhaps her greatest adversary, which she has described as vanity, although "not just vanity, but also the power of these fictional characters."[18] Ten out of the fifty-seven women she approached declined to participate. Their reasons included pregnancy, not wanting to distort the memory of their fictional character by inviting a comparison with how they appear now, and avoiding any further association with the Bond formula. With a few exceptions, nearly all the actresses, and most famously Ursula

Andress (who refused to be photographed by Simon), had not been known before the Bond films.[19] The franchise defined their image; its power left an indelible mark that still bleeds into their reality. This situation only changed in the 1980s, with the appearance of Grace Jones in *A View to a Kill* (1985), who, as an actress and singer with her own career, was not overwhelmed by being a Bond girl. The same is true for Sophie Marceau (*The World is Not Enough*, 1999) and Halle Berry (*Die Another Day*, 2002). Tellingly, all three agreed to be photographed for *Birds of the West Indies*.

The actresses were invited to select their own clothing and to decide how they would pose. Simon imposed a blank screen similar to the one she had used for the smuggled goods in *Contraband* and the portraits in *A Living Man Declared Dead*, but this time she introduced a black ground on which the actresses stand. While in *Contraband* the formulaic presentation was used to offer a space for fantasy and to investigate a self-engrossed taxonomy, and in *A Living Man Declared Dead* it was the placeholder for historical facts, in *Birds of the West Indies* the screen behind the actresses represents absence—the time gone by between the film and the moment when the portrait was taken—while the black space beneath their feet is ungrounded: the same time-capsuled space in which the weapons and vehicles reside. The time span between the images then and now is the source of potential vanity, and there is ruthlessness in exposing temporality so boldly. However, while Simon's work is known for its rigorous approach, with its distant, almost cold view, these portraits strike us as empathetic, since it is precisely in this gap between then and now that life takes place and prevents the actresses from remaining mere accessories. Making time visible is the price to be paid for not being just an element in a film like a weapon or a car, and while some of the women who refused to be portrayed may hope to remain ageless, those who allowed themselves to be photographed distance themselves from the Bond formula, and thus from the status of accessory. However, they remain grounded in their fictions, which ultimately make up the framework within which they are understood. In Simon's formula, the women presented to us are no longer the characters they stand in for, yet they simultaneously remain those characters. We are presented with images that are both patently true and completely false.

There is no such thing for the 331 birds. They are not true nor false; they are outside. They are like servants or people who seem to have missed the train of history. Staying in the background of the background means also not being controlled by the main narrative, but floating like overlooked punctuations in a thoroughly executed phrase. For almost forty years, until they were catalogued by Simon, these birds flew free. Taxonomy, this great bridge to knowledge, brought them back into the frame and took their freedom to pass unrecognized. Never again will I be able to ignore the birds in a James Bond film—which is great. This work forces us to have an eye for more than the supposed center.

More than a mere meditation on the Bond films, *Birds of the West Indies* exposes to what degree stories, objects, and even lives are built through and imprisoned by references and the subplots they construct and are embedded in. The Bond franchise is a great exemplar of, and sometimes solipsistic exercise in, cross-referencing. As much as it is natural or at least human to cross-reference in order to manage experiences and impressions, such strategies are just as often used to solidify existing knowledge instead of producing new knowledge. This is when reference can become fiction. The art

world is particularly fond of cataloguing as a potent tool to market its products. Artists' works, and also their biographies, are continuously branded through reference to stereotypes. This process was described as early as 1934 when psychoanalyst and art historian Ernst Kris, in collaboration with Otto Kurz, published their pioneering study *Legend, Myth, and Magic in the Image of the Artist: A Historical Experiment.*

Birds of the West Indies is a play in four parts cataloguing truth, fiction, and the liminal states that hover between them. Act One is a presentation of the cars and weapons that are the fiction's passive servants. Act Two presents the portraits of the actresses who were all exposed to the devouring Bond formula, but for whom the impact of fiction varies: for some it was defining and took over their lives, becoming an image to be protected and never changed; for others it was a threat, looming over their careers; for some it was just another role. Act Two draws a complicated and nuanced picture of the sometimes-perverse relationship between fiction and reality, and invites us to interpret the gap that this relationship creates. Act Three, *Honey Ryder (Nikki van der Zyl), 1962* (2013), radically departs from this. It reverses the situation and uses exposure to bring down fiction and put reality back on stage through reenacting fiction.

From 1962 to 1979, Nikki van der Zyl provided voice dubs for over a dozen major and minor characters throughout nine Bond films—*Dr. No, From Russia with Love, Goldfinger, Thunderball, You Only Live Twice, On Her Majesty's Secret Service, Live and Let Die, Man with the Golden Gun,* and *Moonraker.* An uncredited performer working behind the screen, Van der Zyl was the most constant voice within the filmic Bond universe and its most prolific agent of substitution. Simon's discovery of Van der Zyl led to another work of art. She decided not to produce a photographic portrait, but to create a film of an actor who had never been seen before. In *Honey*

C.39 *2006 Aston Martin DBS, Birds of the West Indies,* 2006
C.40 *2006 Aston Martin DBS* (with roll damage), *Birds of the West Indies,* 2006

Ryder (Nikki van der Zyl), 1962 (2013), Van der Zyl stands upon the same black floor and in front of the same white screen as the actresses in the photographs and reads the lines of the first character she voiced, the original "Bond girl" Honey Ryder, played by Ursula Andress in *Dr. No*. This short film reveals a well-kept secret and gives back Van der Zyl her voice.

Act four circles back to the "original" James Bond, with Simon in the main role. She uses the ornithologist's field of operation to question the power and limits of taxonomy and photography, the very basis of her artistic practice. One could argue that this collection of 331 accidental birds functions as a Brechtian distancing effect that estranges us not only from the entire Bond project but from Simon's whole approach. Here, photography questions photography (with great results) while taxonomy mimics itself, all of which leads straight into the black hole of the absurd. There is dark humor at work, and, as humor often does, it ignores taxonomy, fiction and reality. Simon adopts, like an actor, the role of James Bond (the ornithologist) to bring James Bond (the fiction) back to where it all started. But it's impossible to say precisely where any of it started, or who started it: everything is the result of multiple accidents not unlike the birds which happen to fly by, some of which may in fact just be particles of dust anyway. Call it contingency, or secrets.

All of Simon's projects investigate how structures build and deploy power through impermeable and often imperceptible formulas—through secrecy. *Birds of the West Indies* pursues this approach while turning to the individual to reveal different forms of dependency and patterns. The vehicles and weapons offer a ballad of advanced dependency. Portrayed with an almost sadistic simplicity, they are presented as perfect fetish objects and a mirror of our desires. Their presence is as total as their absence of character. In the films, the women are attributed the same role: endlessly mirroring the desires of the viewers, the brilliance of Bond, and the sexiness of the franchise. But Simon's portraits break up this pattern by exposing the best-kept secret and biggest enemy of this repetition: the passing of time. The passing of time—in life and in fiction—can be kept a secret only as long as a formula's inherent promise that everything will always remain the same is not altered. By randomly reconfiguring the picture series using the Mersenne Twister, *Birds of the West Indies* mimics this longing for endless reiteration unaffected by time and history. The short film about Van der Zyl breaks the most sharply from this formula precisely because it brings history into the equation. Again, we see the power of dependency: a double dependency of Andress on Van der Zyl and vice versa. Both were bound to secrecy, itself bound to money, vanity, and perpetuating a fiction. But this eight-minute-long exercise in Brechtian distancing drags us into the space where ambivalence reigns, and time pulls us in and forces us to acknowledge that things, once again, are far more complicated than they seem. This is Simon's achievement: that although she lifts the curtain, things don't get easier. Her art is not about redemption.

When shooting images for *An American Index of the Hidden and Unfamiliar*, Simon was denied access to the vaults underneath Disneyland. The corporation stated that its reason for refusing permission was that secrets "protect and help to provide [the public] with an important fantasy they can escape to."[20] Simon comments: "Reality threatens fantasy. They didn't want to let my camera in because it confronts constructed realities, myths, and beliefs, and provides what appears to be evidence of a truth. But there are multiple truths to every image."[21] That fiction wants to be protected is demonstrated in the "portraits" of the women who refused to be pictured in *Birds of the*

West Indies. Just as Simon obscures the image that was on Bond's original book cover in her version of the cover for the exhibition catalogue, she represents the missing Bond girls with a black rectangle that was cut out from the mat to frame the portrait and reinserted, concealing and at the same time representing their absence. The captions were just the same as the rest: the role of the actress followed by her name and the year the film was released. Reality and fiction are still present, but cannot be linked to a portrait, and thus remain ungrounded. Absence creates a space where identity is denied because truth and fiction start to become interchangeable. Secrecy builds on this form of absence in order to maintain its power. These black holes, these murky unknowable spaces, are what Simon investigates—spaces where solitude and misunderstanding reside.

Notes

1. Ronald Dworkin, "Commentary," in Taryn Simon, *An American Index of the Hidden and Unfamiliar*, exh. cat. Whitney Museum of American Art, New York, and Museum für Moderne Kunst, Frankfurt am Main (Göttingen: Steidl, 2007), p. 145.

2. Ian Fleming, interview by Playboy, "The Playboy Interview: Ian Fleming," December 1964, http://www.hmss.com/lagniappe/PlayboyInterview_IanFleming_1964.txt (accessed May 15, 2013).

3. According to James Chapman, *Licence to Thrill: A Cultural History of the James Bond Films* (New York: Columbia University Press, 2000), p. 13.

4. The Mersenne Twister is a pseudorandom number generating algorithm developed by Makoto Matsumoto and Takuji Nishimura. The algorithm has implementations in the computer programming languages, C, C++, D, Erlang, Fortran, Haskell, Java, Javascript, Lisp, MATLAB, Pascal, Perl, PHP, and Python. It was designed to address many of the flaws in various previous generators, and is marked by its fast generation speed and efficient use of memory. http://www.math.sci.hiroshima-u.ac.jp/~m-mat/MT/emt.html (accessed July 7, 2013).

5. Frances Stonor Saunders, "Modern Art Was CIA 'Weapon,' " in *The Independent,* October 22, 1995, http://www.independent.co.uk/news/world/modern-art-was-cia-weapon-1578808.html (accessed May 15, 2013).

6. Taryn Simon, interview by Roxana Marcoci, "Between the Image and the Word: Photographs and Annotations by Taryn Simon," in *Aperture* no. 209 (2012), p. 7.

7. Taryn Simon, interview by Lauren Cornell, "Taryn Simon's Visual Babel," *New Yorker*, August 2, 2012, http://www.newyorker.com/online/blogs/culture/2012/08/on-image-atlas-an-interview-withtaryn-simon.html (accessed July 4, 2013).

8. From artist's website, http://tarynsimon.com/works_innocents.php (accessed May 1, 2013).

9. Geoffrey Batchen, "Revenant," in Taryn Simon, *A Living Man Declared Dead and Other Chapters I–XVIII*, exh. cat. Neue Nationalgalerie Berlin (London and Berlin: Mack and Nationagalerie Staatliche Museen, 2011), p. 743.

10. From the Museum of Modern Art, New York archives, http://www.moma.org/explore/inside_out/2010/11/17/edward-steichen-archive-the-55th-anniversary-of-the-family-of-man (accessed May 6, 2013).

11. Taryn Simon, The Stories Behind the Bloodlines, TED Salon London, November 2011, 16:54–17:11, http://www.ted.com/talks/taryn_simon_the_stories_behind_the_bloodlines.html (accessed June 12, 2013).

12. Batchen, "Revenant" (see note 9), p. 743.

13. Batchen, "Revenant" (see note 9), p. 751.

14. Homi Bhabha, "Beyond Photography", *A Living Man Declared Dead and Other Chapters I–XVIII*, p. 9.

15. Umberto Eco, "Introduction," in *The Role of the Reader* (Bloomington, IN: Indiana University Press, 1979), p. 9.

16. Eco, "Introduction" (see note 15), p. 10.

17. Eco, "Introduction" (see note 15), chapter 6.

18. Taryn Simon, interview by Lauren Wetmore, in Daniel Baumann, Dan Byers, and Tina Kukielski, eds., *2013 Carnegie International*, exh. cat. Carnegie Museum of Art (Pittsburgh: Carnegie Museum of Art, 2013).

19. Chapman, *Licence to Thrill* (see note 3), p. 117. Chapman also names Honor Blackman (portrayed) and Diana Rigg (refused).

20. Excerpted from a faxed response from Disney Publishing Worldwide, July 7, 2005, in *An American Index of the Hidden and Unfamiliar*, p. 133.

21. Taryn Simon, *Taryn Simon Photographs Secret Sites*, YouTube video, minute 1:12 onward, http://www.youtube.com/watch?v=jKl0tb3VmfQ (accessed June 12, 2013).

Originally published in Taryn Simon, *Birds of the West Indies.*
Ostfildern: Hatje Cantz Verlag, 2013

Detail, "'Patterns' [Turkey], 10/27/2014, 5:29 PM (Eastern Standard Time)," *Image Atlas* (2012)

A Polite Fiction

Underneath layers of cement and drywall in the Fondation Louis
Vuitton is a message in green permanent marker on concrete:
"Oubliez la terre. Elle ne vaut pas le coup ... à moins que vous
soyez là pour me sauver" (Skip earth. Not worth it ... unless
you're coming to save me).

In *A Polite Fiction* (2014), Taryn Simon maps, excavates, and
records the gestures that became entombed beneath – and
within – the building's surfaces during its five-year construction.
Designed by Frank Gehry, the Fondation was built to house the
art collection of Bernard Arnault, one of the world's wealthiest
individuals and owner of the largest luxury conglomerate in the
world. Simon collects this buried history and examines the latent
social, political, and economic forces pushing against power
and privilege.

Systematically chronicling four hundred interventions enacted in
the building's cavities by plasterers, scaffolders, engineers, masons,
electricians, security guards, draftsmen, tile setters, interns,
supervisors, and others, Simon documents discoveries that include
a pack of Marlboro Lights with one cigarette left for a future
smoke, concealed behind drywall in a service stairwell; a newspaper
article about the 2013 murder of three Kurdish political activists
in Paris, placed in the ceiling of the executive office; and a plastic
bottle of urine hidden behind ceramic tile in the administrative
restrooms. These markings have now been deleted by the polished
surfaces of the museum. *A Polite Fiction* probes the liminal space
where voices are both quieted and preserved.

Simon's collection also investigates the removal or disappearance
of objects from the Fondation. Simon entered an invisible
marketplace, tracking, purchasing, and photographing objects
taken from the site. Items include copper and aluminum cables
sold to scrap dealers; cement used by a father to build the walls
of his daughter's bedroom; and an oak sapling that a worker took
to Poland, planted, and named after his boss. The custody and
movement of these objects transform their value, as they pass
from employer to worker and, ultimately, to artist.

Some geographic details and all of the names in A Polite Fiction *have
been redacted.*

Installation view. *A Polite Fiction*
Fondation Louis Vuitton, Paris, 2014

Basalt tile (15cm x 13cm) – Donated.

███████ took 30 tiles from stock reportedly rejected by Frank Gehry. She used them to build a barbecue pit at her home.

From: Cassano d'Adda, Italy
Resides: Arcueil, France

LED strip (80cm x 1cm) – Donated.

██████ installed the LED strips in his aquarium and around his picture frames at home.

From: Paris, France
Resides: Montfermeil, France

Universal key – Donated.

███████ took a universal key for the trapdoors on the construction site.

From: France
Resides: Paris, France

Polyester lifting sling (7m x 2cm) – Purchased for €15.

██████ intended to use the sling to secure a heavy parcel he was sending home to Mali.

From: Bamako, Mali
Resides: Cergy, France

Limestone letter U – Donated.

██████ took the letter from the word "Vuitton" in a limestone prototype of the museum's signage.

From: Nouméa, Nouvelle-Calédonie, France
Resides: Neuilly-sur-Seine, France

Aluminum attachment bracket (30cm x 2.5cm) – Donated.

██████ used the bracket as a stress-relief object. He explained that this is why it is so crooked.

From: Paris, France
Resides: Boulogne-Billancourt, France

Plaster model of penis (37cm) – Donated.

████ made the plaster penis and painted the head orange to give himself a break from building walls.

From: Montalegre, Portugal
Resides: Villemomble, France

2 smoke detector cables; 9 spotlight cables; 5 power supply cables; LED lighting cable; RJ45 network cable – Donated.

████ and two of his colleagues claimed they sold approximately €15,000 worth of copper and aluminum cables to a scrap dealer. ████ called it a "petit bonus" (small bonus).

From: France
Resides: France

Steel ratchet (30cm x 10cm) – Donated.

████ gave two ratchets to his brother to use at his horse club.

From: Lille, France
Resides: Lille, France

Eye bolt (34cm) – Donated.

████ kept the eye bolt in his car to use as a weapon for self-defense.

From: Assomada, Cape Verde
Resides: Gournay-sur-Marne, France

10 steel tubes (1.2m x 1.5cm).

████ used the tubes to create a tool to smash potatoes for
his chickens.

From: Geel, Belgium
Resides: Meerhout, Belgium

Firewood.

████ took wood home from the construction site every day to use in his fireplace.

From: Antakya, Turkey
Resides: Garges-lès-Gonesse, France

Installation view. *A Polite Fiction*
Fondation Louis Vuitton, Paris, 2014

Abstract oil painting behind drywall.

████████ created a work of art for the Foundation.

"Maintenant je peux écrire dans mon CV que je suis dans la
collection permanente de la Fondation Louis Vuitton." (Now I can
put on my CV that I'm in the Louis Vuitton Foundation's
permanent collection.)

From: Lille, France
Resides: Paris, France

Escalier Central/Central Stair

Graphite on concrete.

"Fucking WORLD
Fucking Syria
Fucking USA
Fucking France
Fucking Israel
Fucking Germany
Fucking Makokko
Fucking Russia
Best of Cammerun!!!"

Makeshift prayer room.

During Ramadan █████ prayed every day in the restroom. He
wanted to be alone while performing his prayers.

From: Mahalla el-Kubra, Egypt
Resides: Louveciennes, France

Niveau/Level -2
Toilettes Loges/Dressing Room Restrooms

Blue permanent marker on steel.

A smiley face with the words ""Il y a plus d'argent ici que dans tout mon pays...RDC!!!" (There is more money here than in my entire country...DRC!!!)

From: Democratic Republic of Congo
Resides: France

Niveau/Level -2
Réserve des Oeuvres/Art Storage

2015

Taryn Simon
56th International Art Exhibition, Venice Biennale, Venice, Italy

Rear Views, A Star-Forming Nebula and the Office of Foreign Propaganda.
Jeu de Paume, Paris, France

A Living Man Declared Dead and Other Chapters I – XVIII.
Le Point du Jour, Cherbourg, France

2014

Conflict, Time, Photography
Tate Modern, London, United Kingdom

Now You See It: Photography and Concealment
The Metropolitan Museum of Art, New York, NY

The Picture Collection
MOCAK – Museum of Contemporary Art in Krakow, Krakow, Poland

A Polite Fiction
Fondation Louis Vuitton, Paris, France

2013

Birds of the West Indies
Carnegie International, Carnegie Museum of Art, Pittsburgh, PA

A Living Man Declared Dead and Other Chapters I – XVIII
Ullens Center of Contemporary Art, Beijing, China

There Are Some Who Are in Darkness
Museum Folkwang, Essen, Germany

An American Index of the Hidden and Unfamiliar / Contraband
The Pavilion Downtown, Dubai, United Arab Emirates

A Living Man Declared Dead and Other Chapters I – XVIII
Corcoran Gallery of Art, Washington, DC

2012

A Living Man Declared Dead and Other Chapters I – XVIII
Museum of Modern Art, New York, NY

A Living Man Declared Dead and Other Chapters I – XVIII
The Geffen Contemporary at the Museum of Contemporary Art,
Los Angeles, CA

Taryn Simon: Photographs and Texts
Multimedia Art Museum, Moscow, Russia

Taryn Simon: Photographs and Texts
Helsinki City Art Museum, Helsinki, Finland

2011

A Living Man Declared Dead and Other Chapters I – XVIII
Tate Modern, London, England

Speech Matters
Danish Pavilion, Venice Biennale, Venice, Italy

A Living Man Declared Dead and Other Chapters I – XVIII
Neue Nationalgalerie, Berlin, Germany

Contraband
Centre d'Art Contemporain Genève, Geneva, Switzerland

Taryn Simon: Photographs and Texts
Milwaukee Art Museum, Milwaukee, WI

2010

An American Index of the Hidden and Unfamiliar
Dunedin Public Art Gallery, Dunedin, New Zealand

2009

An American Index of the Hidden and Unfamiliar
Institute of Modern Art, Brisbane, Australia

2007.

An American Index of the Hidden and Unfamiliar
Whitney Museum of American Art, New York, NY

An American Index of the Hidden and Unfamiliar
Museum für Moderne Kunst, Frankfurt, Germany

An American Index of the Hidden and Unfamiliar
The Photographers' Gallery, London, United Kingdom

2006

Nonfiction
High Museum of Art, Atlanta, GA

The Innocents
Contemporary Arts Center, Cincinnati, OH

2004

The Innocents
Nikolaj Copenhagen Contemporary Art Center, Copenhagen, Denmark

2003

The Innocents
P.S.1 Contemporary Art Center, Long Island City, NY

The Innocents (and Other Works)
KW Institute for Contemporary Art, Berlin, Germany

The Picture Collection
Paris: Edition Cahiers d'Art, 2015

Birds of the West Indies
Ostfildern: Hatje Cantz Verlag, 2013

A Living Man Declared Dead and Other Chapters I – XVIII
Exh. cat., Tate Modern/Neue Nationalgalerie. Berlin/London:
Nationalgalerie Staatliche Museen/MACK, 2011. 2nd ed., London/
New York: Wilson Center of Photography/Gagosian Gallery, 2012

Contraband
Göttingen: Steidl/New York: Gagosian Gallery, 2010. 2nd ed.,
Ostfildern: Hatje Cantz Verlag, 2015

An American Index of the Hidden and Unfamiliar
Exh. cat., Whitney Museum of American Art. Göttingen: Steidl, 2007.
2nd ed., Göttingen: Steidl, 2008. 3rd ed., Ostfildern: Hatje Cantz
Verlag, 2012

The Innocents
New York: Umbrage Editions, 2003. 2nd ed., New York: Umbrage
Editions, 2004

Rear Views, a Star-Forming Nebula, and the Office of Foreign Propaganda
The Works of Taryn Simon

First published 2015 by order of the Tate Trustees
by Tate Publishing, a division of Tate Enterprises Ltd,
Millbank, London SW1P 4RG
www.tate.org.uk/publishing

Book design by Joseph Logan and Taryn Simon with Andrea Rollefson
Typesetting by Rachel Hudson
Copy editing by Beth Thomas
Repro and print by optimal media GmbH

p. 78: Thomas Eakins, *The Gross Clinic*, 1875 © Courtesy Thomas Jefferson University,
Philadelphia, Pennsylvania. All rights reserved.

pp. 86–7: email reproduced with the permission of Artpace San Antonio. Photos by Todd Johnson.
Artwork originally commissioned and produced by Artpace San Antonio.

p. 169 : *Season 3, Episode 12, "Clear"* courtesy of AMC Film Holdings LLC

p. 202: Leonardo da Vinci, *Lady with an Ermine* (ca. 1490); Rembrandt van Rijn,
Landscape with the Good Samaritan (1638) courtesy of/the Princes Czartoryski Foundation.
p. 175: Neue Nationalgalerie installation photo by DavidVonBecker

p. 299: Folder from the Picture Collection records, New York Public Library, New York, NY
pp. 300–5: Archival material from the Manuscripts and Archives Division, New York Public Library, New York, NY
pp. 306–7: 1998.3.8565 (verso): Andy Warhol (American, 1928-1987). Collage (Campbell's Soup cans), ca. 1961-
1962. coated paper clippings and masking tape on heavyweight paper, 14 ¼ x 10 ¼ in. (36.2 x 26 cm.) / 1998.3.8565
(recto): Andy Warhol (American, 1928-1987). Collage (Coca-Cola advertisement from the New York Public Library
Picture Collection), ca. 1961-1962. coated paper clippings and masking tape on heavyweight paper, 14 ¼ x 10 ¼ in.
(36.2 x 26 cm.): The Andy Warhol Museum, Pittsburgh; Founding Collection, Contribution.
The Andy Warhol Foundation for the Visual Arts, Inc.

pp. 333: Never Say Never Again Shark Brain Control Device provided by Danny Biederman
and the SPY-Fi Archives.

pp. 359–63: ANSP Archives Collection 2010-45; correspondence and bird skins from The Archives of
The Academy of Natural Sciences of Philadelphia.

A catalogue record for this book is available from the British Library
ISBN 978 1 84976 235 9

Distributed in the United States and Canada by ABRAMS, New York

Library of Congress Control Number applied for

With special thanks for the ongoing support of Phase One.